R.S.V.P. Los Angeles
The Project Series at Pomona

Pomona College Museum of Art

Harry,
Thank you for always being true
to yourself, for sharing your
wisdom and wild stories. most
of all Thank You for believing
in me and who I can become.

Gracias.

RSVP
Los Angeles

LEAD CURATOR
Rebecca McGrew

CURATORIAL TEAM
**Terri Geis
Lisa Anne Auerbach
Ian Byers-Gamber
Jonathan Hall
Nicolás Orozco-Valdivia
Valorie Thomas**

COEDITED BY
**Rebecca McGrew
Terri Geis**

Contributions by Lisa Anne Auerbach,
Ian Byers-Gamber, Terri Geis, Doug Harvey,
Kathleen Stewart Howe, Rebecca McGrew,
Nicolás Orozco-Valdivia, Glenn Phillips,
Valorie Thomas, Sarah Wang

The Project Series at Pomona

RSVP

Contents

Foreword

Since its inception in 1999, the Project Series has been the Pomona College Museum of Art's signature program, a continuing and deeply engaged conversation with the ever-changing Los Angeles art world. When I arrived at Pomona College in the summer of 2004 as the new director, there were many strengths to build on—the college's distinguished history in the arts, a dynamic and ambitious staff, and a collection with many gems—but what was immediately apparent was the key role played by the Project Series under Rebecca McGrew's leadership. It was and remains a hallmark, even as other exhibitions have become more complex, and the addition of new staff has permitted the development or expansion of other programs.

This exhibition and publication commemorate the 50th in the Project Series, a convenient marker at which to pause, reflect, and celebrate. The concept of "R.S.V.P. Los Angeles," as developed by senior curator McGrew, Terri Geis (curator of academic programs), and the guest curatorial team, reiterates the centrality of the engagement between artists and the campus audience and focuses on today's emerging artists. Rather than a review of past hits, of which there have been many, this exhibition directs attention to the present. Curators McGrew, Geis, Professors Lisa Anne Auerbach, Jonathan Hall, Valorie Thomas, and students Ian Byers-Gamber ('14) and Nicolás Orozco-Valdivia ('17) have focused on artists making work now and asked how their work might engage today's campus community. Thus,

"R.S.V.P. Los Angeles" continues as the Project Series began, taking chances and emphasizing new forms and new voices.

Pomona College has an illustrious history of artistic engagement. Yet the idea of continuing a tradition does not adequately describe the innovative and resolutely forward-looking stance of McGrew's curatorial vision. Through the Project Series, McGrew continues to bring to the campus the sometimes unruly or difficult experience of making art in Los Angeles, one of the nation's, if not the world's, most diverse regions. Through a kaleidoscopic range of projects, the Project Series brings to our campus community the reality of what it means to be an emerging or mid-career artist in an important art center. Looking back over 50 projects in 16 years, it is impossible to define a "typical" Project Series artist except by reference to the quality and seriousness of his or her engagement. That is because McGrew's curatorial vision is as broad as it is discerning, focusing on art making beyond a narrow range of stars or types of production and engaging questions of continuing relevance.

The Project Series, and this exhibition, are only possible though the magnanimous support of many people. First, of course, are the many artists who have worked with us so generously over the years; their work and their willingness to engage with our campus community have made the series what it is. I especially thank those past Project Series artists who participated as nominators for this exhibition, and I am grateful to the seven artists represented in the "R.S.V.P. Los Angeles" exhibition.

The continuing series of exhibitions would not have been possible without the sustained support of the Pasadena Art

6

Alliance. Their unwavering commitment to the artists and arts of Southern California is exemplary and deeply appreciated. Over the years, additional support has come from Sarah Miller Meigs, Brenda Nardi ('85), Andrew Sloves ('85), Louise and John Bryson, the Estate of Dr. M. Lucille Paris, Carlton and Laura Seaver, the Eva Cole and Clyde Alan Matson Memorial Fund, the Edwin A. and Margaret K. Phillips Fund to Support Museum Publications, and our friends of over 100 years standing, the Rembrandt Club of Pomona College. Josephine Bump ('76), Janet Inskeep Benton ('79), and Graham "Bud" ('55) and Mary Ellen ('56) Kilsby funded a number of gifted interns who have been integral to the Project Series, conducting research and assisting with publications, installations, and programs. We list our many supporters on page 244.

At Pomona College, President David Oxtoby created a climate that confirms the central role of the arts in the liberal arts. Faculty members too numerous to name and representing a number of disciplines have engaged with artists and projects, giving willingly of their time and expertise. In addition to McGrew and Geis, the professional staff of the Pomona College Museum of Art has fostered this program over the years—preparators Gary Murphy, Katie Horak, and Gary Keith; registrar Steve Comba; museum coordinators Justine Bae and Jessica Wimbley; administrative assistants Barbara Coldiron, Debbie Wilson, and Barbara Senn; and our security and information officers Anne Merten and Fred Gallegos. A special recognition is owed to my predecessor, Marjorie Harth, who nurtured the program in its earliest years. Although technically not museum staff members, I include Don Pattison, who over the years has been everything from editor to fundraiser, and Mark Wood, whose early help in design made a publication for every project possible.

Finally, and assuredly not least, I express both institutional and personal gratitude to Rebecca McGrew, who has expanded our understanding of the role a small college museum might play in the art world and reminded us of the centrality of the artist and the arts.

Kathleen Stewart Howe, PhD
Sarah Rempel and Herbert S. Rempel '23 Director,
Pomona College Museum of Art

You Are Invited:
An Introduction to the Project Series at Pomona College

Rebecca McGrew

"R.S.V.P. Los Angeles: The Project Series at Pomona" celebrates the milestone of 50 Project Series exhibitions by connecting the extraordinary artists who have been part of the program with a new generation of artists based in the Los Angeles area. The exhibition features seven artists—Justin Cole, Michael Decker, Naotaka Hiro, Wakana Kimura, Aydinaneth Ortiz, Michael Parker, and Nikki Pressley. While artistic vision has always been the driving force behind the Project Series, the collaborative curatorial process of "R.S.V.P. Los Angeles" prioritized this in a new way. A committee of Pomona College colleagues selected a group of previous Project Series artists. This group was then invited to nominate emerging artists to be considered for "R.S.V.P. Los Angeles." Our curatorial committee then made the final selection.

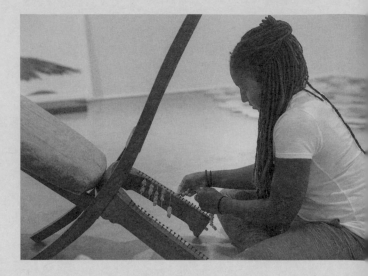

This publication serves as a catalog for "R.S.V.P. Los Angeles," and it includes individual sections devoted to each of the exhibiting artists, contextualizing essays, and an illustrated chronology of the Project Series. My essay frames the exhibition by giving an overview of the vision and history of the Project Series program. Because the work of the invited artists is presented as concurrent solo exhibitions, rather than as a thematic group exhibition, I have chosen to introduce each artist's practice individually, in short texts inserted throughout this essay. The discussions of the seven artists, the unique curatorial process that led to the exhibition, and the history of the Project Series are intertwined and inform each other.

Nikki Pressley (b. 1982, Greenville, South Carolina) fuses cultural, historical, and spiritual concepts—such as contemporary Black theory, Pan-African thought, Gullah culture, and Yoruba religion—with her personal and family-shared histories, as manifested in images, objects, and artifacts. Her focus on process and materiality merges with her history growing up in a Southern Baptist home and her interests in collective Black history. These multifaceted themes provide a grounding structure for her work, but Pressley is fundamentally concerned with how materials shape meaning and process. Pressley explores

10

Rebecca McGrew

rhizomatic meaning and narrative through drawings, sculptures, found objects, and installations. Emphasizing the liminal qualities of storytelling, she often uses organic materials—such as dirt, plants, and moss—combined with carefully fabricated drawings and objects that refer to domestic life or the natural landscape. Most recently, Pressley examines ideas of iteration in a set of handmade cement tiles and a series of graphite landscape drawings. This new work invokes W. E. B. Du Bois's home in Great Barrington, Massachusetts, where Pressley studies the links between the writer and civil rights activist, the contested history of land ownership, nature, and domestic space through the materiality of ink and graphite. Using minimalism and seriality, her work affirms the power held by inanimate objects.

After settling in to my curatorial position at the Pomona College Museum of Art in 1998, I knew I wanted to focus on contemporary art and use the artist residency as the primary model for a new program.[1] Pomona College has an illustrious history of supporting the most avant-garde tendencies in art and has played a vital role in the history of art in Los Angeles. One early example is *Prometheus*, a fresco painted on the campus in 1930 by José Clemente Orozco. Recognized as one of the Mexican artist's great masterpieces, *Prometheus* was his first work in this country and the first artwork by a Mexican muralist in North America.

A more recent precedent for this kind of dialogue at Pomona occurred in 1969, when gallery director Hal Glicksman proposed the then radical idea to work with artists directly, commissioning installations and artists' projects, rather than solely exhibiting discrete art objects. Among others at Pomona, curators Glicksman and his successor, Helene Winer, established a vision of supporting young artists who were based in the Los Angeles area and doing exploratory, innovative projects. In the late 1960s and early 1970s, they presented ground-breaking conceptual, installation, and performance artworks—intensely creative projects that reflected a confluence at Pomona College of art faculty, curators, visiting artists, and students who would go on to make significant contributions to contemporary art history.[2]

Aspiring to continue and extend this remarkable legacy, I envisaged collaborating directly with artists who themselves were engaging with the contemporary cultural moment through a rich, boundary-blurring dialogue of art, culture, history, social issues, politics, music, science, and more.

Nikki Pressley installing her work in "R.S.V.P. Los Angeles," 2015.

II

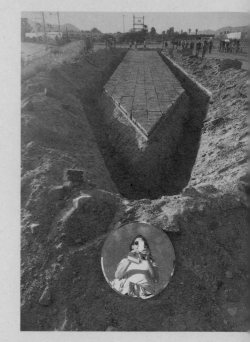

Michael Parker (b. 1978, New York, New York) creates spaces and places for artists and people to collaborate, interact with artworks, and share experiences. Parker works in ambitious, large-scale endeavors that usually involve specific communities and many participants. He is trained formally as a sculptor, but his practice also encompasses performing, facilitating, and engaging. Parker graduated from Pomona College in 2000 with a degree in studio art and received an MFA from the University of Southern California in 2009. His projects include organizing the hugely popular performance venue Cold Storage in 2006; joining the Lineman Class at Los Angeles Trade Technical College in 2009; designing and creating *Steam Egg*, an herb-infused collective sauna (2010–present); planning and overseeing the construction of *The Unfinished*, a 137-foot-long obelisk along the Los Angeles River in 2014; and, most recently, creating the fragrant, messy, and beautiful *Juicework* performance and event (2015). Parker has a profoundly diligent, hands-on, and skilled approach to his craft. While he collaborates with a variety of people throughout the stages of his projects, he ultimately oversees all aspects and completes the majority of the work himself. For this exhibition, Parker presents a rubbing of *The Unfinished* created by hand, and a unique display of components from the *Juicework* project.

I drafted a mission statement for the Project Series in 1998: "The Project Series focuses on emerging and under-represented Southern California artists. Its intent is to bring to the Pomona College campus art that is experimental and that introduces new forms, techniques, or concepts. The Project Series enhances the Museum's role as a laboratory for exploring innovative, cross-disciplinary collaborations and ideas and to serve as a catalyst for new knowledge."

In January 1999, in collaboration with the newly formed Asian American Resource Center at Pomona College, the first Project Series exhibition opened, featuring the work of Soo Jin Kim. Kim exhibited photographs that portrayed images of people and fragments of people on trains, buses, airplanes,

Curatorial team at the site of Michael Parker's *The Unfinished*, Los Angeles, California, 2014.

(facing page) Soo Jin Kim, *Speed #12* (1997), from "Project Series 1," 1999. C-print, 19 × 19 inches.

12

and taxis against the background of passing landscapes and reflections of the vehicle's interior, and the site-specific installation *Flight*, which echoed travel diagrams found in airline magazines. As I wrote in 1999, the installation of Kim's new work "focuses on 'in-between' places, moments of 'invisible' commonality. . . . Kim's imaginary spaces and in-between places bear a strong affinity to the 'any-place whatevers' discussed by Gilles Deleuze. . . . The in-between offers alternatives, different views of how things are and could be."[3] I went on to observe that instead of merely referring to the place represented, Kim's work could give us "the freedom to imagine our own visions of the places we inhabit within the world," which I continue to hold as an aspiration for the Project Series.

When I joined the staff at the Pomona College Museum of Art in the late 1990s, the art community of Los Angeles hadn't yet attained the global recognition it now has. Only a few museum exhibition models regularly supported local Los Angeles artists. They included the Museum of Contemporary Art's Focus Series, which was inaugurated in 1992 as "a long-term series of small-scale exhibitions providing an intimate and focused view of various aspects of contemporary art."[4] Their first exhibition was "Judy Fiskin: Some

Photographs, 1973–1992." The University Art Museum at California State University, Long Beach, founded its Centric series in 1981 as an "on-going series of small, timely exhibitions dedicated to introducing the UAM audience to work by individual artists that has not previously been shown in this area."[5] Other long-running examples include the Orange County Museum of Art's biennales, the Santa Monica Museum of Art's project exhibitions, and the Contemporary Projects program at the Los Angeles County Museum of Art (LACMA). Most of these project-style programs sought to bring artists from outside the region to Los Angeles, rather than featuring the work of local artists.

In 1999, the year the Project Series launched with Kim's exhibition, the Hammer Museum initiated their Hammer Projects exhibition program. Projects curator James Elaine noted recently that, in the 1990s, "L.A. represented a place where new things could happen more quickly, [it was] a city of opportunity, a city of horizontality. . . . I knew that we wanted to show emerging artists, and L.A. had plenty of them."[6] Many of those artists were coming out of the prestigious graduate schools in the area, such as Art Center College of Art and Design, California Institute of the Arts (CalArts), University of California, Los Angeles (UCLA), University of Southern California (USC), University of California, Irvine (UCI), and Claremont Graduate School (CGS), among others, and local artists availed themselves of the often-cited abundance of relatively inexpensive studio space.

Indeed, the conditions of the 1990s Los Angeles art-world were dynamic, as Los Angeles was evolving into a global art powerhouse.[7] While the recession of the 1980s had dealt a setback to many of the region's commercial dealers, DIY spaces, alternative non-profits, and artist-run galleries flourished. For example, Deep River (founded by artists Rolo Castillo, Glenn Kaino, Daniel Joseph Martinez, and Tracey Shiffman) presented exhibitions by Los Angeles artists from 1997 to 2002, prioritizing "the cultural diversity of the city."[8] Several new art journals specific to Los Angeles were publishing intriguing scholarship models. From 1987 to 2001, *Art Issues*, a bimonthly magazine of contemporary criticism founded by Gary Kornblau, focused on Los Angeles art. In 1997, Ellen Birrell and Stephen Berens produced the first issue of *X-TRA* with co-founders Jan Tumlir and Jérôme Saint-Loubert Bié. They also founded Project X, a series of adventurous artist-organized site-specific exhibitions in small non-profit galleries and community colleges.[9]

Few large museums were formally exhibiting emerging and under-represented artists in Los Angeles and backing that commitment by

Installation view of Aydinaneth Ortiz's work in "R.S.V.P. Los Angeles," 2015.

14

publishing exhibition catalogs of their work. Many were encumbered by their collections, long planning cycles, and the dictates of their boards. Commercial galleries often limited their exposure to experimental art. DIY and artist-run spaces generally couldn't provide financial support for realizing complex projects or publishing exhibition catalogs. As a small liberal arts college with a history of engaging with contemporary art, Pomona was uniquely suited to filling in the gaps left by more established mainstream art institutions and alternative venues. The college had both the legacy and the potential to establish itself as an ideal venue for experimental and innovative exhibition projects backed by serious intellectual scholarship published in book form.

> Aydinaneth Ortiz's (b. 1987, Long Beach, California) selections from the series *La Condición de la Familia* (2013) reflect her interest in exploring personal and social issues within a larger cultural framework, using the mediums of photography, book making, and printmaking. Utilizing documentary, portrait, and street photography, she focuses on intersections between urban structures, familial relationships, and social contexts. Her images fuse the individual with the historical while considering conventions of portraiture and representation. Using the strategies of photo-narrative and storytelling, Ortiz's documentary and digitally manipulated photographs ponder memory and grief. Her book *La Condición de la Familia* is an account that combines abstracted photographs of ambiguous street and domestic scenes and portraits of herself and other family members with documentary notes. Informed by meditations on family recollections, the book grew from her brother's untimely death. In the photographic tradition of Larry Clark, Nan Goldin, and Catherine Opie, Ortiz bluntly, and often painfully, confronts a profound tragedy. Like her predecessors, she documents her peers, tracing the arcs of life in a deeply personal way as sorrow and joy unfold.

As I considered the development of the Project Series, many questions came to mind. What could small exhibitions of contemporary artists offer to the Pomona College Museum of Art audience? How could I support the local community of artists? How could we successfully represent the diversity of Los Angeles? How could the museum creatively engage artists with its students in deep, meaningful ways? What is the potential of an exhibition? What is a curatorial practice? How can art help to create a more just society? These

15

questions, which I still consider regularly in my curatorial practice, are hardly unique to me. In the past decade, this kind of questioning has accelerated in academia, symposia, conferences, and published essays and interviews with a global range of curators.

In 2004, scholars Terry Smith, Okwui Enwezor, and Nancy Condee convened the symposium "Modernity ≠ Contemporaneity: Antinomies of Art and Culture after the Twentieth Century," which aimed to assess the primary characteristics of arts and culture today. I attended the conference, which took place on the University of Pittsburg campus during the Carnegie International Exhibition, and the sessions that focused on critical and political art crystalized my thoughts about working with contemporary artists in the Project Series. The essays were published in 2009 in *Antinomies of Art and Culture: Modernity, Postmodernity, Contemporaneity.* In addition to Smith, Enwezor, and Condee, many other scholars have researched and debated "contemporaneity."[10] Recently, *Ten Fundamental Questions of Curating*, edited by Jens Hoffman, curator and director of the Jewish Museum in New York, brought together a selection of curators and theorists who have pondered these issues.[11] In the following, I highlight some contributors to that volume whose strategies of curatorial engagement resonate with the ethos of the Project Series.

In *Ten Fundamental Questions of Curating*, Elena Filipovic, director and chief curator of Kunsthalle Basel, proposes that an exhibition is not neutral. She argues that while it often is a "scrim on which ideology is projected, a machine for the manufacture of meaning, a theater of bourgeois culture, a site for the disciplining of citizen-subjects, or a mise-en-scène of unquestioned values (linear time, teleological history, master narratives) . . . if we adopt instead the model of the exhibition that artists have at times called for—critical, oppositional, irreverent, provisional, questioning—the term might be understood in an altogether different way."[12] Filipovic concludes that an exhibition should strive to "operate according to a counter authoritative logic, and in so doing, become a crucible for transformative experience and thinking."[13]

Adriano Pedrosa, artistic director of the São Paulo Museum of Art in Brazil, states in a clear directive in *Ten Fundamental Questions of Curating:* "There can only be one common goal among curators: to promote diversity while avoiding the 'totalizing interpretation of history, social reality, culture, language, and all the subjective phenomena at the same time.' . . . We must multiply the ways we look at the world, read it, interpret it, write it, and represent it."[14] Could our museum be a place, as Pedrosa proposes, to engage, a place to look, read, interpret, write about, and fundamentally, to represent ourselves and our world as we know it?

João Ribas, director and curator at the Serralves Museum of Contemporary Art in Porto, Portugal, examines how we define the contemporary and why. He questions a curator's responsibility to the present and the future, asking "how the field will situate itself within the dialectic between historicity and contemporaneity."[15] Ribas closes with philosopher Giorgio Agamben's observations about

time. Smith also cites Agamben, at the beginning of an essay in *Contemporary Art: 1989 to the Present,* and he asserts that to be contemporary "is to live in the thickened present in ways that acknowledge its transient aspects, its deepening density, and its implacable presence."[16] As these writers have explored, the present time—fraught with unresolved tensions and uncertainty and filled with dissonant potential—provides multiple, perhaps overlapping narratives. Agamben eloquently sums up these intellectual analyses: "The contemporary is he who firmly holds his gaze on his own time so as to perceive not its light but rather its darkness."[17] Ribas suggests that a fundamental necessity of curating is to situate "itself within those contemporaneities that remain in darkness, untheorized and unlived."[18] When we give artists space and the freedom to take risks and experiment, they can shine a light into the shadows, bringing forth that from which we may otherwise turn away.

Many other curators and scholars are exploring the contemporary art world from a global perspective, and several offer insights into curating in Los Angeles.[19] In an essay about the proliferation of the biennale exhibition in recent years, Brazilian curator Ivo Mesquita proposes a non-traditional format based on "interdisciplinary, intercultural, and international collaboration, taking into account the challenges of a world of fluid identities and trespassed borders—one in which local and global are inexorably linked, where politics is a cultural rather than institutional practice, and where such unresolved contradictions provide the dynamic space of creative inventiveness."[20] Franklin Sirmans, curator of contemporary art at LACMA and curator of the 2014 New Orleans biennial exhibition "Prospect.3: Notes for Now," notes in his introductory essay for the "Prospect.3" catalog, "Every biennial-type show is, essentially, an attempt to gauge the state of contemporary art, to

Zine-making workshop during Andrea Bowers's exhibition "#sweetjane," Pomona College, 2014.

set about to define the immediate past and the present and point toward a future in the discourse of contemporary art."[21] He concludes with a call for action, urging artists "to open the senses, spark imagination, show us other worlds, and otherwise provoke the dreams that have yet to be dreamt— the stuff that makes life worth living.... In our world, nationality, race, and religion overwhelmingly continue to divide rather than unite.... Visual art [is] the common lens through which to view the recent past and, hopefully, imagine the possibilities of a better future."[22]

The compelling potential for artists to unite, imagine, and transform resonates with the vision of the Project Series. Discussions of curating exhibitions, as published in Hoffman's book and elsewhere, indicate a desire for viable models for a considered practice. An academic venue such as Pomona College offers a curator the opportunity to examine the breadth of a historic collection, create thematic shows that bring multiple artists together, and actively collaborate with individual artists. In all cases, we make artists and their practices the basis for every project and program. Thus, the Pomona College Museum of Art's Project Series aims to serve as a vital creative and intellectual hub where one encounters creative responses to aesthetic, social, cultural, political, and intellectual issues.

Wakana Kimura (b. 1978, Izu, Japan) links sensuous materiality with intellectual and spiritual rigor. In evocative paintings, works on paper, and minimalistic videos, she explores the elusive terrain of subjectivity and cultural specificity. Kimura moved to Los Angeles in 2007 and received her MFA at Otis College of Art and Design in 2011. Her influences include Japanese art and mythology, and she combines these in intimate drawings and large paintings. For her daily practice drawings, Kimura applies delicate washes of subtle pastel hues or vibrant rich tones in abstract swirls and linear patterns. Often, she layers pale marks, usually dots, over the color washes. With the large-scale paintings, Kimura combines delicate intimacy with dynamic calligraphic strokes of black ink that define the space of the work. Then, with beautifully detailed and lushly colored fields, Kimura exquisitely renders mythological

18

Rebecca McGrew

WK

figures, animal forms, and decorative patterns that hover in the enigmatic space. For this exhibition, the artist presents *One trifle-beset night, t'was the moon, not I, that saw the pond lotus bloom* (2015). This new monumental painting further expands the scope of her work by adding new layers of meaning through shifting figure/ground relationships and the poetic ambiguity of the narrative content. Exploring painting as a time-based practice, Kimura's video *I* (2010) consists of the artist repeatedly puncturing tiny holes with a stick of burning incense in a long scroll of delicate Japanese paper for three hours. The repetitive, almost obsessive nature of this task echoes her daily practice drawings in both the use of delicate dot marks and the commitment to a rigorous, ongoing practice.

I envisioned the Project Series supporting the vibrant local Los Angeles artist community, and I have showcased emerging and under-recognized artists in a mini artist-residency style. The resultant breadth and depth of the Project Series has consistently addressed differing artistic forms, practices, styles, and content. It also reflects the increasing cultural and geographic diversity of the Pomona student body, the Los Angeles region, and indeed, the nation as a whole. (See page 216 for a chronology of Project Series exhibitions.)

For each project, I have looked for new perspectives on a topic; a synthesis and presentation of existing knowledge in a provocative and thoughtful way; a particularly powerful or beautiful body of work; exceptional creativity and intellectual rigor; and/or a profoundly personal, emotional response to the world today. Each exhibition offers transformative potential, whether through abstract landscape paintings, documents addressing violence against women, a social practice think-tank, photographic representation of the artist's community, or sublime images of the night sky.

Each exhibition in the Project Series is accompanied by a unique printed document—an artist's book, newspaper, or monograph—that is produced in collaboration with the artist. These publications provide critical contextual and historical information and insight to the public and extend the museum's ability to reach and educate a broad audience. Without discounting the potential for works of art experienced in person to have a deep effect on the viewer, exhibitions are ephemeral; publications provide a lasting legacy. The publications also echo the objectives of the Project Series by supporting local graphic designers and writers, and over the years we have published contributions by a range of curators, critics, poets, scholars, and theorists.

Curatorial team members (from left to right) Lisa Anne Auerbach, Terri Geis, Jonathan Hall, and Nicolás Orozco-Valdivia with Wakana Kimura (pictured center) at the Japanese American Cultural & Community Center in Los Angeles, 2014.

21

Installation view of Project Series publications
in "R.S.V.P. Los Angeles," 2015.

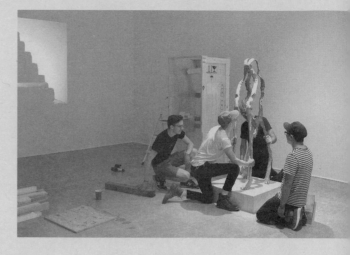

Another fundamental aspect of the Project Series responds to the museum's academic context, where the primary mandate is to actively contribute to and engage with Pomona College's curriculum, both within the visual arts and across disciplines. Accordingly, all participating Project Series artists work collaboratively with faculty and students in relevant departments, offering workshops, lectures, performances, and other carefully designed and focused programs during their exhibitions. Most recently, for example, Sam Falls (Project Series 49) presented a public lecture at the museum about his exhibition; hosted a tour to one of his studio spaces, located in a nearby parking lot; then concluded the day over an informal pizza dinner with students from three classes, where he generously shared his experiences as an artist and his perspectives on the current art world. In 2013, Krysten Cunningham (Project Series 47) embarked on a complicated series of adventures with college students. She presented a weekend-long lecture series that culminated in a performance collectively demonstrating "Minkowski space." Both the lectures and the performance were a collaborative experiment regarding participation in the phenomena of appearances and the modeling of modern scientific theory for the purposes of experiential learning. These are but two examples involving the college's studio art, art history, math, physics, media studies, and English departments.

The Project Series exhibitions and programming have grown in ambition, scale, and critical recognition. In many cases, the Pomona exhibition was an artist's first museum show and provided the artist with his or her first professional and critical publication. In other cases, the Project Series "recuperated" a career, and brought work new acclaim. The Pomona College Museum of Art has also made it a priority, within modest budget parameters, to acquire some of the artworks exhibited by Project Series artists for the permanent collection. (Several of these acquisitions will be highlighted during "R.S.V.P. Los Angeles.") While the changes over time are significant, the essential goals have remained the same. From the beginning, it has been imperative to establish a collaborative working process with each artist, from exhibition planning to public programs. In sum, the vision for the Project Series has been to highlight contemporary artists from Southern California by presenting unique, cutting-edge art projects to diverse constituencies through wide-ranging, collaborative, innovative, and provocative concepts and ideas, with a legacy through equally significant publications.

Naotaka Hiro (right) installing his work in "R.S.V.P. Los Angeles" with (left to right) Ian Byers-Gamber, Davis Menard, and Gary Murphy, 2015.

Rebecca McGrew

Using his body as a performative tool to create sculptures, videos, and sound works, Naotaka Hiro (b. 1972, Osaka, Japan) attempts to map and identify the fragmented terrain of every aspect of his body and his body's actions. For Hiro, the unknown includes that which is part of us but that we cannot see—the backs of our heads, torsos, genitals, and thighs—or do not want to fully comprehend—bodily substances like viscera, excrement, urine, semen. Influenced by the groundbreaking experimental art and performative impulses of the Gutai group in Japan in the 1950s and the history of abject body art and performance art in Southern California, Hiro explores the human body and its functions and its refuse. He uses different mediums that purport to reveal truth, such as documentary film and body casting, to reveal imperfections and mistakes through the distortions of his process. Hiro makes life-casts of his own body, following rules that he determines in advance, such as using only his right hand to cover every inch of his body he can reach, or making a cast of his buttocks in a limited time frame. The resulting beeswax molds and bronze casts are often activated in his abstract films and serve as instruments for the ambient soundtracks of the films. Hiro also uses watercolors to paint lyrical abstract images that obliquely refer to body parts. Mapping his body like a landscape, Hiro acts as an explorer of mysterious or mythical regions. He imagines a variety of unusual narratives to expand an awareness of stories of self-identity and cultural identity.

Timed to commemorate the 50 Project Series exhibitions that have taken place at Pomona College, "R.S.V.P. Los Angeles: The Project Series at Pomona" honors this dynamic contemporary art program. The current exhibition connects the many Project Series artists to a new generation of emerging or under-recognized artists in Southern California. The exhibition celebrates the philosophy of collaboration, engagement, and openness that has guided the series since the beginning.

"R.S.V.P. Los Angeles" offers an ideal opportunity to revisit the mission and vision of the Project Series and expand its model. Given the plethora of biennial-type exhibitions in Los Angeles today—including the 2012 and 2014 iterations of "Made in L.A." at the Hammer Museum and the well-established biennials at the Orange County Museum of Art—one could ask why another

group exhibition looking at contemporary artists in Los Angeles? I wanted to "imagine the possibilities of a better future," in Sirman's words, by attempting to create an exhibition based on a different type of model. And how could "R.S.V.P. Los Angeles" distinguish itself from other exhibitions in the region? I hoped to find a way, as Pederosa challenges us, to "multiply the ways we look at the world, read it, interpret it, write it, and represent it."

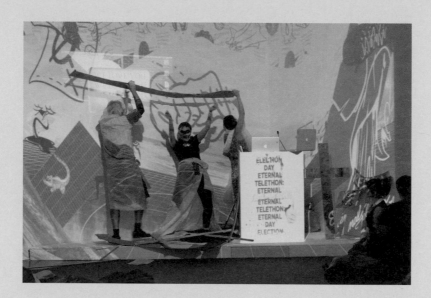

Rebecca McGrew

As discussed above, contemporary curators are frequently concerned with issues of representation, diversity, and inclusiveness. The Project Series mission of highlighting emerging and under-represented artists speaks to this mandate of reflecting our changing culture in the often exclusionary context of the "ivory tower" and the "white cube." While it is becoming standard practice for survey exhibitions and biennials to include artists who explore class, gender, locality, race, and religion, an important challenge remains: Who makes the curatorial selections? I have been discussing these issues for years with my co-curator and colleague at the museum, Terri Geis. We questioned whose work gets recognized for major biennials and surveys and wondered how we could make our program more inclusive. "R.S.V.P. Los Angeles" was launched with an intention to address this dilemma by expanding the curatorial framework.

We wanted to think outside art world boxes and represent the diversity of Los Angeles art, in terms of background, content, geography, media, schooling, and training. As a small liberal arts college museum with a history of supporting radical art, is not Pomona College

Installation view of "Project Series 44: The Eternal Telethon at The Bureau of Experimental Speech and Holy Theses," at the Pomona College Museum of Art, 2012.

(facing page) Charles Gaines performing with the Charles Gaines Ensemble at the Pomona College Museum of Art, 2012.

an ideal place to highlight risk and experimentation? We planned to emphasize inclusivity by inviting artists to select the artists for consideration. Knowing full well this action could convey a loss of curatorial criticality, we vowed to foster aesthetic excellence through a format and practice new to us.

Michael Decker (b. 1982, Spokane, Washington) is interested in the cultural products of the United States, especially a particularly homespun sort of Americana. Decker sources his materials primarily from thrift stores, which house the objects rejected by one group to be claimed later by another. Attracted to the shifting state of in-between-ness of treasure and trash, Decker dallies neatly with expressionism, pop art, and abject art. In drawings, collages, sculptures, and assemblages, Decker presents individual artworks and assorted collections of multiple objects. This reflects his wide-ranging interests in the discovery of unique individual stories, which he often finds in the abandoned "collectibles" he rescues from thrift stores. He essentially recycles nostalgia, augmenting each object's history and meaning. For example, in *Mélange La Croix* (2015), Decker presents an assembly of found wooden carvings that he has collected over the years. He carefully considers their arrangement and placement, constructing multiple meanings. In his signature found cardboard paintings, he collages commercial packing boxes. He flattens them and arranges them thematically so that the sum of each painting idiosyncratically amplifies a specific subject: floral designs, power tools, and metal storage containers, for example. Decker bridges an obsessive sense of hoarding with a formalist's knack for elegant, almost minimal design. His works can be seen as psychological portraits of ourselves and our society. Decker also creates intricate ink drawings that have a Hieronymus Bosch quality of detail and magical perversity.

The "R.S.V.P. Los Angeles" exhibition extends the Project Series' support of artists in Southern California and expands its collaborative nature. We sought to play with the curatorial process in a new way. Wanting to avoid individual artists' works being subsumed in the greater curatorial armature of a group exhibition, we hoped to generate energy among the former Project Series artists and the artists in the current exhibition toward a goal of achieving a more dynamic and complex whole.[23]

26

Rebecca McGrew

Aiming for a more egalitarian, less authoritarian version of the process of selecting artists and planning the final exhibition, Geis and I organized a committee composed of Pomona College faculty and students with a broad research focus that would collectively determine the artists, exhibition strategies, and publication contents. The committee consisted of Lisa Anne Auerbach, associate professor of art; Jonathan M. Hall, assistant professor of media studies; Nicolás Orozco-Valdivia, curatorial intern and Pomona College '17 studio art and art history major; Valorie Thomas, associate professor of English/Africana studies; Geis; and me. A practicing artist in Los Angeles with an extensive exhibition history in California and internationally, Auerbach addresses themes of communication, media distribution, language, and politics. Hall's research includes critical and psychoanalytic theories, avant-garde and experimental literature and film, queer theory, and cultural studies; he is currently working on a project about the history of Japanese experimental film. Thomas's areas of interest are African Diaspora literary and cultural theory, indigenous spirituality as decolonizing practice, vernacular culture and language, and contemporary Native American literature; she recently curated "Vertigo@Midnight," an exhibition exploring AfroFuturism. The team also includes graphic designer Kimberly Varella, of Content Object, who has creatively and collaboratively designed many previous Project Series books, editor Elizabeth Pulsinelli, who likewise has worked on several previous projects, and curatorial assistant and Pomona College '14 graduate Ian Byers-Gamber.

The "R.S.V.P. Los Angeles" committee launched the project with meetings to select previous Project Series artists to serve as nominators for the final pool of artists considered for the exhibition. With 50 great possibilities to choose from, our challenge was to pick seven candidates that we felt best represented the breadth of the Project Series in the range of artistic practice, scope of background and training, and access to artistic communities unfamiliar to us or typically underrepresented in Los Angeles. Seven Project Series artists— Christina Fernandez, Charles Gaines, Ken Gonzales-Day, Katie Grinnan, Soo Kim, Hirokazu Kosaka, and Amanda Ross-Ho—were each invited to nominate two emerging or lesser-known artists based in the Los Angeles area. These nominating artists were asked to propose artists whose work contributes to the contemporary art dialogue in Southern California. In order to encourage a broad and diverse pool of nominated artists, no other specific criteria were given, and no theme was imposed on the exhibition.

Michael Decker installing his work in "R.S.V.P. Los Angeles," 2015.

Over two weeks in July 2014, the committee conducted studio visits with the nominated artists. We traveled across Southern California, interspersing conversation during the visits with later debates about the current state of art in Los Angeles and beyond. Driving through Los Angeles County from edge to edge and in many neighborhoods in the city, we felt we had traveled every freeway. After multiple lengthy meetings in August, involving complicated and intense conversations, the committee selected seven artists. This dialogue resulted in a curatorial partnership committed to considering the legacies of Pomona and the Project Series in the context of the artists under consideration.

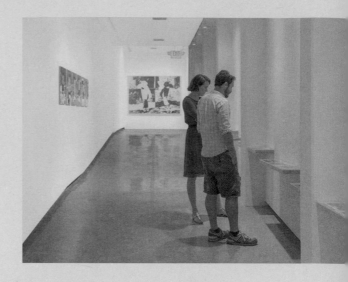

We invited Justin Cole, Michael Decker, Naotaka Hiro, Wakana Kimura, Aydinaneth Ortiz, Michael Parker, and Nikki Pressley to participate in "R.S.V.P. Los Angeles." The exhibition was envisioned as seven solo shows, and each artist was invited to present new and/or recent projects. The artists work in a range of media, from drawing, installation, photography, sculpture, and social practice to sound art and video. Despite having no overarching theme, serendipitous connections emerged. Topics circulating through the group include: an interest in the archive and documentation, the use of storytelling and theatricality, the delights of obsessive drawing practices, examinations into troubling recent history, spiritual exploration, and commitment to craftsmanship.

28

Rebecca McGrew

Exploring the slippery areas between text and image, Justin Cole (b. 1981, Detroit, Michigan) uses photography, drawing, sculpture, and audio to address complex notions of culture, nostalgia, and politics in recent United States history. Primarily interested in the interstices of traumatic moments in society, he offers new interpretations of cultural touchstones, such as the Detroit music industry; the civil rights conflicts of the 1960s; the Black Panther Party; 1970s cultural/musical/political intersections, including the far-left, anti-racist White Panther Party; and the more recent Los Angeles uprising of 1992. Combining found text fragments with staged photography, Cole seeks to invert and subvert how these key moments in history are framed. He closely examines the interconnections between the archive and the document. In

this exhibition, Cole presents *Detroit, Dust and Scratches*, a new installation based on his photographs of building facades of key sites of the Detroit music industry, which he has been documenting since 2010. In another work in the exhibition, *41st & Central (White Panther Party)* (2014–15), a colleague holds a sign on which quotes from John Sinclair, founder of the White Panthers, are shown inverted and reversed. The photographs were made at the intersection of 41st and Central, former headquarters of the Black Panther Party in Los Angeles.

As the exhibition highlights the seven individual artists, the "R.S.V.P. Los Angeles" publication showcases the artists and their varied practices with new scholarly, in-depth essays and interviews. Catalog essayists include members of the curatorial team as well as critic and writer Doug Harvey (who has written for several Project Series publications over the years); Glenn Phillips, Curator of Modern and Contemporary Collections at the Getty Research Institute in Los Angeles (who also co-curated "Project Series 46: Hirokazu Kosaka"); Sarah Wang, critic and writer; and Pomona College Museum of Art director Kathleen Stewart Howe. In addition, Geis contributed "Encyclopedia Archipelago," a wide-ranging web of themes and subjects that loosely connects the previous Project Series artists with the artists in "R.S.V.P. Los Angeles." A detailed chronology documents the histories of the Project Series exhibitions from 1999 through 2015.

"R.S.V.P. Los Angeles" presents a distinctive picture of supporting artists and innovative projects that matches the vision for the Project Series I dreamed of in 1998. Former Hammer Projects curator James Elaine notes about working with contemporary artists, "Sometimes you just have to let it go, trust your intuition, and see where it takes you.... The curator needs to know when to step forward and when to withdraw and be invisible and just let it happen."[24] Both curatorial intuition and invisibility are at play in "R.S.V.P. Los Angeles." The experience of sharing the curatorial process with a team of artists, scholars, designers, and students has yielded a revelatory exhibition that highlights the importance of trusting in artists and their creative visions.

The title "R.S.V.P. Los Angeles: The Project Series at Pomona" evokes ideas of what an invitational is and what binds this exhibition together. The expression of RSVP—*répondez s'il vous plaît*—is a heartfelt directive that empowers the invited artists and audience. It is an invitation to bring one's own point of view to the work—respond favorably, if you will.[25] It is an opening up of a transformative conversation true to the spirit of the Project Series. "R.S.V.P. Los

Justin Cole (with Terri Geis) installing his work in "R.S.V.P. Los Angeles," 2015.

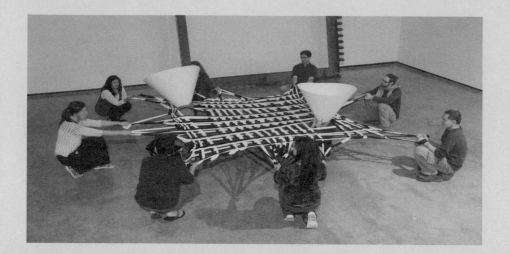

Angeles" provides for a new example of curatorial practice that supports artists and provides space for experimentation. The exhibition format and this book capture some of the dynamism of the Southern California art scene and Pomona College Museum of Art's signature program, while further extending its impact on the Los Angeles arts community. As an invitational, this exhibition brings people and artists together, and I invite you to step in, take a look, and enjoy, if you please.

Rebecca McGrew

Krysten Cunningham rehearses *Sensing Your World Line in the Fabric of Space/Time* with students and faculty at the Pomona College Museum of Art, 2013.

Notes:

1. Former Pomona College Museum of Art director Marjorie Harth supported this endeavor from the beginning, encouraged me throughout, and helped make it possible on a very limited budget. Current director Kathleen Howe has continued to support the Project Series as it has grown in ambition, scale, and budget.

2. See my introduction and essay "Opening Things Up: Why and How It Happened at Pomona," in *It Happened at Pomona: Art at the Edge of Los Angeles 1969–1973* (Claremont: Pomona College, 2011). From the fall of 1969 through June 1970, Glicksman devised a unique series of exhibitions for a program that he called the "artist's gallery." Under this program, the gallery functioned as a studio-residency for artists in Southern California. Participants included Michael Asher, Lewis Baltz, Michael Brewster, Judy Chicago, Ron Cooper, Tom Eatherton, Lloyd Hamrol, and Robert Irwin. Following Glicksman, Winer became the gallery director and curator in the fall of 1970. She organized exhibitions of Bas Jan Ader, Ger van Elk, Jack Goldstein, Joe Goode, William Leavitt, John McCracken, Ed Moses, Allen Ruppersberg, and William Wegman She also presented performance work by Chris Burden ('69), Hirokazu Kosaka, and Wolfgang Stoerchle. In concert with this exhibition programming, the art department thrived under a unique group of faculty members, including Mowry Baden ('58), Lewis Baltz, James Turrell ('65), David Gray, and Guy Williams. In addition to Burden, other outstanding students at the time included Michael Brewster ('69), Thomas Crow ('69), Judy Fiskin ('66), Peter Shelton ('73), and Hap Tivey ('69).

3. Rebecca McGrew, *Project Series 1: Soo Jin Kim* (Claremont: Pomona College Museum of Art, 1999), unpaginated.

4. Museum of Contemporary Art, press release for "Judy Fiskin: Some Photographs, 1973–1992," September 1992, http://www.moca.org/museum/pastexhibition.php?syear=1992&eyear=1992.

5. "Seth Kauffman: Centric 59," *Artscene.com*, http://www.artscenecal.com/Listings/LongBeach/CSULBFIle/CSULongBeachExhibitions/SKaufmanFIle/SKaufman0400PR.html.

6. "A Conversation with James Elaine and Lauren Bon," moderated by Gary Garrels, in *Hammer Projects 1999–2009* (Los Angeles: Hammer Museum and University of California, 2009), 414.

7. Numerous books and articles address the history of the recent Los Angeles art scene. I will cite just a few examples. Exhibitions include "Helter Skelter" at MOCA, curated by Paul Schimmel in 1992; "Sunshine and Noir: Art in L.A., 1969–1997," presented at the Hammer Museum in 1998; and "LAX 94: The Los Angeles Exhibition" (presented in nine venues throughout Los Angeles, including the Armory Center for the Arts, the California African American Museum, Cal State L.A., the Japanese American Community and Cultural Center, LACE, the Municipal Gallery at Barnsdall Park, USC, Otis College of Art and Design, and the Santa Monica Museum of Art). Recent articles and books include Robby Herbst, "Can Creative Practice Gentrify Creative Practice?" KCET Artbound, July 2, 2014; Christopher Miles, "Hammer Projects and the Indwelling of the Project Spirit," in *Hammer Projects*, 20–31; Connie Butler's and Michael Ned Holte's essays in the *Made In L.A. 2014* reader; "Thing: New Sculpture from Los Angeles," Hammer Museum, February 6–June 5, 2005; *OTIS L.A.: Nine Decades of Los Angeles Art* (Los Angeles: Otis College of Art and Design, 2005); and Chris Kraus, Jan Tumlir, and Jane McFadden, *LA Artland: Contemporary Art from Los Angeles* (London: Black Dog Publishing, 2005).

8. Lauri Firstenberg, "From Temporality to Longevity," *LAXART>5* (Los Angeles: LAXART, 2010–11), 8.

9. See Brica Wilcox, "From X to XV: Conversation with *X-TRA* Founders Ellen Birrell and Stephen Berens," *X-TRA* 15, no. 4 (Summer 2013), http://x-traonline.org/article/from-x-to-xv-conversation-with-x-tra-founders-ellen-birrell-and-stephen-berens/. *Art Issues* is no longer extant. *X-TRA* is still in print.

10. Terry Smith, Okwui Enwezor, and Nancy Condee, eds., *Antinomies of Art and Culture: Modernity, Postmodernity, Contemporaneity* (Durham, North Carolina: Duke University Press, 2009). In 2012, Terry Smith (professor of art history and theory at the University of Pittsburg) published *Thinking Contemporary Curating* (New York: Independent Curators International, 2012), which was billed as the first publication to comprehensively explore what is distinctive about contemporary curatorial thought. Smith also contributed the essay "'Our' Contemporaneity?" to art historians Alexander Dumbadze and Suzanne Hudson's *Contemporary Art: 1989 to the Present* (Oxford, United Kingdom: Wiley-Blackwell, 2013).

11. Jens Hoffman, ed., *Ten Fundamental Questions of Curating* (Milan, Italy: Mousse Publishing, Fiorucci Art Trust, 2013). All of the essays were originally published between 2010 and 2012 by Mousse Publishing.

12. Elena Filipovic, "What Is an Exhibition?" in Hoffman, ed., 74–75.

13. Ibid., 81.

14. Adriano Pedrosa, "What Is the Process?" in Hoffman, ed., 131.

15. João Ribas, "What to Do with the Contemporary?" in Hoffman, ed., 98.

16. Smith, in Dumbadze and Hudson, eds., 17.

17. Giorgio Agamben, *What Is an Apparatus? And Other Essays*, trans. David Kishik and Stefan Pedatella (Stanford: Stanford University Press, 2009), 41.

18. Ribas, 108.

19. In addition to the above sources, the following also address many of these issues: Hans Belting, Andrea Buddensieg, and Peter Weibel, *The Global Contemporary and the Rise of the New Art Worlds* (Karlsruhe, Germany: ZKM Center for Art and Media Karlsruhe, 2013); Bruce Altshuler, ed., *Biennials and Beyond—Exhibitions That Made Art History 1962–2002* (London: Phaidon Press, 2013); Paul O'Neill, *The Culture of Curating and the Curating of Culture(s)* (Cambridge, Massachusetts: The MIT Press, 2012); Judith Rugg and Michele Sedgwick, eds., *Issues in Curating Contemporary Art and Performance* (Bristol, United Kingdom: Intellect Books, 2007); and Hans Ulrich Obrist, *Everything You Always Wanted to Know About Curating* (New York: Sternberg Press, 2011).

20. Ivo Mesquita, "Biennials Biennials Biennials Biennials Biennials Biennials Biennials," in *Beyond the Box: Diverging Curatorial Practices*," Melanie Townsend, ed. (Banff, Alberta, Canada: Banff Center Press, 2003), 66.

21. Franklin Sirmans, "Somewhere and Not Anywhere," *Prospect.3: Notes for Now* (Munich: Delmonico Books/Prestel, 2014), 25.

22. Ibid., 29.

23. Constance Lewallen mentions curator Nancy Spector's attempt to do something like this in her "theanyspacewhatever" exhibition at the Guggenheim in New York in 2008–9. Spector sought an alternative curatorial model through determining the exhibition content of the group show in collaboration with the exhibiting artists. Constance Lewallen, "Back in the Day: The Eighties in 1970," *The Exhibitionist* 2 (June 2010), 17–21.

24. "A Conversation with James Elaine and Lauren Bon," 418.

25. I am grateful to Kimberly Varella for suggesting this complimentary vision of the "R.S.V.P. Los Angeles" title.

You Are Invited

31

Encyclopedia Archipelago

Terri Geis

The seven artists in "R.S.V.P. Los Angeles" evade synthesis. They were selected through nomination and committee deliberation; they work with widely varying styles, themes, and materials; and they practice in different spheres throughout the city. Yet connections and overlaps between their disparate endeavors can be found. The encyclopedic form—and its undermining by surrealist collectives in the early twentieth century—provides a useful model of examination that allows seepage between the discrete borders of each artist's work.

The traditional encyclopedia attempted to consolidate "complete knowledge" and objectively present information on a vast array of subjects, interpreting our world in manageable yet authoritative fragments.[1] Recognizing both the power and inherent biases of this form, Georges Bataille, Isabelle Waldberg, and other surrealist artists and affiliates compiled their own encyclopedias in the first half of the twentieth century. Their works maintain the alphabetized structure but reject standardization of entries, circulate ideas and themes between adjacent entries, appropriate materials from other sources, and accentuate the intuitive, humorous, and abject over the objective. The results are both elucidating and disruptive. "Encyclopedia Archipelago" is structured with these techniques in mind in order to cast a different light on the "R.S.V.P. Los Angeles" artists' practices and foreground the larger realm of their sources and imaginative worlds.

The encyclopedia also invokes the archipelic concept of Martinican writer Édouard Glissant: "Archipelic thought makes it possible to say that neither each person's identity nor the collective identity are fixed and established once and for all. I can change through exchange with the other, without losing or diluting my sense of self."[2] Reflecting politically, geographically, and metaphorically on island chains (specifically the Caribbean), Glissant suggests that we can circulate on a personal, national, or international level, maintaining our "opacity"—the distinct outlines of our islands—while also recognizing the shared and conflicting influences that inform and change us.[3] The entries that follow circulate themes between the "R.S.V.P. Los Angeles" artists and previous Project Series artists, while deferring any unified interpretations of their work.

Terri Geis

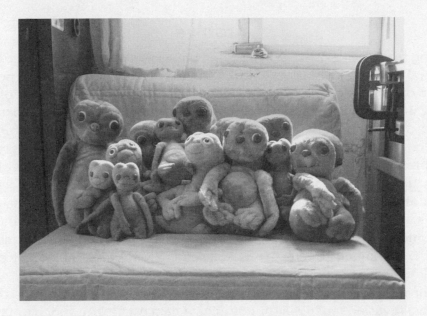

Americana

The first edition of *The Encyclopedia Americana* was published in 1829; the publisher's intention was to move away from a Eurocentric model toward one based on the United States. In the early 1900s, W. E. B. Du Bois sought to create an encyclopedia Africana to examine the cultures and histories of the African continent and the African diaspora. A similar mission was adopted by *The Liberator*, a journal that Nikki Pressley has been involved with since 2007.

35

Objects of Americana are related to the culture, folklore, and industry of the United States, at times with a highly patriotic, traditional, or nostalgic sensibility. Some artists use Americana to celebrate and critique United States culture. For example, vintage vehicles manufactured in Detroit and old record label logos figure prominently in the history referenced by Justin Cole. Michael Decker collects E.T. dolls and Sillisculpts and reconfigures them into subtly autobiographical sculptures.

Afro-Americana music draws inspiration from traditional rural music forms, including the fife and drum blues exemplified by Othar "Otha" Turner and his Mississippi-based Rising Star Fife and Drum Band. Fife players often carve their instruments out of local river cane, while vocals relate to the call-and-response format of traditional Black Spirituals. Pressley's 2013 exhibition "Elsewhere, in Another Form" (a title borrowed from a passage by Glissant) included the work *fife, fife, fife. . . .* This 12-foot sculpture combines multiple bamboo pipes, alluding to both collective creativity and an extended timeline of ancestral heritage.

Michael Decker's collection of E.T. dolls before he removed their stuffing and used them to make *Fetal Ring*, 2011.

Archive

Resulting from the desire to organize and preserve a body of knowledge that developed systematically or organically, such as official documents of a political or social organization, illegible love letters, or amateur photographs of an evolving urban landscape. In contemporary artistic production, Hal Foster has noted an archival impulse, which he describes as "a will to relate—to probe a misplaced past, to collate its different signs . . . to ascertain what might remain for the present."[4] Objects sourced by Michael Decker from thrift shops on Holt Boulevard in the eastern borderlands of Los Angeles County provide a highly selective archival record of consumer decisions regarding desirable goods versus cast-offs. For Wakana Kimura, old books and catalogs of historic Japanese images and symbols salvaged from the discard pile at the Japanese American Cultural & Community Center in Los Angeles' Little Tokyo become an inventory of the elephant, octopus, and phoenix.

Archival engagement may also indicate the desire to reorganize and undermine classifications to highlight political violence, cultural shortcomings, prejudices, gaps, and failures. Many documents, like ritual objects on display in museum vitrines, were never intended for viewing by strangers. Can these objects refuse our cultural intentions? In the opening of the 1953 film on the art of Africa in Paris museums, *Statues Also Die*, writer and filmmaker Chris Marker reflects, "When men die, they enter history. When statues die, they enter art. This botany of death is what we call culture."[5] Dinh Q. Lê (Project Series 6) slices and weaves photographs together, including images of himself and his family, photographs of stone statues from the ancient temple complex of Angkor Wat in Cambodia, and photographs from an archive constructed by the Khmer Rouge of men, women, and children murdered by the Cambodian regime.

36

Terri Geis

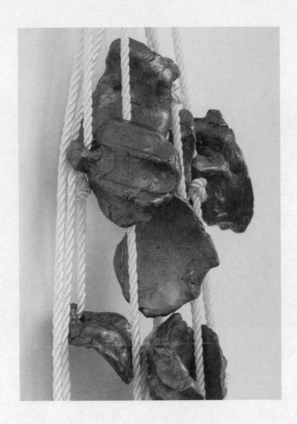

Body Casting

A three-dimensional archive is achievable through exploration, documentation, and reproduction of one's own body. Since 1991, Naotaka Hiro has made casts of different parts of his body as private performances in his studio, suggesting that "to make the body double is to see myself." But it is a separate self, one that can even seem "half dead."[6]

In a 2015 sculpture *Untitled (Mocap),* Hiro cast the front half of his body in hand-size segments, which randomly added up to 58 pieces. Strung together with rope, the bronze body parts chime melodiously when moved. In "Fifty-eight Indices on the Body," philosopher Jean-Luc Nancy reflects on the body as, among many other possibilities, a "marionette drawn by a thousand threads," or "an accordion, a trumpet, the belly of a viola."[7] Nancy coincidentally provides the number 58 as a tally of the body, but it is also a collection of never-ending parts: "Corpus: a body is a collection of pieces, bits, members, zones, states, functions. Heads, hands and cartilage, burnings, smoothnesses, spurts, sleep, digestion, goose-bumps, excitation, breathing, digesting, reproducing, mending, saliva, synovia, twists, cramps, and beauty spots. It's a collection of collections, a corpus corporum, whose unity remains a question for itself."[8]

Naotaka Hiro, *Untitled (Mocap)* (detail), 2015. Bronze, rope, and steel; dimensions variable.

(facing page) Installation view of "Project Series 6: Dinh Q. Lê," 2000.

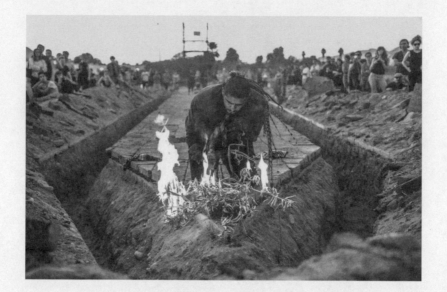

Bricks

Historian William Deverell notes, "The color of brickwork is brown."[9] The Simons Brickyard opened circa 1905 near Montebello. The compound, which included housing, a restaurant, school, store, and post office for the immigrants who worked at the brickyard, was one of the few company towns in Los Angeles. By 1925, the population of El Hoyo (The Hole), as it came to be known, was around 1,600. Around the same time, anthropologist Manuel Gamio studied the brick industry in California and noted seemingly endless classifications for the labor: "*cortadores, dampeadores, metedores de moldes, areneros, paleteros, templadores, arriadores, cargadores, asentadores, pichadores, arregladores,* and *apiladores.*"[10]

In August 2014, artist Rafa Esparza presented a performance piece with dancer/choreographer Rebeca Hernandez, entitled *Building: A Simulacrum of Power* at Michael Parker's *The Unfinished* sculpture. The performance was the culmination of an on-site residency in which Esparza, his parents, and five siblings created adobe bricks with water from the Los Angeles River and used these to cover the entire span of Parker's obelisk. Wearing a Danza Azteca costume, Esparza crawled over the bricks in movements partially inspired by their fabrication, and concluded the performance by burning sage at the tip of the sculpture.

Rafa Esparza, *Building: A Simulacrum of Power*, 2014. Still from performance at Michael Parker's *The Unfinished* (2014–15).

(facing page) Wakana Kimura, *I*, 2010. Stills from color video with sound, 180 minutes.

Terri Geis

Burning

An act frequently carried out with repetitive, ritualistic intention. Incense, sage, or sweetgrass burning accompanies many spiritual traditions, with fragrances and smoke facilitating access to a different dimension. Wakana Kimura accompanies her daily drawing practice with a secular burning of incense and has also used burning sticks as a tool to mark rice paper. The three-hour video *I* (2010) features Kimura's silhouette as she repetitively burns tiny holes through rice paper. The holes become a million eyes for the artist to peer through. Mark Bradford (Project Series 16) burned the edges of found street posters and hair perm end papers to create collages; the burned areas became lines in the compositions.

Burning is at times related to expenditure and protest. Reflecting on the cycles of growth and destruction in Detroit, Justin Cole notes that October 30 is known as Devil's Night in the city due to extensive arson attacks on residences. The practice was at its height in the 1970s through the 1990s, but still occurs. More than 800 fires were set in the city in 1984. Allan deSouza (Project Series 23) constructed and then burned a scale model of his childhood home in Kenya in the 2004 piece *House*. The artist subsequently used wax, hair, dust, and other detritus to cover and then carve out the burnt remains.

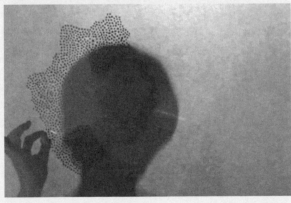

Double Image

The human brain can perceive connections between objects that are not actually connected, often making the leap between the organic and inorganic. Drawing on this phenomenon, Salvador Dali illustrated his Paranoiac-Critical method with an old postcard of a hut in an African village that, when turned 90 degrees, resembles a human face. Naotaka Hiro's photocollage *Ass Fall (The Hidden Fall)* (2004) composites a natural landscape of a waterfall with the artist's ass, referencing the eighth-century chronicle *Kojiki (Records of Ancient Matters)*. In this text, the creation of the Japanese archipelago is accomplished through the urine of deities. A related three-dimensional exploration by Hiro involves a beeswax cast of his ass transformed into an erupting volcano.

Exhibition

Le Da Costa Encylopédique, published in Paris in 1946 by anonymous members of the surrealist group, offers the following explanation of the exhibition process: "Certain individuals called artists have a custom by which they place their works before the eye of the public when these are particularly distressing or ridiculous. In other words, they abandon their works to passers-by who at the moment they take possession of the abandoned works, receive the title of art-lovers. But it quite often happens that none of the passers-by pass for an art-lover, the works thus placed leaving the passer-by who prefers to pass them by impassive. When this result is obtained, the artist experiences a splendid satisfaction and a legitimate pride, which is easy to understand since the work he has abandoned to the passer-by, has equally been abandoned by the latter; the exposure is double, and thus it counts as two. It suffices for an artist to regularly repeat this exploit for him to achieve fame."[11]

Terri Geis

Forty-One

The number is associated with an infamous twentieth-century police raid that informs Justin Cole's *41st and Central (White Panther Party)* (2014–15). On December 8, 1969, police raided the Los Angeles headquarters of the Black Panther Party, which was located at 41st and Central. The incident involved 350 officers and was the first SWAT operation in history. (The paramilitary group was conceived by Daryl Gates after the 1965 uprising in Watts.) The SWAT team used a battering ram, helicopters, tanks, and dynamite. Approximately 5,000 rounds of ammunition were exchanged, but no deaths occurred. Multiple Black Panther members were imprisoned under charges of conspiracy to murder police officers and their headquarters building was subsequently demolished. The number 41 appears on a SWAT team patch in commemoration of this operation.

41st and Central (White Panther Party) (detail), 2014–15. Six silver gelatin prints mounted on plywood, 20 × 16 inches each.

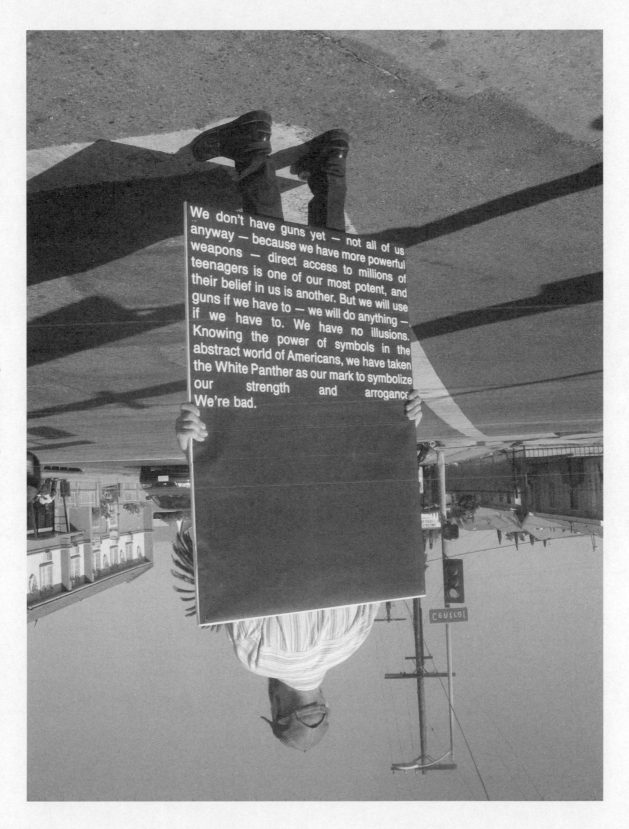

We don't have guns yet — not all of us anyway — because we have more powerful weapons — direct access to millions of teenagers is one of our most potent, and their belief in us is another. But we will use guns if we have to — we will do anything — if we have to. We have no illusions. Knowing the power of symbols in the abstract world of Americans, we have taken the White Panther as our mark to symbolize our strength and arrogance. We're bad.

Terri Geis

Charles Gaines, *Black Ghost Blues Redux*, 2008. Stills from color video with sound, 6 minutes 10 seconds.

(facing page) Amanda Ross-Ho, installation view of "Project Series 40: Amanda Ross-Ho *The Cheshire Cat Principle*," 2009.

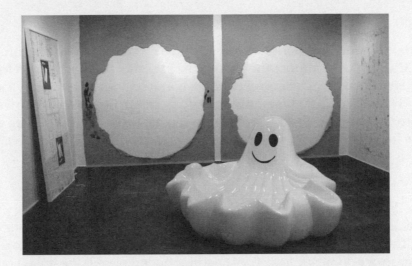

Ghosts

The popularity of communicating with ghosts through Oujia boards and séances increased dramatically after World War I.[12] Literary scholar Katharine Conley asserts, "Unconstrained by mortal chronology or rules of behavior, spiritualist ghosts are simultaneously threatening and inspiring in their freedom, symbols of rebellion against fate and the constraints of mortality."[13]

Like automatic writing and drawing, the use of a Ouija board can create a system in which process is as important as outcome and full conscious intention is relinquished. Michael Decker and Christian Cummings explore this in their practice of Spectral Psychography. After identifying a willing spirit with the help of the board, the blindfolded artists proceed to create drawings that reflect the otherworldly influence. But is the result a confession, a secret message, or an inside joke? Of the ghost collaborators guiding their hands, Decker has reflected, "They seem to enjoy leaving us with more questions than the few of ours they answer."[14]

The Ouija board is related to the silhouette or shadow, a ghost traced through letters into a shape/message that the bereaved can perceive. Aydinaneth Ortiz's series "Not Alone" investigates this sense of longing, inserting the silhouette of her recently deceased brother into the landscapes of her daily life. Ortiz reflects that she is attempting (without success) to summon his presence.[15]

Charles Gaines (Project Series 43) references connections between ghosts, doubles, and representation in the video *Black Ghost Blues Redux* (2008), which features Lightnin' Hopkins's lyrics, "Black ghost is a picture, and the black ghost is a shadow too."[16] Amanda Ross-Ho (Project Series 40) addresses concepts of visibility and invisibility with a sculpture consisting of an enlarged reproduction of a candy dish shaped like a ghost, suggesting that the original object "intended to represent a spirit or lack of a body—while containing the body—turned into a different kind of container."[17]

At times it is more desirable to keep spirits away. The Gullah community of South Carolina, an important and recurring cultural inspiration for Nikki Pressley, developed the tradition of painting porch ceilings a light blue ("Gullah Blue" or "Haint Blue") to resemble the sky, attempting to fool malevolent spirits into flying up and away through the ceiling. Front doors are also painted this color to imitate water, which spirits are said to be unable to cross.

Gift

Surrealist and sociologist Pierre Mabille writes, "Having penetrated our dwelling places, [gifts] enjoy a curious extraterritoriality. Although they belong to us and are subject to our domestic laws, they continue nonetheless to be linked by invisible threads to those who sent them to us."[18] Michael Decker's practice includes gifted objects that have been excavated from the contemporary thrift shop economy. He feels they are imbued with special characteristics that can be sensed by others who later encounter them. The concept that gifts should remain moving—consumed and then passed on—has a history in many traditions. One of the most carefully documented ritual gift systems is the Kula exchange among the Massim peoples of the South Sea Islands, in which armshells and necklaces "move continually around a wide ring of islands in the Massim archipelago."[19]

44

Terri Geis

Graphein

Ancient Greek verb (γράφειν), interchangeably meaning to write, to draw, or to depict; it provides the basis of the English noun "graphite." Justin Cole uses highly reflective graphite for his drawings in order to instigate a "troubling reproductive nature" when the drawing is photographed.[20] For Nikki Pressley, graphite (along with concrete) can provide an indexical record of her process, and she has also used the material to create rubbings of furniture in an attempt to convey the thoughts of inanimate objects. In Michael Decker's series "And All I Got Was This Lousy Graphite Seashell That I Used to Make This Drawing" (2011), the artist created four large drawings with highly abstracted, anthropomorphic imagery. He presented the drawings alongside his graphite tool, which is inexplicably shaped like a seashell. Likely intended to be a non-functional souvenir, the seashell instead serves as both creative inspiration and technical means. In 2015, Michael Parker used graphite and large rolls of paper to create rubbings of his obelisk sculpture.

(above) Michael Decker, *And All I Got Was This Lousy Graphite Seashell That I Used to Make This Drawing no. 2* (detail), 2011. Graphite on paper, 52 × 31 × ½ inches.

(below) Nikki Pressley installing her work in "R.S.V.P. Los Angeles," 2015.

Encyclopedia Archipelago

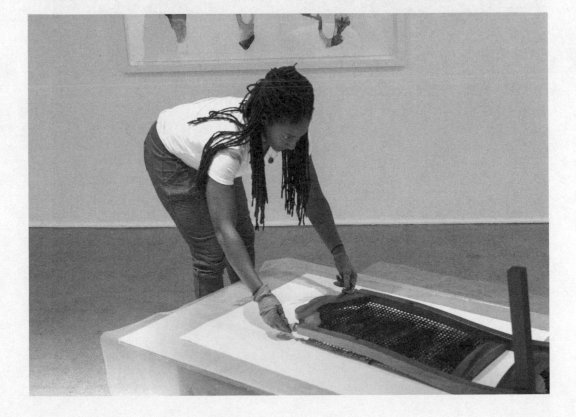

Historic Preservation

The Mount Vernon Ladies' Association is the oldest historic preservation organization in the United States. Founded in 1853, this group worked to preserve the plantation home of George Washington, located in Virginia along the Potomac River, and in early years offered visits to Washington's tomb on the property. In Solomon Northup's 1853 narrative, *Twelve Years a Slave,* the author recounted his own experience of "visiting" Washington's tomb after being kidnapped and smuggled by steamboat into the slaveholding South by James H. Burch: "Soon the vessel started down the Potomac, carrying us we knew not where. The bell tolled as we passed the tomb of Washington! Burch, no doubt, with uncovered head, bowed reverently before the sacred ashes of the man who devoted his illustrious life to the liberty of his county."[21]

Contemporary historic preservation works with photographic documentation and oral histories to create archival records and to trace places and communities in the face of development and destruction. As a result of the 2009 survey "Historic Resources Associated with African Americans in Los Angeles," seven sites were added to the National Register of Historic Places. These included the 28th Street YMCA in South Los Angeles, which, when built in 1926, was among the few public places where the city's Black residents were allowed to swim.

Similar documentary strategies can be found in contemporary art. In the series "Detroit, Dust and Scratches," Justin Cole uses the aesthetics of historical society photography in order to document the disappearing legacy of the music industry in Detroit. Nikki Pressley has paid multiple visits to the razed childhood home of W. E. B. Du Bois in Great Barrington, Massachusetts. In this wooded area, punctuated by remnants of a chimney and a few foundations, Pressley has collected moss for propagation. Katie Grinnan (Project Series 31) used photographs of a recently demolished building materials store as a "skin" for *Rubble Division* (2005–6). Ken Gonzales-Day (Project Series 30) has extensively documented sites of lynching in the West and created a walking tour of sites in Los Angeles. In the 1996 series "Manuela S-t-i-t-c-h-e-d," Christina Fernandez (Project Series 18) photographed facades of sweatshops in East Los Angeles. Aydinaneth Ortiz's newest project documents the buildings and grounds of a state-run psychiatric facility in California.

47

Ken Gonzales-Day, *Franklin Avenue (1920),* 2006, from the series "Erased Lynching." Lightjet print on paper, 5 7/8 × 3 7/8 inches. Pomona College Museum of Art. Museum Purchase with funds provided by the Estate of Walter and Elise Mosher.

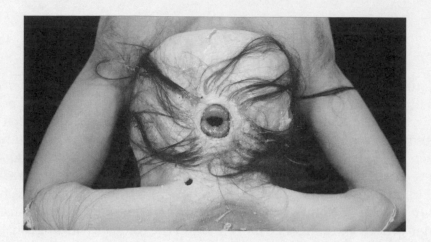

Terri Geis

Holes

The creation of different types of holes involves varying sounds and vibrations. The burnt holes created by Wakana Kimura poking lit incense through rice paper make little noise, while an erupting volcano, a regular theme in Naotaka Hiro's work, can sound like a jumbo jet or make "swishing sounds like ghostly winds through a pine forest."[22] A bronze cast of one's own ass and anus can double as a volcano or a resonant gong, as Hiro has demonstrated. Michael Parker's egg-shaped steam chamber in use is punctuated by the sound of sweat dripping out of the bottom entry hole. Prior to receiving permission to excavate an obelisk in twenty-first-century Los Angeles, Parker utilized high-frequency radio waves to determine feasibility and provide information on underground toxicity levels.

48

Hospital Emergency Code Colors

Assigned to systematize urgent communication within hospitals and often an attempt to veil trauma from anxiously waiting family members. The colors are not standardized across facilities, which can cause confusion for doctors who work in multiple hospitals. For example, Code Yellow can varyingly indicate a missing patient or an assault, while Code Purple is used in some facilities for a hostage situation, in others for a bomb threat. Code Red consistently indicates a fire.

Code colors sometimes tap into physical or emotional conditions. Code Blue, which Aydinaneth Ortiz notes as deeply informing her family's experience during her brother's hospitalization, indicates that a patient requires resuscitation. Code Blue has subsequently become a subtext within her work. In his classic study on color theory, spirituality, and emotion, artist Wassily Kandinsky suggests, "Blue is the typical heavenly color. The ultimate feeling it creates is one of rest. When it sinks almost to black, it echoes a grief that is hardly human."[23]

Naotaka Hiro, *The Pit (Dancer with Golden Lips)*, 2013. Still from HD video.

(facing page) Aydinaneth Ortiz, *Time to Reflect*, 2013. Archival pigment print; 30 × 22 inches, unframed.

Linguistic Relativity

Fire prevention chemical engineer and linguistic theorist Benjamin Whorf attributes to language the ability to build the house of human consciousness.[24] This house—in which resides the inner *I* of the thinker—is unique to all yet universal in its linguistic cause. To speak Gullah is to have a structurally varying house of consciousness from someone who speaks English and therefore a differing human experience. The house surrounding one's consciousness is a singular mediating apparatus that creates our worldly experience. Nikki Pressley's work on paper *Word* (2010) presents on one side the Biblical passage of John 1.1 translated into Gullah and written repeatedly in graphite: "Fo God mek de wol, de Wod been dey. De Wod been dey wid God, an de Wod been God." On the other side of the paper, Pressley embossed passages from a West African folk tale about the trickster Anansi, who often takes the shape of a spider and maintains the knowledge of all stories. [Entry by Parker Head ('17)]

Los Angeles Archipelago

Terri Geis

In 1946, Los Angeles cultural historian Carey McWilliams described the city of Los Angeles as an archipelago of separate, isolated cultures: "Throughout Southern California, social lines do not run across or bisect communities; on the contrary, they circle around and sequester entire communities. 'Migration,' [urban sociologist] Dr. Robert E. Park once wrote, 'has had a marked effect upon the social structure of California society . . . a large part of the population, which comes from such *diverse and distant places,* lives in more or less *closed communities,* in intimate economic dependence, but in more or less complete cultural independence of the world about them' . . . Southern California is an archipelago of social and ethnic islands, economically interrelated but culturally disparate."[25]

Los Angeles Trade Technical College

Founded in 1925 in South Central Los Angeles, the college is the oldest of the public two-year colleges in the Los Angeles Community College District. Programs include Automotive Technology, Community Planning & Economic Development, Correctional Science, Nursing, and Welding Technology. In the 2009 publication *Lineman,* Michael Parker documents four months that he spent in the power pole yard at LATTC while enrolled in the lineman-training program. Comprised of oral histories, performance documentation, and photographs, the *Lineman* project explores Parker's desire to interact with and reflect a "diverse microtopia."[26]

Michael Parker, *Lineman* (single page), 2009. Newsprint publication, 60 pages, full color; 11 × 17 inches, closed.

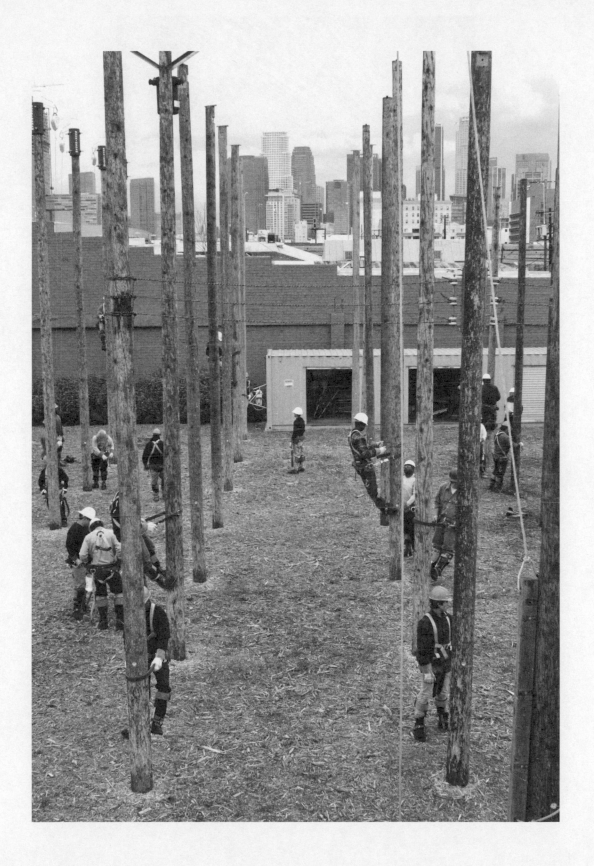

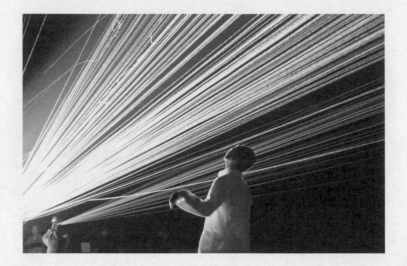

Time

The concept of *deep time*—extended geological time over hundreds of thousands of years—and the impact of extended time on natural materials, informs Nikki Pressley's new series of cement tiles, *iterations* (2014–15). Deep time may be translated best into a comprehensible notion for humans through metaphor or analogy. Hirokazu Kosaka (Project Series 46) often explores varying experiences of time, for example, the impressive speed of the Japanese bullet train that allows him to hastily arrive at his ancestral home, which is over 800 years old. Here, he sees a spider in the eaves, perhaps a descendant of an arachnid line dating back to the seventeenth century. Kosaka also regularly references the Hindu/Buddhist concept of *kalpa*, a long period of time, and its metaphorical application, in which an angel descends from heaven and swipes her silk sleeve against a seventeen-mile stone. This is repeated once every hundred years, until the rock has vanished. Soo Kim (Project Series 1) cuts and layers her photographic prints with the intention of creating a "slowness in the reading and understanding of an image that makes evident the materiality of the medium as well as the time of labor and deliberation, marked by imperfection, that works against the speed and perfection of developing technologies."[27]

Trans-Love Energies

Communal living environment established in Detroit by John Sinclair in 1967, in connection with the proto-punk band the MC5 and the White Panther Party (formed to support the Black Panthers). Trans-Love Energies, regularly referenced in the work of Justin Cole, sought to use rock music to radicalize the youth movement and envision/establish an alternative, anti-racist, anti-capitalist society. The commune

Hirokazu Kosaka, *Kalpa*, 2012. Performance at the Getty Center, Los Angeles.

(facing page) Drexciya, *Aquatic Invasion*, 1995. Center labels, sides A and B.

emerged out of the Detroit Artist Workshop, which was founded in a storefront in 1964 by Sinclair and other artists, writers, and musicians. In his manifesto, Sinclair explains: "What we want is a place for artists—musicians, painters, poets, writers, film-makers—who are committed to their art and to the concept of community involvement to meet and work with one another in an open, warm, loving, supportive environment (what they don't get in the 'real' world)—a place for people to come together as equals in a community venture the success of which depends solely upon those involved with it."[28]

Edgar Arceneaux (Project Series 11) has recently explored another Detroit-based collective, the electronic band Drexciya. In the 1990s, Drexciya envisioned an underwater civilization, descended from pregnant slaves thrown overboard during the Middle Passage, that was planning an attack on the human world above.

Weaving

Basket weaving with locally harvested sweetgrass has been a tradition in the Gullah community of the coastal counties of South Carolina (and the Sea Islands chain) for 300 years, with methods passed down from ancestors in West Africa. Nikki Pressley identifies these practices as transcending the uprooting and enforced migration of the slave trade, and references this living patrimony when weaving string trellises for sculptures such as *Run* (2013).

The Seigaiha (blue ocean waves) motif is prominent in Wakana Kimura's large drawing, *One trifle-beset night, t'was the moon, not I, that saw the pond lotus bloom*. The motif has been woven into textiles in Japan for over 1,000 years and possibly originates from ancient Chinese maps, where it was used to illustrate water. Krysten Cunningham (Project Series 47) uses giant looms to weave hypersurface models for performative enactments of theories of physics. The histories of European textile factories and labor organizations also inform her weaving practice.

Terri Geis

54 Michael Decker's use of fabrics, including thrifted t-shirts compiled into large collage-panels, has also resulted in a textile composed of hundreds of tags sewn together. Company names and logos on many of the tags reference the multinational garment industry, and they were likely sewn into the t-shirt by a worker on an assembly line in a factory. Each tag subsequently brushed up against the skin of at least one wearer, absorbing sweat, rubbing uncomfortably, possibly tucked back in to the shirt by a well-meaning stranger. Each tag was removed and stitched into a new associative adjacency by Decker, who was partially driven by a love of objects and reluctance to remove even the smallest fragment from circulation, as with a crazy quilt.

In *Poetics of Relation*, Édouard Glissant suggests, "Opacities can coexist and converge, weaving fabrics. To understand these truly one must focus on the texture of the weave and not on the nature of the components. For the time being, perhaps, give up this old obsession with discovering what lies at the bottom of natures. There would be something great and noble about initiating such a movement, referring not to Humanity but to the exultant divergence of humanities.... This-here is the weave, and it weaves no boundaries."[29]

Krysten Cunningham, *Ret, Scutch, Heckle*, 2013. Aluminum, brass, concrete, pebbles, epoxy, cotton, wool, silk, bamboo, and natural dye; 92 × 48 × 48 inches.

Notes:

1. The word "encyclopedia" has its origins in the Greek terms *enkyklios* (general) *and paideia* (education), together meaning "complete knowledge."
2. Édouard Glissant, *Le Discours antillais* (Paris: Éditions du Seuil, 1981), quoted in English translation in Hans Ulrich Obrist, "Le 21ème siècle est Glissant," Édouard Glissant and Hans Ulrich Obrist, *dOCUMENTA (13): 100 Notizen—100 Gedanken* (Berlin: Hatje Cantz, 2012), 4.
3. On Glissant's concept of opacity, see *Le Discours antillais* and "For Opacity," in *Poetics of Relation*, trans. Betsy Wing (Ann Arbor: University of Michigan Press, 1997), 189–94.
4. Hal Foster, "An Archival Impulse," *October* 110 (Autumn 2004): 21.
5. Chris Marker, essay-script for the film *Les statues meurent aussi (Statues Also Die)*, directed by Alain Resnais, Chris Marker, and Ghislain Cloquet, produced by Présence Africaine, Paris, France, 1953.
6. Naotaka Hiro in conversation with author, January 29, 2015.
7. Jean-Luc Nancy, "Fifty-eight Indices on the Body," *Corpus*, trans. Richard A. Rand (New York: Fordham University Press, 2008), 152.
8. Ibid., 155.
9. William Deverell, *Whitewashed Adobe: The Rise of Los Angeles and the Remaking of Its Mexican Past* (Oakland: University of California Press, 2005), 149.
10. Manuel Gamio, *Mexican Immigration in the United States* (New York: Arno, 1930), cited in Deverell, 149.
11. *Le Da Costa Encyclopédique,* published in Paris in 1946, reprinted in English translation as *Encyclopædia Da Costa*, trans. Iain White (London: Atlas Press, 1995), 154.
12. See Mitch Horowitz, *Occult America: White House Seances, Ouija Circles, Masons, and the Secret Mystic History of Our Nation* (New York: Bantam, 2010).
13. Katharine Conley, *Surreal Ghostliness* (Lincoln: University of Nebraska Press, 2013), 3.
14. Michael Decker, quoted in Janice Lee, "On Spectral Psychography," *Bright Stupid Confetti*, January 16, 2013, accessed February 28, 2015, http://www.brightstupidconfetti.com/2013/01/authors-on-artists-janice-lee-on.html.
15. Aydinaneth Ortiz in conversation with author, December 4, 2014.
16. Sam Lightnin' Hopkins, "Black Ghost," recorded in 1964.
17. Rebecca McGrew, "Project Series 40: Amanda Ross-Ho" (2000), Pomona College Museum of Art, accessed April 1, 2015, http://www.pomona.edu/museum/exhibitions/2010/project-series-40-amanda-ross-ho.
18. Pierre Mabille, *Le Miroir du merveilleux* (Paris: Sagittaire, 1940), reprinted in English translation as *Mirror of the Marvelous*, trans. Jody Gladding (Rochester, NY: Inner Traditions, 1998), 183.
19. Lewis Hyde, *The Gift: Creativity and the Artist in the Modern World* (New York: Knopf Doubleday, 2009), 16.
20. Justin Cole in conversation with author, December 30, 2014.
21. Solomon Northup, *Twelve Years a Slave* (Auburn, NY: Derby & Miller, 1853), 56.
22. Richard V. Fisher, Grant Heiken, and Jeffrey Hulen, *Volcanoes: Crucibles of Change* (Princeton, NJ: Princeton University Press, 1998), 179.
23. Wassily Kandinsky, *Über das Geistige in der Kunst. Insbesondere in der Malerei* (1912), reprinted in English translation as *Concerning the Spiritual in Art and Painting in Particular,* trans. Francis Golffing, Michael Harrison, and Ferdinand Ostertag (New York: George Wittenborn, 1970), 58.
24. Benjamin Lee Whorf, *Language, Thought, and Reality: Selected Writings*, ed. John B. Carroll (Cambridge, MA: Technology Press of Massachusetts Institute of Technology, 1956).
25. Carey McWilliams, "The Los Angeles Archipelago," *Science & Society* 10, no. 1 (Winter 1946), 41. Italics added by McWilliams to Park quote.
26. Michael Parker, *Lineman*, accessed February 28, 2015, http://www.michaelparker.org/1/lineman2.html.
27. Lesa Griffith, "Artist Soo Kim: I consider my practice mistake-driven," *Honolulu Museum of Art Blog*, March 14, 2014, accessed February 28, 2015, http://blog.honoluluacademy.org/artist-soo-kim-i-consider-my-practice-mistake-driven.
28. John Sinclair, "The Artists' Workshop Society: A 'Manifesto'" (November 1, 1964), *Detroit Artists Workshop*, accessed February 28, 2015, http://www.detroitartists-workshop.com/the-artists-work-shop-society-a-manifesto.
29. Glissant, "For Opacity," *Poetics of Relation*, 190.

Artists in the Exhibition

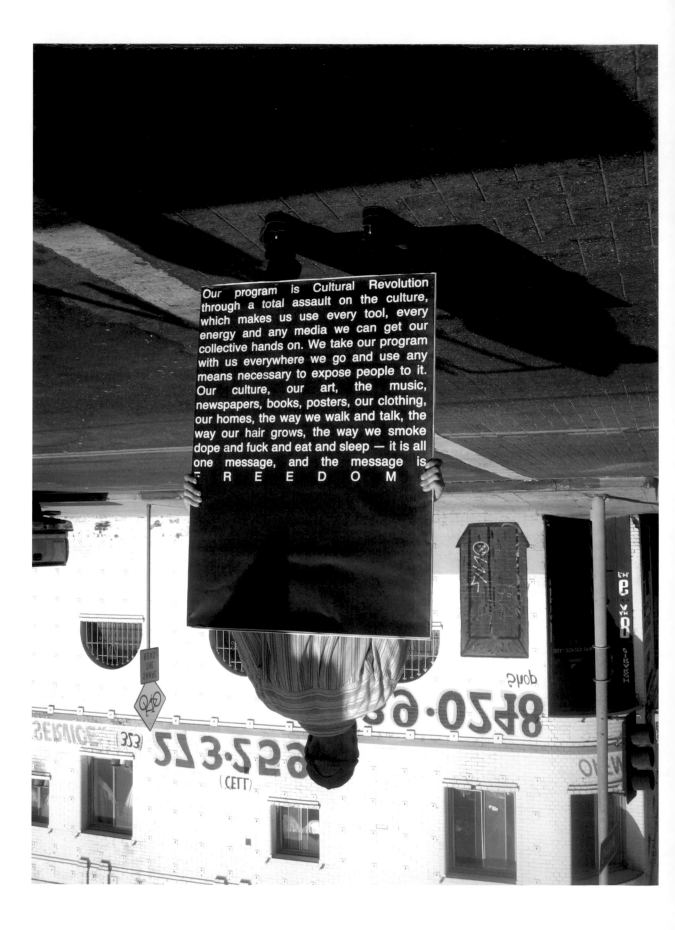

Our program is Cultural Revolution through a total assault on the culture, which makes us use every tool, every energy and any media we can get our collective hands on. We take our program with us everywhere we go and use any means necessary to expose people to it. Our culture, our art, the music, newspapers, books, posters, our clothing, our homes, the way we walk and talk, the way our hair grows, the way we smoke dope and fuck and eat and sleep — it is all one message, and the message is F R E E D O M

Justin

Cole

Dis/Orientations: Justin Cole

Terri Geis

Nor had they dreamed that the past, while certainly refusing to be forgotten, could yet so stubbornly refuse to be remembered.[1]
—James Baldwin

The preceding quote, from Baldwin's 1965 short story, "Going to Meet the Man," is spelled out across a concrete floor in indestructible but light-as-air Styrofoam pieces. Photographed as a diptych by Justin Cole for his 2007 "Timelines" series, the image/message alludes to both a refusal to acknowledge a changing world (the story is a condemnation of anti-Civil Rights violence), and an awareness of how significant histories can rest dormant or even be erased. Cole persistently tracks discarded pasts in order to assert their relevance for the present, reflecting on wider culture through its marginalized aspects. Tracing literary and musical quotes with Styrofoam; photographing people standing at significant sites holding hand-painted messages on cardboard signs; and referencing old maps and floor plans for large-scale drawings in graphite, Cole reactivates locations and ideas that are central to the political and cultural history of the Americas. These erased sites range from the Black Panther Party's headquarters in Los Angeles to the Brewster-Douglass housing project in Detroit, where Motown luminaries such as Smokey Robinson and Diana Ross grew up, and Tenochtitlán, epicenter of the Aztec Empire prior to the Spanish Conquest.

Cole has a deep impulse to understand roots, both personal and national. He was born in Detroit and regularly visited relatives there throughout his childhood. The city serves as a compass and gauge through which he measures the broader currents and connections of labor, civil rights, and music. Cole is also a bassist and founding member of the seven-person art/music collective OJO, which was formed by MFA students at the University of California, Los Angeles, in 2005. At performances in art venues, OJO played in the round, moved in circles, and directed intensive audience participation. As Cole explains, "It's all about the sound being made more permeable and more open to everyone."[2]

Cole's work demonstrates permeability between artist, performer, and spectator as well as the fluidity of boundaries between the image, the text, and the aural. His artwork prioritizes the investigation of text as image, but he often chooses to reflect on his artistic influences and themes—including the syncretic nature of root cultures—in musical

(previous spread) *41st and Central (White Panther Party)* (detail), 2014–15. Six silver gelatin prints mounted on plywood, 20 × 16 inches each.

61

terms: "I think that cultural pollination is really important to American innovation, for instance the blues coming out of African hollers and call and response mixing with Western instruments and harmony to produce rock 'n' roll and jazz. The mixture of these two cultures here in the U.S. has produced some of the most treasured art forms, uniquely American because of this cultural negotiation."[3]

The sites of Cole's photographs often have accumulated painful histories related to socioeconomic disparities, political control, and media manipulation.[4] In 2012, Cole visited numerous public places associated with the 1992 uprising in South Central Los Angeles, which is imprinted on the country's memory through aerial footage shot by hovering media helicopters. Cole returned to the intersection of Florence and Normandie, the location of the attack on truck driver Reginald Denny, and photographed a woman holding a sign that he had painted. The sign read: "There is no such thing as a society," a notorious statement made by British Prime Minister Margaret Thatcher in 1987.[5] Cole's images complicate and amplify the significance of sites of trauma through association with more recent crises, such as the Great Recession and the use of militarized police forces to quell protests. In a photograph Cole made at Lakeview Terrace, where Rodney King was beaten by police officers, a sign offers: "We certainly must not stop eating for fear of choking."[6] This statement, published in 1989 in the official Chinese state newspaper, *The People's Daily,* urged the continuation of free-market reforms after the massacre at Tiananmen Square. That Cole's photograph also presciently evokes recent instances of police brutality—especially deadly chokeholds—indicates cycles in which the past is still present. The disconnect between Cole's sites and the adamantly neoliberal statements on the signs is also compounded by his system of rotating the photographic negative to throw his subject and viewer off-center—the cityscape unmoors and slides away from the message.

A flight in Peru in 2006 to view the Nazca lines—large-scale geoglyphs in the shapes of animals and abstract forms created between 400 and 650 AD—greatly influenced Cole's examinations of orientation and language. Cole recalls the feeling of an "upended stomach," and the strange sensation of viewing from above these mysterious symbol-messages.[7] Seeking a similarly unsettling mode for his 2007 "Timelines" series, he photographed Styrofoam-formed statements (including the Baldwin quote mentioned above) upside down, while standing on a ladder. All of the messages in the series are reflections on time and chance; many are

62

WE CERTAINLY MUST NOT STOP EATING FOR FEAR OF CHOKING

related to song lyrics and album titles, and some are positive messages, such as "Fate in a Pleasant Mood" (Sun Ra, 1961). Other messages are foreboding, such as in a diptych with a quote from Alexis de Tocqueville's *Democracy in America* (1835): "As the past has ceased to throw its light on the future, the mind of man wanders in obscurity."[8] Cole is intrigued by Tocqueville's outsider perspective as a Frenchman traveling through the United States and marking its customs, politics, and eccentricities. And Cole agrees with one of Tocqueville's key assessments, finding it to be true 180 years later: the United States is not a critical culture, and it cares little for philosophical discourse.

Lakeview Terrace (People's Daily) from the series "LA Riots," 2012–13. Silver gelatin print, 20 × 16 inches.

64

Cole's own travels to document and reflect on United States culture can be seen in "Detroit, Dust and Scratches." For this series, begun in 2010, Cole researches and photographs buildings related to the vast legacy of the music industry in Detroit, home of Motown, Parliament, and Funkadelic. In January 2015, Cole shot over 50 locations in four days, including Aretha Franklin's old mansion, now a co-op; Cobb's Corner Bar, an important venue for jazz in the 1970s and now home to the Spiral Art Collective; and United Sound Systems, the oldest recording studio in the city (established 1933), which is now in operation again after two decades of dormancy. In some instances, such as at the Brewster-Douglass housing project, Cole encountered expansive empty lots, the predominant sign of a city that has lost half of its population during the artist's lifetime. (Abandonment and demolition have so transformed the city that when Cole's father, an architect who grew up in Detroit, accompanied the artist on his last visit, he repeatedly had difficulties orienting himself.) Impromptu discussions with local residents add another important subtext to the project. With a documenting impulse similar to community-based historical societies, Cole gathers visual and oral histories (cultural, political, and personal) in a city in the midst of decline, immense change, and the potential of renewal.

"Detroit, Dust and Scratches," references the impact of time and weathering on objects produced serially, such as photographs and vinyl records. The artist describes it as "the mediation and accruing of history on a specific copy."[9] The project also contains an ambient sound recording component, marking the influence of acoustic guitarist John Fahey, who was a wide-ranging explorer of traditional yet syncretic musical influences. Fahey's celebrated experimental record of 1967, *Days Have Gone By*, is layered with distant train whistles, singing birds, and other non-instrumental background noises. In a piece in Cole's "Timelines" series, he poignantly puns on Fahey's title with the message "Days Have Gone Bye." The artist draws his own analogies between longing for the past, capturing time on a sound recording or in a photograph, and the lapse of time as a needle moves along a record. The spots Cole chooses for his own ambient recordings are as charged with significance as those in his photographs. For example, the razed site of the Algiers Motel is the location of a deadly shoot-out during the 1967 Detroit uprising that was widely considered as a key turning point in the city's history. Cole's recording captures the stillness

Photographs from the series "Detroit, Dust and Scratches," 2010–present. Silver gelatin prints, 8 × 10 inches each.

of an abandoned urban space, punctuated by wind, beeping noises of a truck backing up, occasional passing cars, and the almost indistinguishable sounds of birds chirping.

The Algiers Motel is also a ghostly presence in Cole's large graphite drawing, *First as Tragedy, then as Farce* (2011). The work juxtaposes a floor plan of the motel, taken from a publication analyzing the shoot-out, with a map of the Aztec city of Tenochtitlán, taken from the *Codex Mendoza*, created twenty years after the Spanish conquest of the city. Both source images visually represent verbal accounts from memory of violent acts with major historic repercussions; they are "relics of some-thing that doesn't exist any more, produced to historicize the place and the event."[10] The title of the drawing is extracted from an essay by Karl Marx, in which he wryly reflects on cycles of history.[11] *First as Tragedy, then as Farce* points to parallels and continuity in the North American time-line between the Conquest and the decline of Detroit. While the former is in many ways "the beginning of large-scale destruction on the North American continent, the beginning of the capitalist takeover of the hemi-sphere," the latter "symbolizes the beginning of the end for the largest center of production for North America."[12]

In the drawing, the images of Tenochtitlán and the Algiers Motel are overlaid with the traced outline of a double image of a blindfolded figure with arms tied behind his back, who appears on the verge of falling over. Divorced from its original context—an album cover—the image is a stand-in for a universally recognizable combination of violence, power, and powerless-ness. This double body melds into the patterns and words of the maps, which form grids around the head, torso, and legs; larger history marks, forms, and circumnavigates the nameless individual.

Cole's most recent exploration of society, power, and text is *41st & Central (White Panther Party)* (2014–15). This landscape is comprised of six photographs of the intersection of 41st Street and Central Avenue, former location of the Black Panther Party's headquarters in Los Angeles. Scene of the first-ever SWAT team raid in 1969, the building was demolished a few months after the shoot-out. At this site, Cole's colleague holds signs that outline the White Panther manifesto, which was written in Detroit in 1968 by poet and political activist John Sinclair. The "State/meant," as Sinclair called it, ended with a ten-point plan that aspired to support the Black Panthers and included the principles: "Free exchange of energy and materials,"

66

Source material in Justin Cole's studio, 2015.

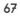

Diagram of ground floor of the Algiers Motel Annex used in court.

67

68

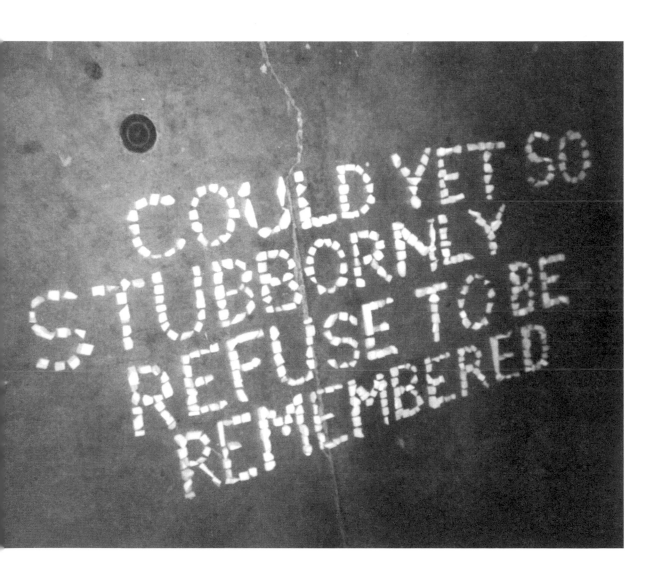

Baldwin Diptych, 2007. Two silver
gelatin prints, 11 × 28 inches overall.

"Free access to information media," and "Free the people from their 'leaders.'"[13] Cole's *41st & Central (White Panther Party)* pays tribute to the utopian vision of the manifesto and of the period, as well as the tremendous creative output in the Detroit musical community that orbited around Sinclair, including the proto-punk band the MC5 and the jazz experimentation that led to the founding of Strata Records and Tribe Records.

Through overlay and juxtaposition, Cole both orients and disorients, invoking the past while simultaneously charging it with new contexts and provocative, perhaps unanswerable, questions. When asked if the musical form of call and response—a prominent structure within jazz—has impacted him as a visual artist, Cole reflects that perhaps he is "responding to calls delayed by a few decades."[14]

Terri Geis

Notes:

1. James Baldwin, "Going to Meet the Man," short story in the collection *Going to Meet the Man* (New York: Dial Press, 1965), 238.
2. Justin Cole, quoted in Ben Provo, "OJO," *ANP Quarterly* 2.4 (2009), 21.
3. Cole in email to the author, October 14, 2014.
4. Cole notes the strong impact of Naomi Klein on his work and recalls spending a long-haul flight in a heightened state of revelation while reading her 2007 book, *The Shock Doctrine*. Cole, conversation with the author, October 14, 2014.
5. Margaret Thatcher, interviewed by Douglas Keay, September 23, 1987, published as "Aids, Education and the Year 2000!" *Woman's Own* (October 31, 1987), 8–10.

6. Cited in Naomi Klein, *The Shock Doctrine: The Rise of Disaster Capitalism* (New York: Metropolitan Books/Henry Holt, 2007), 205.
7. Cole in conversation with author, December 30, 2014.
8. Alexis de Tocqueville, *Democracy in America*, trans. Henry Reeve (New York: George Dearborn & Co, 1835).
9. Cole in email to the author, November 17, 2014.
10. Ibid.
11. The full quote from Marx is "Hegel remarks somewhere that all great, world-historical facts and personages occur, as it were, twice. He has forgotten to add: the first time as tragedy, the second as farce." Marx, *The Eighteenth Brumaire of Louis Napoleon*, originally published

in 1852 in the New York magazine *Die Revolution*. Cole has also noted the influence of Slavoj Zizek's 2009 book, *First as Tragedy, Then as Farce*. Cole in conversation with author, November 11, 2014.
12. Cole in email to the author, November 17, 2014.
13. John Sinclair, "White Panther State/ Meant," November 1, 1968, published in John Sinclair, *Guitar Army: Rock & Revolution with MC5 and The White Panther Party* (Port Townsend, WA: Process Media, 2007), 89–91.
14. Cole in conversation with author, December 30, 2014.

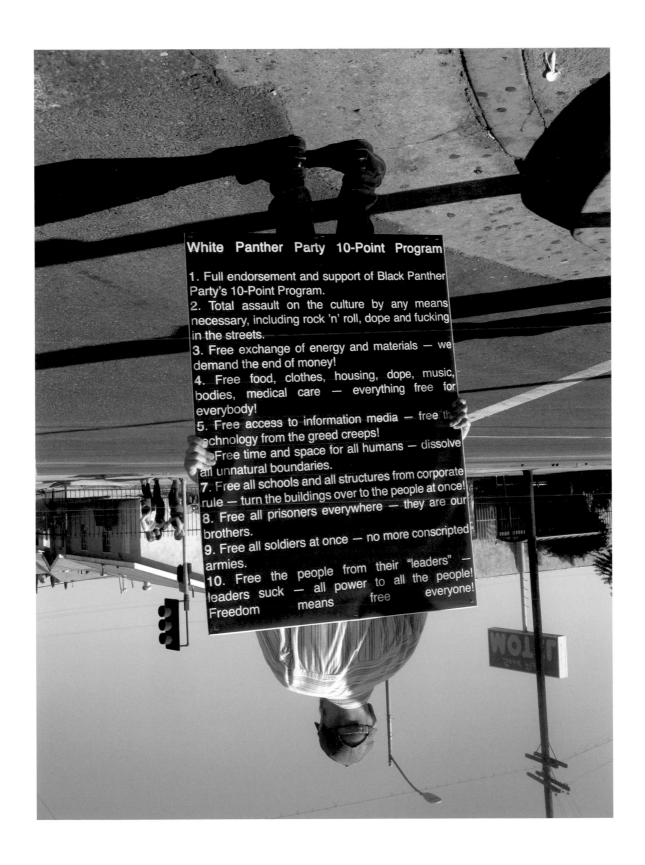

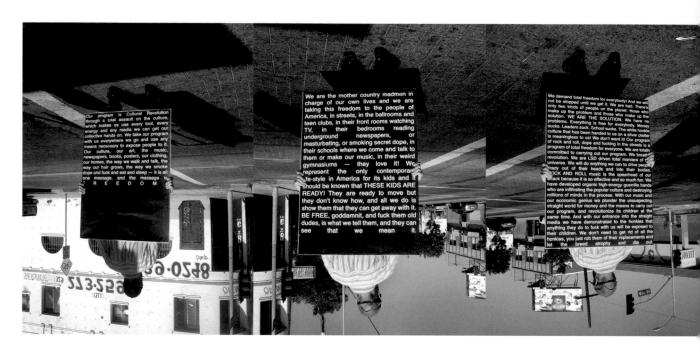

41st and Central (White Panther Party),
2014–15. Six silver gelatin prints mounted
on plywood, 20 × 96 inches total.

(previous page) *41st and Central (White
Panther Party)* (detail), 2014–15.

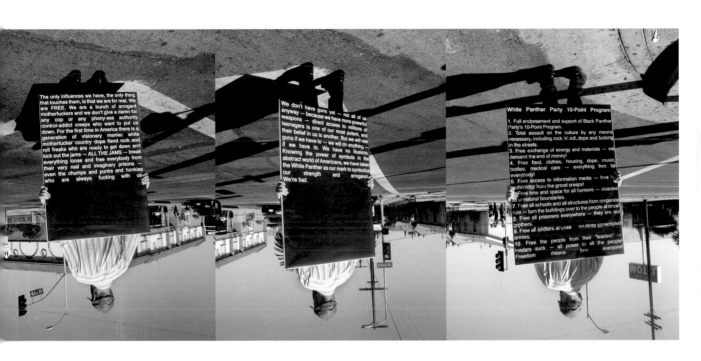

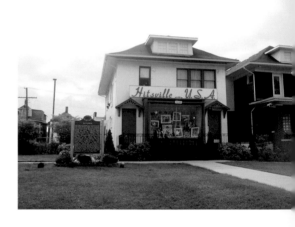

Photographs from the series "Detroit,
Dust and Scratches," 2010–present. Silver
gelatin prints, 8 × 10 inches each.

(following spread) *First as Tragedy,
Then as Farce,* 2011. Graphite on paper;
60 × 80 inches, unframed.

Florence & Normandie (Margaret Thatcher)
from the series "LA Riots," 2012–13. Silver
gelatin print, 20 × 16 inches.

5th & Western (Anonymous) from the
series "LA Riots," 2012–13. Silver gelatin
print, 20 × 16 inches.

Michael

Decker

Allusion to Freedom

Lisa Anne Auerbach

Michael Decker has a thrift store habit. Two a day, at least. Sometimes, as many as ten or twelve. When asked how many miles he drives daily in search of the incredibly specific cast-off items he collects, he shakes his head. Too many, he says. The outer reaches of Los Angeles County are his stomping grounds. Pomona, Valencia, the O.C. He drives a charcoal gray Prius and carries a debit card and a glass water bottle. He moves quickly, scanning shelves full of mugs, glassware, baskets, adult diapers, vases, tin boxes, and puzzles. He has a list in his head of the things he's looking for, a list that changes depending on the project he's working on.

Decker has the ability to immediately spot treasures amid clutter, to pare down massive amounts of information into juicy nuggets, then spit them back, neatly collected and composed, in an artwork. His studio is tiny and tidy. He is a Virgo, and if you've lived in California as long as he has, which is all his life, this means something. Virgos are neat, organized, and meticulous.

<div style="writing-mode: vertical-lr">Allusion to Freedom</div>

Decker's trips to the thrift stores are as methodical as the work he makes with the objects he collects. He spent years buying Sillisculpts, which are those white figurative sculptures engraved with sayings like "World's Greatest Mom" or "I love you this much." In the 2010 installation *I Wish I Could Say What I Feel*, Decker cut off the figures of 100 Sillisculpts, replacing each with a pinecone. Without the

Sillisculpt bases in Michael Decker's studio.

(previous spread) *Laura and Me*, 2014. Fiberglass and fine iron paint, 50 × 52 × 48 inches.

cartoonish character, the sentimentality of the language applied instead to the pinecone, an absurd stand-in for humanity, one equally imbued with individuality and reproduction. For a long time, he sought T-shirts printed with images of animals wearing sunglasses for a large quilt. Soon after, he made a group of collages constructed of boxes from the kinds of products that fill incredibly specific consumer needs, like an outdoor heating pad for cats, or a cordless grass shearer. (He's also collected Beanie Babies, tin boxes shaped like buildings, refrigerator magnets, wood carvings, plaques, curious items still in blister packaging, VHS videos, and assorted books.)

The common denominator uniting nearly everything Decker takes home with him is that the objects hold a promise to improve the lives of those who possess them, whether it be a reminder of a sentiment, a clever solution to a modern problem, or something that elicits a smile. Each object was originally purchased with optimism, and each object has been discarded and is now back on the market. The work highlights the transience of American consumer culture, the quick fix, the satisfaction found in a product, and the idea of a gift purchased to make someone feel better. The things he purchases have a messy humanity about them, ranging from practical idealism to pathetic desperation to sweet melancholy.

Together, collaged from boxes, sewn from T-shirts, or pieced together from wood carvings, stuffed animals, or figurines, the collection is more than the sum of its parts. Decker's creation is in the accumulation and ordering of these sentiments and slogans and desires. In taking what is sincere and real and combining it with a plethora of similarly structured or analogous ideas, he demonstrates the complexity of sentimentality. The objects he collects portray the world in black and white; after Decker puts it all together, they mirror back a portrait of a world in yellow or mauve, where nothing is clear cut, everything is up for grabs. The challenge of the artist is to love what is inspiring, while being able to keep a critical distance, and to act with sincerity, while simultaneously dismantling what is in front of him. Decker is impeccably sincere, his true desire is that these mottos and sayings are accurate, that love and friendship and kittens really do make the world go round. Irony isn't part of this dialogue. Irony is too easy, and it's a yawn.

Decker grew up in Fresno, California. He was a self-described "hardcore thrifter" in high school, searching the secondhand shops for frames for the mixed media artworks

Lisa Anne Auerbach

Mélange La Croix (detail), 2015. Found wood carvings on mirrored plywood tables; sculptures: dimensions variable; tables one and two: 33 × 40 × 32 inches; table three: 33 × 40 × 60 inches.

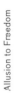

86

he was then creating. It was in Fresno, too, that his art education began. His high school art teacher was a young MFA student who encouraged him to audit Charles Gaines's Content and Form course at Fresno State University. There, he started reading critical theory—Jean Baudrillard and Roland Barthes—and began thinking of an art practice within a larger context. In 2000, he rode a Greyhound bus to Los Angeles to see Tony Oursler's mid-career retrospective at the Museum of Contemporary Art. Decker was blown away by the exhibition, and his passion for art, what it is and what it could be, was cemented.

Much of what he collects and the thriftstore aesthetic that he connects with come from the seventies and eighties, from a nostalgia for his youth and the years just before he was born. It was a time of cultural transformation. Collective American ideology was reeling from the shock of the sexual revolution, hurtling into the conservatism of the Reagan years, and moving from marijuana to cocaine. Ideas of home, country, and family were being constantly affirmed, in needlepoint wall hangings and on figurines, pillows, ceramic tiles, and wood plaques. Inherent in these desperate objects is the idea that we as humans need frequent reminders to be civil to one another, which hints at a wildness, an unending battle against our animal nature.

Decker explores that animal nature in his intricate drawings of naked people occupying what initially appear to be halcyon towns. In the drawings *Crockpot Compound* and *Crockpot Compound 2*, trees and fanciful dwellings line pathways and courtyards full of humans. Animals frolic and a seashore looks enticing. Upon closer examination, *Crockpot Compound* reveals a section of anguished dystopia; puffy clouds are seen to emanate from smoke stacks and chimneys, and the nude occupants are holding signs and banners with slogans like, "NO," "Please Help Us," "I want to believe," and "Freedom is an Allusion" [*sic*]. Nearby are orgies and people climbing walls, swimming, and dancing. In the center, a group is sitting atop a gazebo that reads "Total Freedom." The mass of humanity allows for all viewpoints and all realities. It encompasses both the love and celebration of freedom and the skepticism that such an idea actually exists. In concert with the sentimentality of the objects collected from thrift shops, the drawings create a context. The collected objects communicate a particularly American ideology, and the drawings provide a fanciful space in which these ideas might take root.

Crockpot Compound 2, 2015.
Archival ink on watercolor paper;
29 ¾ × 22 inches, unframed.

How to Do Anything (A Call to Action)

Sarah Wang

1. Go from city to city, inspired by the monks in the Middle Ages who carried knowledge from one monastery to the next.

2. Befriend someone who scares you. (You see yourself in her.)

3. Recall your father's absence, and his almost generic unknowability.

4. When you can't communicate in words, orchestrate dramas to communicate them. The social situations in which these words unfold are themselves communicative.

5. In order to make your work sound appealing, tell people: It's a lurid fable of wronged innocence, irrational cruelty, and wild coincidence set in a landscape of betrayal, brutality, and corruption.

6. Never stop resisting or else they'll pull you under completely.

7. Take into account the notion that spaces cling to their pasts, and sometimes the present finds a way of accommodating this past and sometimes it doesn't. At best, a peaceful coexistence is struck up between temporal planes, but most of the time it is a constant struggle for domination.

8. Ignore the collective stare.

9. Unashamedly wear thrift store shoes with preexisting foot odor.

10. Observe the rats run up the unbranched trunk of the palm tree.

11. Look at photos of a female patient enacting symptoms of hysteria for a live audience in the late nineteenth century. Conducted by the father of French neurology, Jean-Martin Charcot, the artificially-induced photos demonstrate the woman (1) contentedly sleeping with her arms crossed in front of her chest, hugging her shoulders; (2) angrily propped up on an arm, tongue protruding from a mouth agape, one elbow jutted out, as if to strike an unseen bedfellow; and (3) sitting up with her hands forming a pair of parenthesis around her head, eyes rolled up to the heavens, a naïve expression of rapture pinned to her face. Charcot considered the ability to be hypnotized as a clinical feature of female hysteria. Susceptibility to hypnotism was synonymous with the disease. The woman in the photos you're looking at is under Charcot's hypnosis.

12. Live constantly under the threat of two seemingly opposed forces.

13. Once he's dead, crowd source ideas about what to do with the body.

14. Insert long gaps of silence in conversation, not because you don't have enough to say but rather because you have too much.

15. Long to see your mother in the doorway.

16. Locate, at the heart of your desire, your very own lack, the materiality of the Real staring back at you.

17. Notice the blank spaces between frames.

18. Disable the Snap to Grid function the moment you open the application because the gains in predictability and accuracy are balanced against the losses of ambiguity and expressiveness.

19. Question why you settle for the depersonalized, apolitical reading.

20. When people call you a loser, tell them that every day you feel like giving up, and staying alive for one more day is an achievement in itself.

21. Situate yourself between repulsion and fascination.

22. Eat shit and carry around a skull for a bowl because everything is holy; shit is holy.

23. Do not forget the degree to which what doesn't happen is also caught up in your experience. This is the negative element of experience. You can write, in this way, autobiographically, from experiences you didn't have, because the experiences you don't have are experienced negatively in the experiences you do have.

24. Dedicate yourself not to the fulfillment of desire but to the transformation of desire into work.

25. Get lost in order to invent a way out.

26. Become a symptom of yourself.

27. Collect objects as a way to re-inhabit a place, a feeling, a time.

28. Anticipate more.

29. Resist the urge to feel sorry about her solitude, her rages, her dark edges, her impecunious existence. Make her not into a martyr but allow that she may have had the life she wanted.

30. Obtain answers that only beget questions.

31. Occupy a place where error and accomplishment are close kin.

32. Think about all the sadness because that's real; that's not a fantasy.

33. Buy things and return them so you have something to do.

34. Aspire to erasure.

35. Watch a 40-minute video of an autofellatist anarchist who lives in a four-thousand-square-foot loft in Philadelphia. What's important to me, he says, is the idea that people should be able to live in a just and peaceful world without hierarchal relationships.

36. Wonder what your mother is doing.

37. Obtain a position in which you can only reveal your incompetence.

38. Cry as soon as you enter the room because you are alone.

39. Buy three pounds of cherries from WalMart and re-bag them in an unmarked brown paper sack. Bring

Sarah Wang

the cherries to a dinner party and tell everyone you got them at the farmer's market.

40. Take the baby out of the car but don't go anywhere with her.

41. Do nothing as a form of protest against the idea that humans are units of energy in an industrialized society.

42. Go to seven parties in one night because only the thrill of velocity will keep you entertained.

43. Make a film about failed masculinity. Call it *The False Terror of Tiny Town*.

44. Make yourself crazy because that's the way you like it.

45. Feel the effect of language on your body.

46. Multi-task. Watch a documentary on castes in India while doing crunches in your office, wondering if anyone has a crush on you, eating an eggplant sandwich, researching the history of artificial organs, talking on speakerphone with your therapist, deciding what to wear tonight, debating if you should say yes or no, and responding to an email with the subject: ARE YOU OK?

47. Use kitchen tongs to pot cacti in order to avoid getting pricked.

48. Read this sentence: From a dark and stormy sleep, his head in a tunnel, the brown light of Paris dawn began to emerge.

49. Go to a dance performance and think about movement as a kind of corporeal writing.

50. Regard dance and poetry as expressions of the in-between, slippages in perception from one surface to another.

51. Teeter on the edge of humiliation.

52. Get into grotesque verbal entanglements.

53. Take back half of what you say.

54. Consider the violence in addressing the second person.

55. Write a book from inside a delirium.

56. Drink a glass of bull's blood to cure you of cat allergies.

57. Learn discipline though repetition and routine, through the quiet power of habit and consistency.

58. Admire the work of a hackneyed parvenu.

59. Pass through a place cognizant that it carries every other place within it—historically, psychically, potentially. The psychic history of all the other stories that have taken place there, the non-native plants in California, the deep palimpsest of land.

60. Hand wash cold separately. Flat dry. Do not bleach. Block to original size and shape.

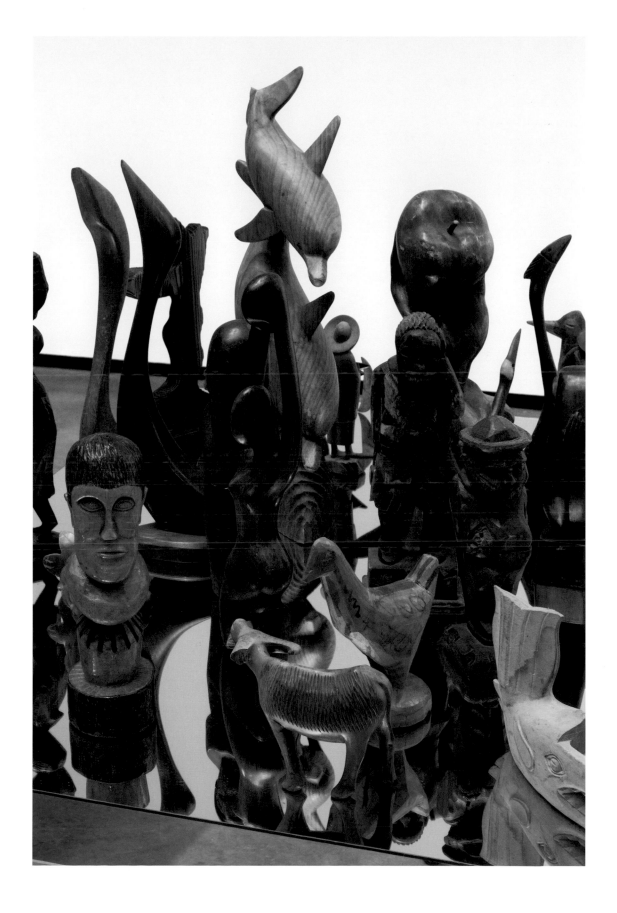

Mélange La Croix (detail), 2015.

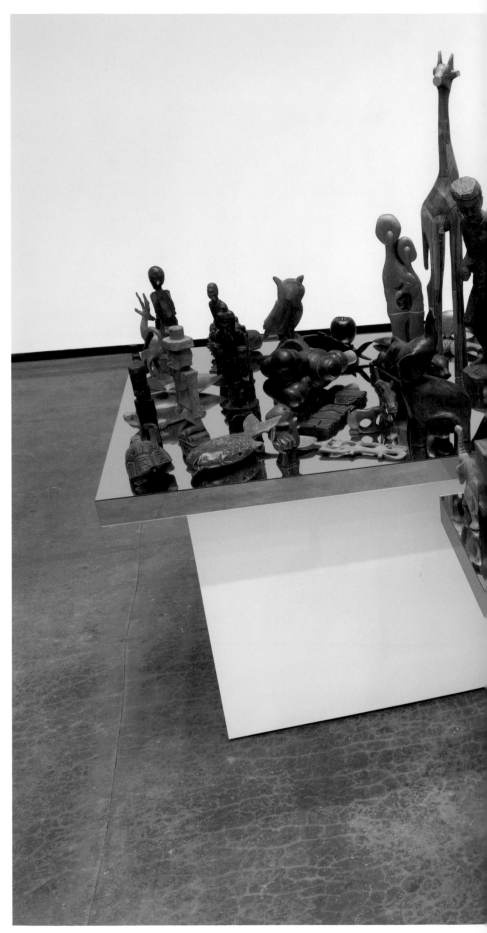

Mélange La Croix, 2015. Found wood
carvings on mirrored plywood tables;
sculptures: dimensions variable;
tables one and two: 33 × 40 × 32 inches;
table three: 33 × 40 × 60 inches.

Crockpot Compound, 2013.
Archival ink on watercolor paper;
22 × 30 inches, unframed.

Location Station, 2014. Found card-
board boxes, PVA, and museum board
on hardwood panel; 96 × 66 inches.

Compress 'n' Dress, 2014. Found card-
board boxes, PVA, and museum board
on hardwood panel; 96 × 66 inches.

Sliders, 2014. Found cardboard boxes,
PVA, and museum board on hardwood
panel; 96 × 78 inches.

Index of Questions, 2013. Found t-shirts, polyester thread, staples, painted wood, and hardware; 72 × 96 × 1 inches.

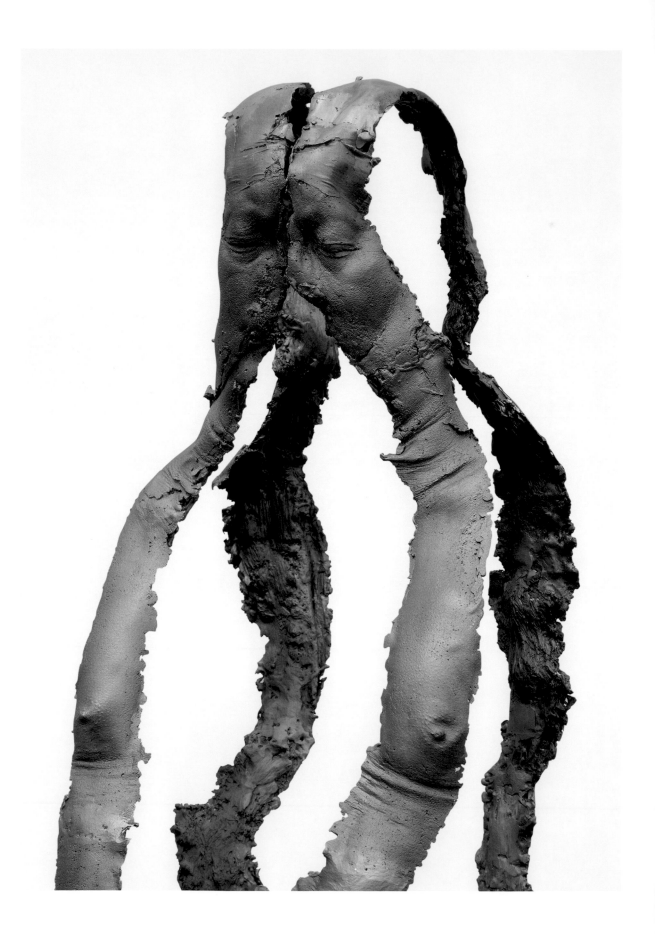

Naotaka

Hiro

Streams of Embodiment: Naotaka Hiro

Glenn Phillips

I'll never forget the day in high school when our biology teacher explained to us about worms. Worms are considered the lowest animals: they lack brains, eyes, noses, ears, and skeletons. They don't have appendages, or lungs—they breathe through their skin. Most of them are hermaphrodites, and some of them reproduce asexually. The teacher described them to us as essentially being tubes that just feed and excrete, feed and excrete. "But if you think about it," the teacher said, "the human digestive system is the same thing: a tube. At the core of all of us is a tube that is not so different from a worm. And surrounding that worm is the human body, which gives the worm armor and mobility, as well as appendages and better sense organs, which in turn give it crucial advantages when it comes to analyzing and interacting with the environment. You should try to remember this in your lives: the core of your body is really just a 30-foot worm that's coiled up inside of you, and your job is to feed it and keep it safe."

Much, of course, was wrong with my teacher's well-intentioned but factually suspicious parable of worms. But the story stuck with me, and I recalled it particularly when, years later, I learned a surprising piece of art historical trivia: Vito Acconci's canonical 1972 performance artwork *Seedbed* had almost been a story about worms. For *Seedbed*, Acconci built a low ramp that extended the full width and half the length of Sonnabend Gallery in New York. For two weeks, during gallery hours, Acconci hid underneath the ramp, continually masturbating and talking, broadcasting, via loudspeaker, his stream-of-consciousness fantasies to gallery visitors, many of whom were walking right above him on the ramp. Acconci imagined himself to be a worm underneath that ramp, and one of his first ideas for the piece would have involved actually infecting himself with a parasitic tapeworm. As the tapeworm began to grow along the length of his intestine, Acconci would have been probed with a medical video camera that would transmit live footage of the worm to a video monitor. When this idea proved impossible to realize, Acconci developed the piece into *Seedbed*, which became one of the most famous works in the history of performance art. But the idea of the worm did remain, inspiring Acconci's abject vision of himself: the worm, writhing and squirming underneath the floor, broadcasting shameful fantasies that we all might recognize, but which most of us might think best to keep secret.

107

(previous spread) *Four-Legged (Toe to Heel)* (detail), 2014. Cast aluminum, 65 × 18 × 20 inches.

Acconci was one of dozens of artists in the 1960s and 1970s who saw abject notions of the body as a vital area for artistic exploration (other examples include Marina Abramovic, Paul McCarthy, Gina Pane, the Vienna Actionists, and certain strands of Japan's Gutai Art Association). Often focusing on their own bodies as a site of both art making and conflict, performance artists created real-time, real-life situations in which viewers might witness the artists' often-unsettling physical acts as both spatial and social experiences. For the artists themselves, performance was a phenomenological experience that could potentially lead to heightened awareness of both one's own consciousness and one's own body, and the inextricable connections between the two. Though performative actions in their particulars may be somewhat contrived or extreme, they also represent, for many artists, a fundamental form of artistic research into the self.

Naotaka Hiro is an Osaka-born, Los Angeles-based artist who takes inspiration from earlier generations of performance artists but in nearly every way reverses their priorities. Although he utilizes many performative tactics in his work, Hiro does not seek phenomenological experiences that might unify mind and body. Rather, he seeks to know the body from the outside, as a surface. He celebrates fractured and partial representations of the body, which he feels more accurately represent the course of our normal perceptions. The artistic mind, for Hiro, does not seek to occupy the body but instead to produce— or rather re-produce—the body, acting from its own un-mediated faculties. Art making for Hiro is a process of nonverbal visual thinking that allows the artist to continually process and re-process information, sifting through true and false data and gradually arriving at new concepts.

Essential to Hiro's practice is the daily act of drawing. Working on multiple scales, ranging from small notebook-sized sheets of paper up to very large sheets that are approximately six feet in height, Hiro practices a stream-of-consciousness style of drawing, focusing almost entirely on notions of the body. Hiro's bodies are fantastical and wrong in their details. They are missing some of their parts, or perhaps have too many. They often appear to be bending or contorting to examine focal points of the body and, as if missing a skeleton, they simply continue bending, elongating, sometimes multiplying. Unpresumptuous and worm-humble, Hiro's figures rarely have heads, or at least not faces. Appendages present themselves as complete

Glenn Phillips

creatures: sinewy long tubes terminating with hands or feet on either end; limbs that coalesce into vaguely sexual organs, which in turn penetrate an unknown orifice. Bodies fold in on themselves, exploring and blindly probing. Hiro's drawings also move inside the body: tangles of vessels, ganglia, and other ropy viscera float freely; ribcages struggle and fail to keep organs inside; a mass of cells seems to multiply and form new connections. Some drawings present tubes, perhaps intestines, simply winding. Occasionally inside and outside merge, as figures shit or vomit impossible torrents, or as other substances make an amorphous escape from bodies that are no longer

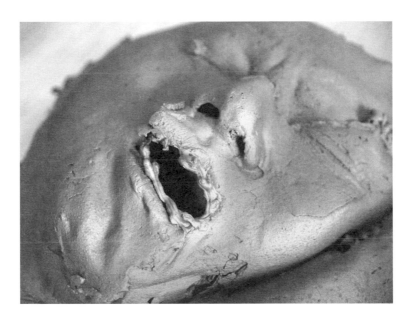

whole. Hiro's most visceral drawings are often softened by a particularly delicate quality of line or, at times, by dissociative color palettes of pastels or rainbow hues. Hiro continues to produce these drawings, in watercolor, ink, charcoal, and acrylic; his finished drawings number in the thousands.

From these drawings, Hiro frequently develops further ideas for artworks. For instance, two drawings from 2013 depict a featureless head, missing eyes, nose, and ears, and sparsely covered in long black hairs that surround a circular hole. Within that hole sits a human mouth. The drawings became the basis for

The Log (detail), 2013. Bronze and wood, 93 × 27 × 13 inches.

Hiro's 2013 video *The Pit (Dancer with Golden Lips)*. To make the work, Hiro produced a latex cast of his head and shoulders. Splitting the face in two (another recurring image in the drawings), Hiro cut a hole in the back of the head, attached hair around the opening, and then, reclining, draped the cast, with latex shoulders facing away from his own, across his face. For more than twenty minutes, the video focuses on Hiro's lips, lightly coated in golden glitter. The lips move almost constantly though slowly, quiveringly, and they never close. The effect is unsettling, transforming the mouth into a gaping sphincter, at the center of which is a pitch-black void. For most of the video this orifice fills the screen, though at times the camera pulls back to show Hiro's shoulders and the cast's shoulders facing away from each other, filling the top and bottom of the projection with an uncanny bilateral symmetry. At one point, Hiro's arms are raised above his head and tucked into the shoulders of the cast, creating an interconnected tangle of appendages not unlike many of those depicted in his drawings.

Glenn Phillips

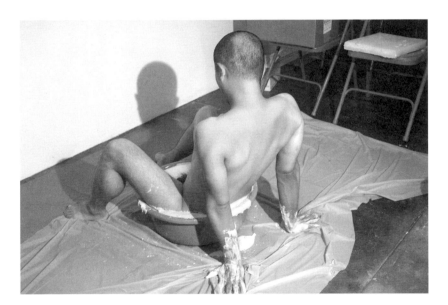

Hiro often works with body casts as a basis for his sculpture. *Ass Gong* (2010) presents a hollow bronze cast of the artist's posterior. Displayed on

Photograph of production of *Untitled (Ass Gong)*, 2010.

(facing page) *Untitled (Ass Gong)*, 2010. Gold, patina, and bronze; 16 × 13 × 6 inches.

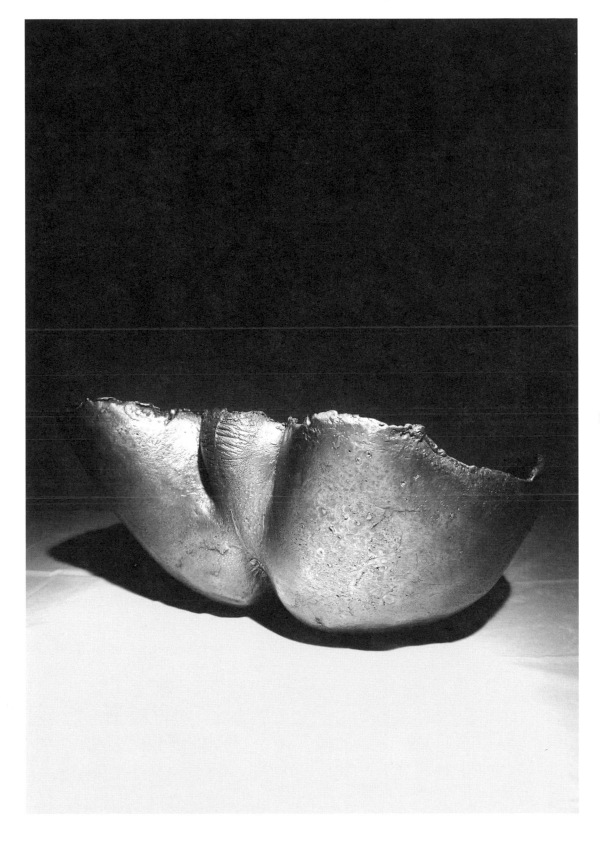

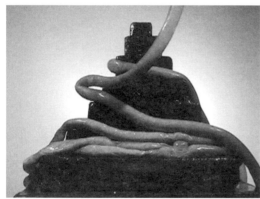

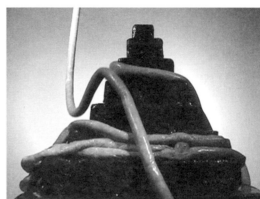

a pedestal, the sculpture appears from most angles to be a beautiful vessel, perhaps an irregularly shaped bowl with attractively jagged edges. Seen straight on, however, the sculpture clearly depicts the intricately detailed folds of the artist's anus and scrotum. A little below the opposite edge of the sculpture are two small holes that can be used to thread wires through the piece, so that it can be suspended and played as a gong.

Hiro does, in fact, utilize *Ass Gong* as a musical instrument. For his 2010 video *Night and Fog (Tubes on Black Mountain)*, the gong becomes part of a rhythmic, percussive soundtrack that accompanies the video for its twenty-two minute duration. To produce the imagery for the work, Hiro built a small black ziggurat, approximately two-feet high and slightly irregular and rough-hewn in form. He stuffed natural sausage casings full of ground beef to create a long intestinal meat tube. Suspending the tube from monofilament and a stick, Hiro created a moist and abject marionette that, throughout the video, attempts to snake and un-snake its way around the steps of the pyramid. Though he does not hide the artifice behind his use of monofilament, Hiro does present most of the footage in reverse, which grants a muscular determinism to the tube, making it at times seem to rear its head and leap from one step to the next. Hiro occasionally intercuts the footage with shots of the tube in its "perfect" position, wrapped tight and horizontal along each step, creating a pleasing pattern of symmetrical stripes against the black ziggurat. During these moments the video runs forward rather than in reverse, chimes play, and a light-hearted shower of golden glitter falls from above and covers the tubes and structure. At other points in the video, Hiro drapes and folds the tube across the monofilament, allowing seven or more segments of the tube to seem knotted or gathered around a shared point. It is surprising, in these moments, to see how much the forms begin to resemble his more sinuous and entangled drawings.

In his most recent sculptures, Hiro has begun to take casting into the realm of drawing. In *Four-Legged (Toe to Heel)* (2014), Hiro smeared two continuous stripes of casting medium vertically along the left and right sides of the front and back of his body. Beginning with the tops of his feet, the stripes (which are approximately the width of Hiro's hands) continue up his shins,

Night and Fog (Tubes on Black Mountain), 2010. Stills from color video with sound, 22 minutes.

Glenn Phillips

knees, and legs, up the front sides of his pelvis and stomach, along his nipples, collar, neck and face. The medium covers his eyes, where the two stripes almost touch, but miss his nose and mouth. The stripes continue over the top and back of his head, down his back, ass, legs, and calves, and end at the back of his heels. The stripes touch only at one point, where Hiro added a third stripe of casting medium down the crack of his ass and through to his scrotum. The finished work, cast in pewter-hued aluminum, presents a creature both spectacular and terrifying: a four-legged alien composed of human features yet missing a human structure. Moving around the sculpture, the figure at times becomes more line than body, snapping in and out of abstraction and figuration. The sculpture is a perfect embodiment of so many of Hiro's drawings, presenting impossibly formless strips of coalescing anatomy that, in their incompleteness, form a new whole. What is most surprising, however, to consider about this

Untitled (Mocap drawing), 2015. Ink and pencil on paper, 72 × 48 inches.

(facing page) *Untitled (Mocap)*, 2015. Bronze, rope, and steel; dimensions variable.

sculpture is the fact that it is, in its particulars, the precise opposite of abstraction, as it is a direct impression of the artist's own body. Thus the abstracted nature of this sculpture occurs not through detaching the work from the specificity of its subject but rather from removing information from that subject and presenting only a partial impression of the figure.

When speaking about his work, Hiro often refers to the impossibility of truly seeing one's own body. We see our bodies as two-dimensional reversed images in mirrors, or in photographs or videos, but these images are already mediated and thus separated from the body's physical materiality. In real life, we can only see our own body in fragments, and some parts we can never see at all. In many ways, Hiro's drawings summarize and partially rectify this situation, presenting fragmented bodies made whole and proposing new anatomies that allow for enhanced and specific explorations. In individual succession, the drawings present a parade of false knowledge, wrong information, and misunderstandings. Like worms, Hiro's figures lack the necessary organs for advanced perception and rely instead, in their abjection, on more blind and primeval modes of sensation and exploration. Yet collectively, Hiro's drawings, sculptures, and videos begin to form a larger and perhaps self-correcting corpus. Within each misfired creature lies a figment of truth, and those truths accumulate. Streams of consciousness transform into streams of embodiment, and Hiro's barrage of fragmentary bodies coalesce into something larger than a whole—an atlas, encyclopedia, and summa that, within Hiro's universe, presents everything known of the body, a lifetime of research. And somewhere, within that writhing mass of limbs, within those tangles of flesh and meat, lies the self. Somewhere. The problem is that it never seems to be where you look.

116

Glenn Phillips

Four-Legged (Toe to Heel), 2014. Cast aluminium, 65 × 18 × 20 inches.

(following spread) Installation view of "R.S.V.P. Los Angeles" at the Pomona College Museum of Art, 2015.

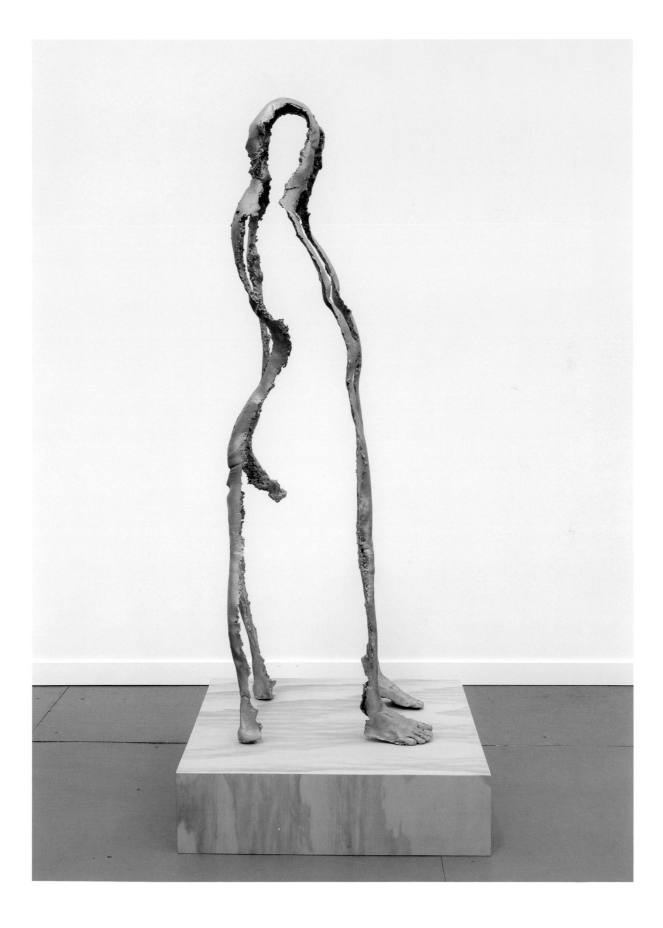

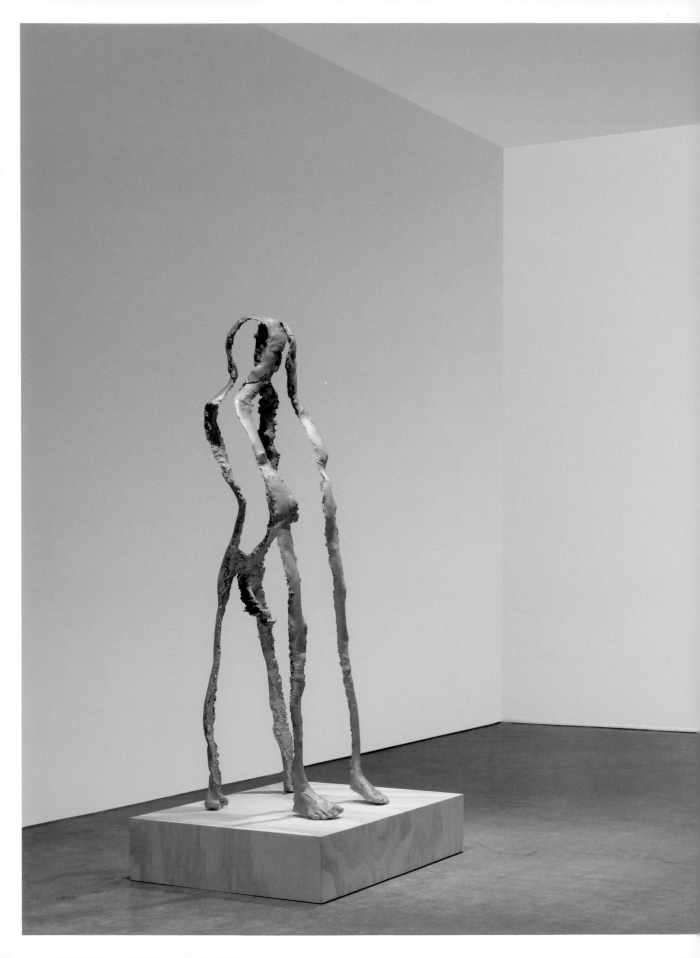

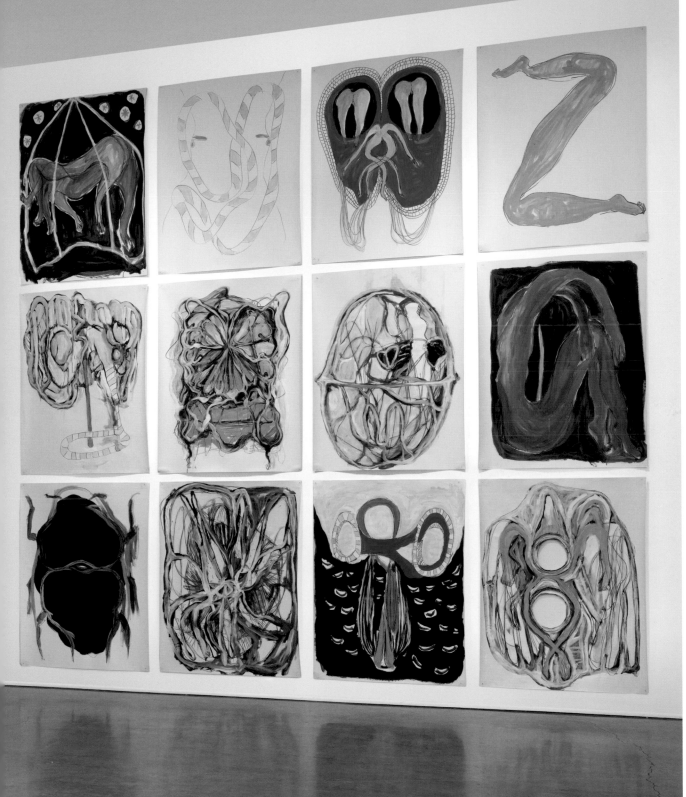

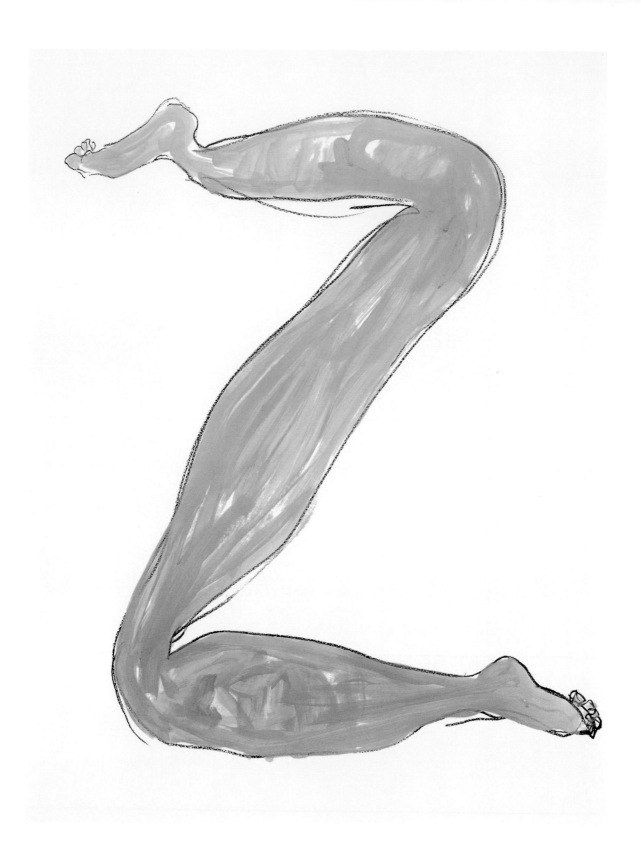

Drawings from untitled series, ongoing.
Acrylic and graphite on paper, 42 × 32
inches each.

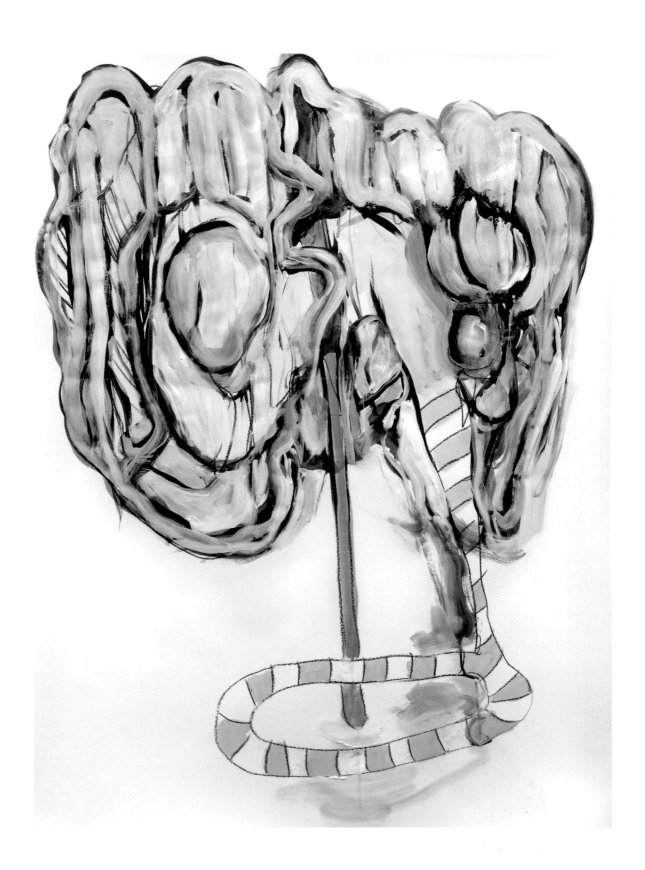

Photograph of production of *Night and Fog (Tubes on Black Mountain)*, 2010.

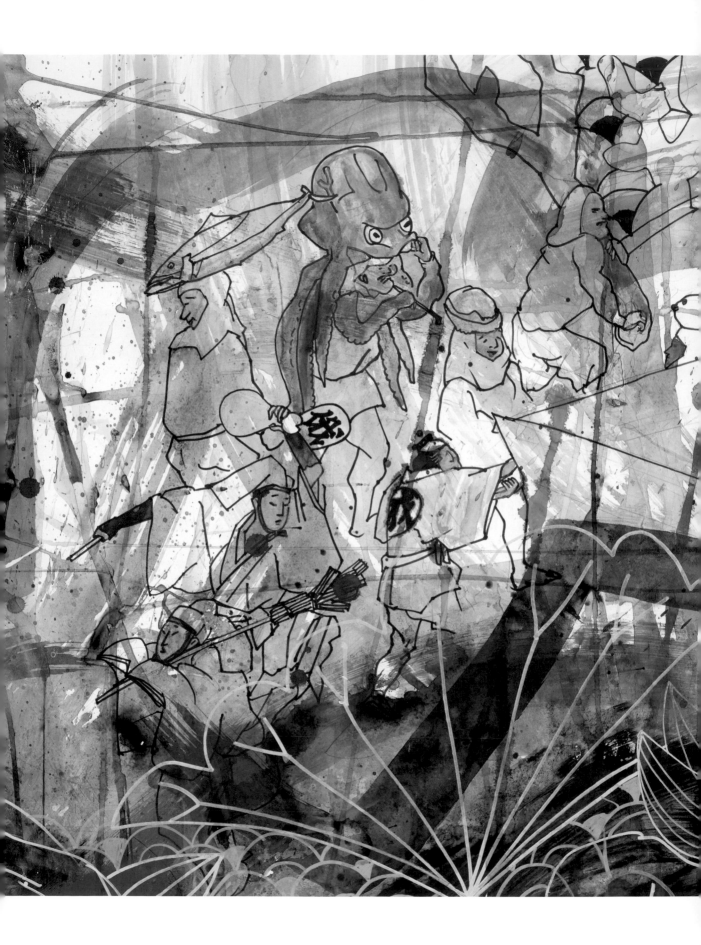

Wakana

Kimura

Wakana Kimura: Circles

Valorie Thomas

The disciplined bliss of daily practice grounds Wakana Kimura's artistic process, and has done so since she was eight years old. The Japanese-born artist's work ranges over a broad terrain that includes intimate daily drawings, vast multi-panel pieces that combine painting and drawing, portraits of Buddhist spiritual scholars, and durational time-based videos that bring all of these together. Her repetitive practice supports the creation of discrete works but also serves, importantly, to establish a process that unfolds over time. Every step of the practice is important individually and as a part of the whole. Kimura's art is a practice of meditation, contemplation, translation, and expansion of the circles of community. In its breadth, Kimura's work suggests the intense movement and vibration of making paradoxical worlds that are simultaneously contained and uncontainable.

The small abstract drawings are mostly watercolors, and everything in her vicinity can be subject material, including street scenes, trees, flowers, incense from ancestor altars, horses, and donuts. This practice is guided by the Japanese principle that all subjects of drawing and painting have equal value. Kimura also tells me that, in Japanese culture, there is "no consideration that abstraction and representation are separate." She comes from a background in which language is both visual and musical, within the concept of script. Living in the United States, she observes, she must navigate a different cultural imperative—one of hierarchies of meaning and definition. Thus, in the space of duration, color, line, symbol, and abstraction, the artist enacts and becomes translation, past to present to future, across transnational locations, languages, philosophies, and spiritual traditions. She dances across a metaphoric tightrope.

In a 2005 installation in Tokyo, Japan, called *Existence as Apiece Relation with the other*, Kimura painted a series of repetitive circles on canvas panels that lined and divided the gallery walls. Marks, dots, circles, lines, and hue travel through shifting landscapes. The installation evoked impressions of migration, layered histories and experiences, and changing perspectives. Her video composition *I* (2010) contemplates beauty as a state of constantly shifting awareness. In the video, moments appear transient; their physical and material manifestations are continuously dissolving, but their renewal produces duration and constancy. For example, in *I*, each time she carefully punctures

(previous spread) *One trifle-beset night, t'was the moon, not I, that saw the pond lotus bloom* (detail), 2015. Watercolor, Sumi ink, marker, acrylic color, venial color on Washi paper (Daitoku roll, machine made in Fukui Prefecture, Japan, Hiromi Paper Inc.); 98 × 308 inches (four panels, 98 × 77 inches each).

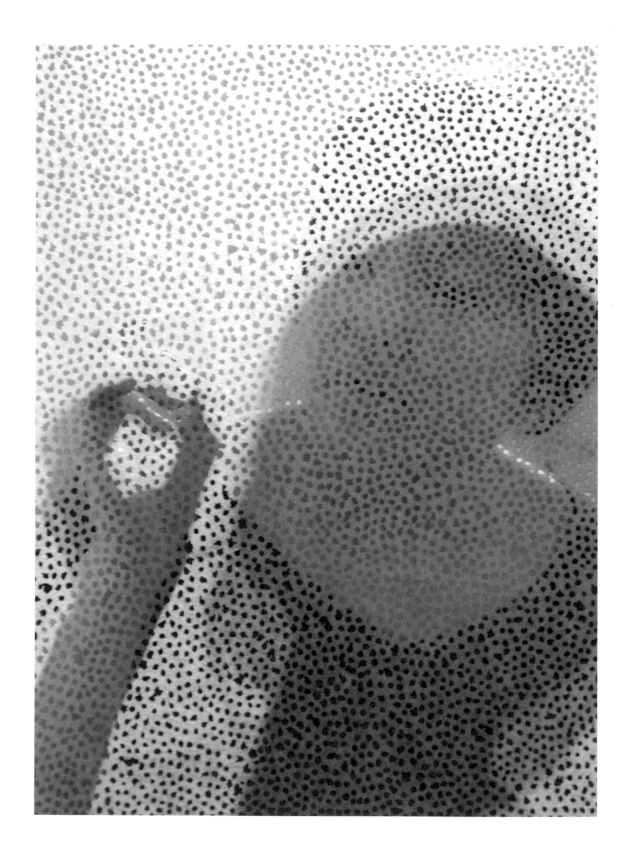

Valorie Thomas

the paper with burning incense sticks she is engaged in coaxing the contours of time. These gestures create a web of interconnected relationships bound by liberating practices and intention. Kimura relies on visual expression as a means of mediating old and new identities. Through her artwork, she attends to memories, locations, literacies, and the vagaries of fragmentation as a person who considers contingency a valid mode of knowing and praxis.

Kimura often uses bold, daring calligraphic flourishes, intense color, and layer upon layer of entangled shapes, lines, and patterned networks of markings. Light travels through and around her work in nuancing murmurs and loud bursts, as if following changes of frequency from soft to blaring. In her newest painting, *One trifle-beset night, t'was the moon, not I, that saw the pond lotus bloom,* which was created for the "R.S.V.P. Los Angeles" exhibition, she begins the work with dramatic calligraphic strokes across its 25½-foot length, loosely framing the structure with a map of the world. Over this map, Kimura layers tighter patterns and imagery that allude to Japanese decorative textiles and mythological figures; the lotus flower, a symbol for Buddhist enlightenment, is prominent. I happily note her inclusion of Hou-ou, the phoenix, an avatar of Kanzeon (Guan Shi Yin/ Avalokiteshvara), a deity of grace and compassion. For Kimura, this figure refers to Fugen Bosatsu, Japanese goddess of compassion. Kimura's *Character* (2011) and *Kaigu* (2012) also combine vibrant swirls of color with patterned marks overlaying mythological creatures or other representations of significant symbols or figures from her daily experience and her readings.

In her artist's statement, presented in English and Spanish, Kimura alludes to the layered landscapes of her adoptive home of Los Angeles:

> I use visual communication to express unification and individuality.... I use art as a medium to openly communicate the individual differences among us. Ideally, there is a ripple effect. As with drops of rain in a pond, each drop forms a concentric circle that joins with another concentric circle, and this intertwining has a larger effect. Each individual mark I create enables communication and creates conversation.

> *Uso la comunicación visual para expresar unidad e individualidad.... Uso el arte para comunicar abiertamente las diferencias*

I, 2010. Still from color video with sound, 180 minutes.

129

130

Installation view of *Existence as Apiece
Relation with the other*, 2005. Mixed media,
dimensions variable.

individuals entre nosotros. Con suerte, se genera una reación en cadena. Como gotas de lluvia en un estanque, cada gota es un circulo concentrico que se une a otro circulo concentrico, y estos encuentros generan un efecto mayor. Cada una de las marcas que creo es capaz de comunicar y establecer un diálogo.

For me, Kimura's work reflects qualities of Southern Californian *mestizaje,* indicating that, like any good border dweller, she has become accustomed to navigating the interstices and clashes of numerous cultures as they meet in shared spaces sometimes mapped by barbed wire. Her work appears imprinted by the jazz-inspired improvisations, dissonances, make-believe, and dead serious challenges that make up Los Angeles. Her investigative mixed-media drawings, such as *Character* and *Experimental Drawing (Black and White)* (2009), point to themes of dislocation and repeated re-placements of home, extended family, presence, and identity as a process of constant movement and transformation. Sometimes, in the constellation of dots that the artist calls "marks," as in *Elevator* (1997), the video *I,* and her *Existence as Apiece Relation with the other* installation paintings, the location resembles Australian Aborigine paintings that tell stories of the dreamtime. Kimura's eye travels the globe, mapping the horizons of converging cultural literacies.

I met Kimura in downtown Los Angeles, at the Japanese American Cultural & Community Center (JACCC), where she serves as media arts director and curator. She gave me a guided tour of an exhibition of exquisite, precisely woven traditional and contemporary baskets from Japan and took me to see a basket teahouse of bamboo mounted on a platform, where only the day before dignitaries had shared a tea ceremony. I spotted a tea ceremony service in the JACCC collection that is nearly identical to one owned by my great aunt Olive, an African American Red Cross worker in Japan who used the tea set to teach me about art that respects its imperfections. Kimura echoes my aunt's stories, noting that Japanese artists honor imperfections, and the ceramic cup's blue-gray glaze and unglazed bottom edge invite us, through texture and sound, to contemplate the poetics of roughness and grace. We walked the back edge of the center's tiered garden, crossed a bridge, and returned to our starting point. Kimura said her sense of beauty is "always changing," and she invited me back again.

132

Valorie Thomas

One trifle-beset night, t'was the moon,
not I, that saw the pond lotus bloom, 2015.
Watercolor, Sumi ink, marker, acrylic color,
venial color on Washi paper (Daitoku roll,
machine made in Fukui Prefecture, Japan,
Hiromi Paper Inc.); 98 × 308 inches (four
panels, 98 × 77 inches each).

(previous page and following spread) One
trifle-beset night, t'was the moon, not I, that
saw the pond lotus bloom (detail), 2015.

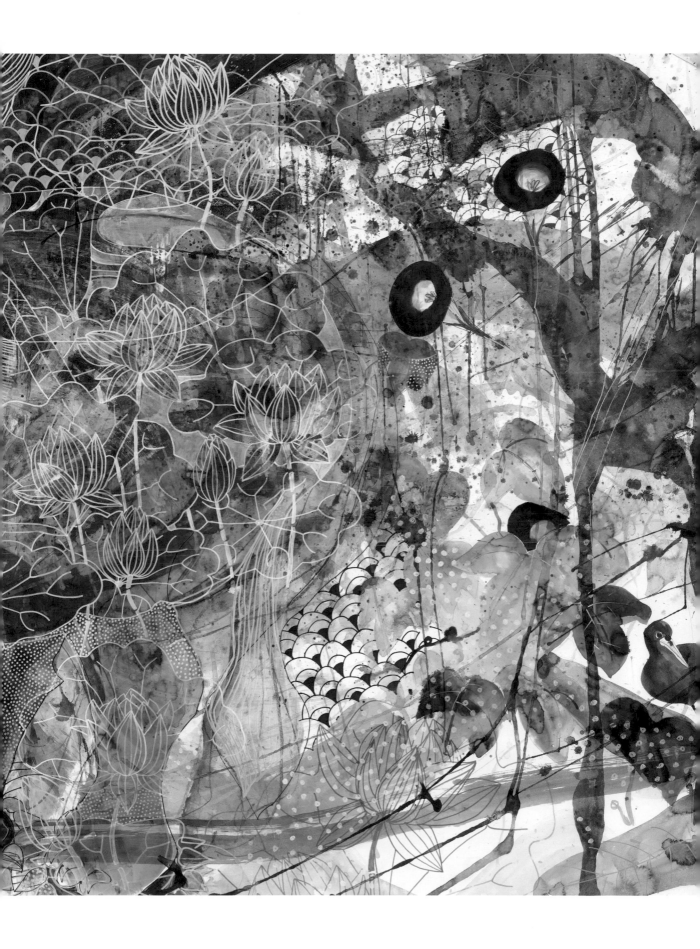

Untitled drawings from the series "Daily Practice,"
ongoing. Watercolor, Sumi ink, and acrylic paint
on TMK poster paper; 4 × 6 inches each.

Aydinaneth

Ortiz

The Intimacy of Loss:
Aydinaneth Ortiz

Kathleen Stewart Howe

In the artist book *La Condición de la Familia* (2013), Aydinaneth Ortiz redirects the conventions of domestic photography, a photography of intimate connections casually rendered, to explore and mediate a family tragedy. The visual vocabulary of the family snapshot and photographic album, reservoirs of communal memory (although now a format under siege as images and memory move to digital spaces), are repurposed and joined with more formal pictorial strategies to communicate private experience publicly.[1] The seemingly un-self-conscious, day-to-day, almost confessional mode of image making has been part of the language of contemporary photography since the 1970s, when Nan Goldin began what would become *The Ballad of Sexual Dependency* and Larry Clark issued *Tulsa*. Both artists created visual diaries of the chaotic lives of their milieu, whether the New York club scene or the drugs and gun culture in Middle America. In other hands, such as British artist Richard Billingham and American Larry Sultan, the casual photograph explores the contours of their family lives, recording moments usually shrouded from view. Billingham's *Ray's a Laugh* (1996) documents his family life in a crowded council flat frequently disrupted by his father's drinking. In the book *Pictures from Home* (1992) and in the continuing series, Sultan combines his family's archive of snapshots and 8 mm films with his own photographs.

The power of this mode derives from the extent to which viewers have internalized the domestic photograph, typically made at symbolic points in personal life. These pictures encode bonds, mark achievements, and record milestones. They are documents of shared moments in the ongoing life of an extended family and community, from highlights—weddings, christenings, birthdays, graduations—to less significant events—a day at the beach, a party, a moment of play. Since the late nineteenth century, this visual language has communicated across time, place, class, and ethnicity. Susan Sontag claimed, "Through photographs, each family constructs a portrait-chronicle of itself—a portable kit of images that bears witness to its connectedness."[2] Whatever disrupts that narrative of connection and coherence—pain, illness, abuse, addiction, loss—is left out of the traditional family photo album. Ortiz's work departs from the conventions of a family record; she documents, and tries to make sense of, the rupture in familial connection and the loss of coherence.

La Condición de la Familia melds the power of the family photographic album with the mediated stance of an artist book. Ortiz

(previous spread) *Israel y la Virgen*, 2013. Archival pigment print; 30 × 22 inches, unframed.

143

constructs her report on her family's condition by layering vernacular, amateur family photographs with the cool compositional structures of her own portraits, interiors, and streetscapes. This interweaving of vernacular and formal builds a dynamic sequence that simultaneously provides the story with a narrative arc while resisting a totalizing, authoritative narrative. The result is emotionally resonant, compelling viewers to decipher the tragedy that unfolds over the 40 pages of the book and across years of family life—the death of her younger brother as the result of an older brother's downward spiral into schizophrenia. We are primed to narrativize the bound presentation of sequential images by a shared acceptance of the conventions of the photo-narrative, which extends back through the picture magazines of the 1930s and the dominance of the photo-essay in print media. We read meaning in this format through the formal strategies employed by the picture editor—the sequence of images, their placement and weight on the page, and the pauses afforded by white space—and we expect that meaning to be anchored textually by captions. Yet, Ortiz denies immediate comprehension by withholding textual information that would identify the actors in the family drama or provide a clear chronology. The photographs and documents become mute witnesses, as the artist prompts the viewer to search within them for clues or warnings.

La Condición de la Familia begins with evidence of shared family moments and smiling siblings then gives way to formal portraits. One family member is increasingly seen at a distance, no longer part of the group seen in earlier photographs. Even the photographer stands back, photographing him at a remove. Images of furiously disheveled rooms and punched out wire mesh bear witness to disintegration. Family portraits, presented as multiple exposures, encode a whirlwind of fear and confusion. At the still center of the book is the intimacy of loss. Here, private photographs afford us scalding views of intimate moments at the funeral home and gravesite. In the sequence of images that follows those pictures, Ortiz changes register from the informality of domestic photography to formal documents of loss—flowers on a gravesite, RIP scrawled on the stanchion of a street sign—rigorously composed in classic black-and-white photographs. Mourning is now more public and the "what-ifs" more pressing. Family anguish has become public, recorded in files moving through the medico-legal system. Ortiz ends this study with an early family snapshot of siblings smiling and clowning for the camera. It is indistinguishable from thousands of family pictures. The artist reclaims this private family

Kathleen Stewart Howe

moment and offers it to public view. Now this ordinary photograph, which once might have interested only other family members, demands our scrutiny. Is it possible to read the future in this image? The pressure it exerts on the viewer to find some clue to the family tragedy that later unfolded destabilizes the security of our own family pictures. Ortiz's work grapples with the dynamics of memory, representation, and loss. Roland Barthes saw in every photograph a chilling reminder of death, as the photograph simultaneously records what is, only to reveal what is no more.[3] *La Condición de la Familia* narrates this tension through visual changes of voice and flashbacks.

In 2014, Ortiz began work on a new series, "California State Mental Hospital." She sought out the state facilities that she felt should have been there to help her family as they faced the deteriorating mental condition of her sibling. What she found were shuttered buildings, victims of ever decreasing funding for mental health care. She began to photograph, in her own words, "large structures [that] were abandoned, boarded up... left to decay." What had seemed to her "exclusive to my family" was one of many stories in an underfunded and broken system. Photographs in "California State Mental Hospital" catalog boarded up cottages and treatment facilities set against sprawling, unkempt grounds. The structures themselves seem ghostlike, there yet not there. Similarly, in the series "Not Alone" (2011), Ortiz inserted the silhouetted form of her dead brother into photographs of the landscapes he once moved through and that the family continues to inhabit, creating a parallel of choreographed presence and documented absence.

Notes:

1. For a brief critical survey of domestic photography and the use of its conventions by contemporary artists, see Patricia Holland, "'Sweet it is to scan...' Personal Photographs and Popular Photography,", in *Photography: A Critical Introduction*, Liz Wells, ed., 4th edition (London and New York: Routledge, 2009), 117–65; and essays in *Family Snaps, The Meaning of Domestic Photography*, Jo Spence and Patricia Holland, eds. (London: Virago, 1991). Several exhibitions have explored the range of intimate and domestic photography, for example, "Who's Looking at the Family," at the Barbican Art Gallery, London, in 1994.

2. Susan Sontag, *On Photography* (New York: Farrar, Strauss and Giroux, 1973), 8.

3. See Roland Barthes's influential meditation on the nature of photography as an insistent reminder of mortality. Roland Barthes, *Camera Lucida* (New York: Hill and Wang, 1981).

State of the Family

Aydinaneth Ortiz in Conversation with
Nicolás Orozco-Valdivia

NICOLÁS OROZCO-VALDIVIA: Your book *La Condición de la Familia* combines family photographs and bureaucratic documents with your more abstract images to reflect on family, loss, and mental illness. Part of the strength of this piece is how it operates both on the level of the juxtaposition of images on each page spread and as a dramatic narrative whole. Why did you choose a book format in the first place, as opposed to presenting the works on the wall?

AYDINANETH ORTIZ: I chose to make a book for this project because I felt it was the most appropriate format to tell a visual story with still images. I recorded events in my life that at the time felt exclusive to my family. With the book format, I was able to share the hardships that my family endured while my schizophrenic brother, Israel, self-medicated with street drugs and acted out against us. The aftermath of this was his fight with our youngest sibling, Geovany, which tragically led to Geovany's death. The book also allows me to display many images in one space, and it allows me to control the sequence and the narrative arc.

NO: Could you talk about the order of images in the book. How did the final sequence come about?

AO: I start off the book by introducing the main characters and then proceed to tell my story. The images are not in chronological order. Instead, I focused on what sequence made the most sense for the sake of the narrative.

NO: Tell me more about your process with regards to how you think about an audience.

AO: So far I've been making art for myself, more than anything, because I use art as therapy or healing process. At the same time, I welcome an audience that can connect with the subject of mental illness through personal experience, or even those who haven't had to live with mental illness but are able to gain some understanding of the problem through the book.

I would like for those who are dealing with similar experiences to see this book and maybe realize that there are ways of coping with pain and dealing with stress other than resorting to drugs or alcohol. When I show my art, I receive positive responses from people who have had similar experiences. That is powerful for me. Even with my family, I feel like the book has helped us to have this conversation, because they tend not to want to talk about all that has happened to us. When I show them my work, however, they have no choice but to confront our reality and talk about it. The work facilitates communication.

This interview took place in Los Angeles between October and November 2014 and was edited for publication.

147

When my youngest brother passed away, all of my family and our friends got together in the cemetery. I put up among the gravestones photographs from my series "Not Alone," in which I've placed my brother's silhouette in different Southern California locations. I put those photographs in the cemetery, and they *got* it!

NO: Do you think of yourself as a Latina or Chicana artist?

AO: Well, there are people who don't want to be called Chicana/o artists, and others who embrace it. The reason some don't want to is because they don't want to be pigeonholed. When I asked Cathy Opie one day about whether I was a "Chicana artist," she told me, "I don't think your work necessarily falls into the category of Chicano art." And I agree, but that does not mean I will not be dealing with those issues in the future. Right now my focus is on my family and what we have gone through. But I do think about other issues that happen in my community.

I took a class with Alma López on Chicana Artists. As I learned more, it made me appreciate their work because it's not mainstream. In that class, a lot of speakers came in, and they would say, "I felt like an outsider." THAT'S ME! Our experiences in this country and in this educational system are almost the same. We feel like we don't belong but we prove that we do. We stick it out, and we do it!

NO: How has your education affected your art?

AO: My education has helped me in various ways, from learning about my roots to getting to know myself better and figuring out what's important to me. I learned why it is I make art and what I want to say with my work.

At the University of California, Los Angeles, I took a class titled History of Chicano Peoples. My question was: "How do you become a Chicano?" I think it's about being aware. A lot of people are so closed up in their own little world that they don't see what's really out there. Before college, I didn't associate myself with anything. There was a point when I was younger, in high school, where if we talked about culture, I would say, "I don't have culture." But we didn't just become who we are out of nowhere, we have history. Our history is the result of how our parents grew up and how we grew up. All of these things factor into who we are.

Right now I'm working with a group of other artists I met through Cerritos College, as part of a collective. We call ourselves One of One, like a unique print edition, because we each bring a different style and background to our practice.

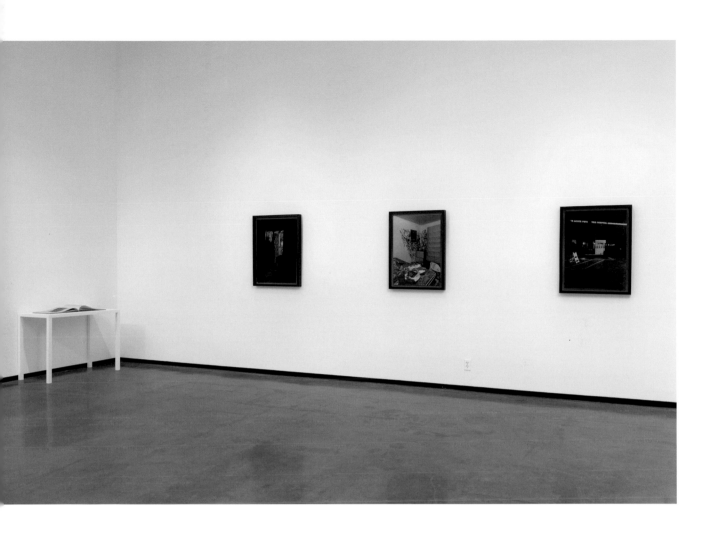

Installation view of "R.S.V.P. Los Angeles" at
the Pomona College Museum of Art, 2015.

La Condición de la Familia, 2013.
Page spread from 40-page artist
book; 11 × 17 inches, closed.

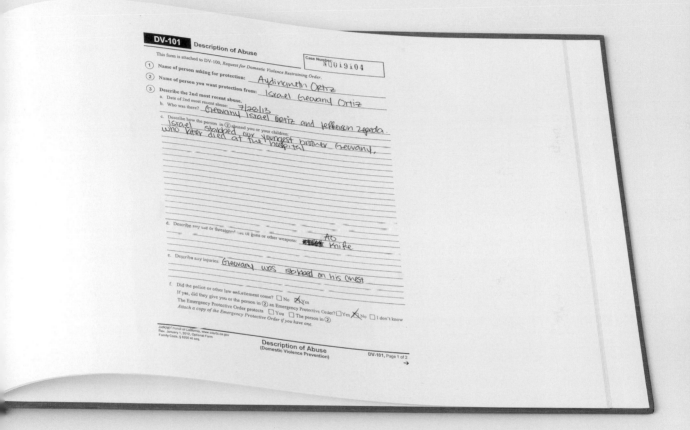

DV-101 Description of Abuse

This form is attached to DV-100, *Request for Domestic Violence Restraining Order.*

Case Number: NU019104

(1) Name of person asking for protection:

(2) Name of person you want protection from: Aydinameth Ortiz

(3) Describe the 2nd most recent abuse. Israel Greovany Ortiz
 a. Date of 2nd most recent abuse: 7/28/13
 b. Who was there? Greovany Israel Ortiz and Jefferson Zepeda.
 c. Describe how the person in (2) abused you or your children: Israel stabbed our youngest brother Greovany, who later died at the hospital

 d. Describe any use or threatened use of guns or other weapons: ~~knife~~ AO knife.

 e. Describe any injuries: Greovany was stabbed on his chest

 f. Did the police or other law enforcement come? ☐ No ☒ Yes
 If yes, did they give you or the person in (2) an Emergency Protective Order? ☐ Yes ☒ No ☐ I don't know
 The Emergency Protective Order protects ☐ You ☐ The person in (2)
 Attach a copy of the Emergency Protective Order if you have one.

Judicial Council of California, www.courts.ca.gov
Rev. January 1, 2013, Optional Form
Family Code, § 6200 et seq.

Description of Abuse
(Domestic Violence Prevention)

DV-101, Page 1 of 2
→

La Condición de la Familia, 2013.
Page spread from 40-page artist book.

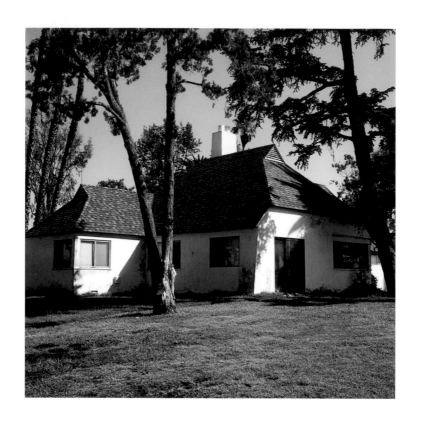

Photographs from the series "California State Mental Hospital," 2014. Archival pigment prints; 10 × 10 inches each, unframed.

Michael

Parker

Michael Parker 101

Doug Harvey

The history of Modern art could be mined for precursors to relational aesthetics at least as far back as the Dada antics at the Cabaret Voltaire.[1] But most of the current practitioners of this newest of New Genres distinguish themselves by subscribing to a conceptualist austerity of means—favoring deadpan structural and procedural documentation; emphasizing, often exclusively, the social interactions produced by their artworks; and eschewing formalist content, such as the tactile, sensual, and perceptual elements of art and the visual language they comprise.

While the relational artists' puritanism can be helpful in focusing and clarifying their intentions (plus having the bonus effect of destabilizing their claim to creative authority), it also abdicates subjectivity, idiosyncrasy, most of the non-narrative non-verbal information (which provides a much different kind of ambiguity than crowd-sourced content), and the majority of the sensory rewards that many still consider integral to art. It is a dry medium, lacking juice. But it doesn't have to be that way.

In his most recent solo exhibition, Michael Parker brought the juice with a vengeance. For *Juicework*, held at Human Resources in Los Angeles' Chinatown district over four days in February 2015, the artist filled the cavernous white cube of the gallery—a former neighborhood movie house— with an array of interactive components that took sensual engagement to an absurd but exquisite extreme. Consisting of a dozen or so stations where visitors could produce and consume juice from the abundant supply of citrus fruits (plus a dishwashing area), the installation functioned perfectly as a locus of conviviality, with perhaps a spritz of social commentary (juice boutiques being currently synonymous with the sustainable gentry).

What made *Juicework* remarkable was its extravagant sensuality and homespun eccentricity. Each of the juicing stations consisted of a table fashioned from an irregular tree slab raised about 10 inches off the floor and lit by hanging porcelain pendant lamps that had been hand pressed from what the artist called "the ugliest watermelon of the summer." Various sizes of coiled fabric cushions sealed in clear vinyl and an array of ersatz African stools provided seating.

But the pith of the display consisted of over 1,000 handmade ceramic artifacts—mostly freeform juice reamers of various sizes, but also sufficient quantities of cups, funnels, trays, and larger vessels to hold the mounds of yellow, orange, and green fruit. The ceramic tools were mutantly variegated in shape, scale, and finish—with organic forms

(previous spread) Installation view of *The Unfinished (Standing and Separated #1–12)*, 2015, in "R.S.V.P. Los Angeles," Pomona College Museum of Art, 2015.

recalling sea anemones and sumptuous mottled glazes in the blue-violet-red end of the spectrum.

Visually, the installation was like nothing so much as an immersive stained glass Art Nouveau theme park, like walking through Antoni Gaudí's studio during a minor earthquake. And an aromatherapy session. And experimental choreography workshop. And yes, the social aspect was delightful. But it might not have been so without the opium-den intimacy and Haight-Ashbury facture to knock the public's discursive minds off their "I-am-participating-in-a-social-artwork" pedestals.

The brief happening was a hit, garnering tweets and kudos left and right, giving critic Carol Cheh "hope that maybe the truly great, unique, and beautiful stuff—the stuff that to me defines LA much more than any giant-warehouse-turned-blue-chip-gallery—can continue to co-exist alongside the annoying dreck."[2] And while it was easy to fall under the spell of Parker's handmade California psychedelic vernacular, it would be a mistake to imagine that this was the extent of his formalist conceptual vocabulary.

The first time I noticed Michael Parker's work—at least the first time I realized it was Michael Parker's work that I was noticing—was when he was a graduate student at the University of Southern California. His thesis project involved infiltrating a training program for power-pole linemen at the adjacent Los Angeles Trade Tech College. *Infiltrating* isn't quite the right word, since it was all on the up-and-up: Parker presented himself as a student artist and managed to build a consensus among the diverse student body that these seemingly disparate academic disciplines could work together to make something surprising.

The result—apart from the artist's actual relational pedagogical performance with his collaborators—was a series of photographs, videos, and audio interviews presented in various configurations and culminating in the publication of the 60-page full-color newsprint broadsheet titled *Lineman* (2009). This "yearbook" contains transcribed interviews, bios, and individual photo profiles for each of the program's 50 participants. This sort of taxonomic photo-text artist book tack is diametrically opposed to (if historically convergent with) the hippy baroque of *Juicework*.

What had *initially* caught Parker's eye was the class' practice yard—a fenced-off grid of faux utility poles—very much the kind of inadvertent industrial land art sculpture that the Center for Land Use Interpretation loves to document with consummate objectivity. Between the binary

Lineman (back cover), 2009. Newsprint publication, 60 pages, full color; 11 × 17 inches, closed.

160

Doug Harvey

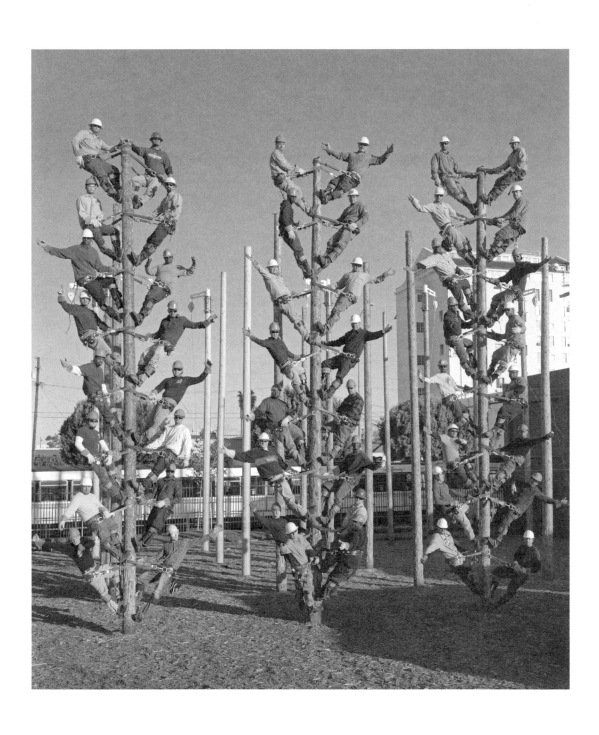

poles of conceptual rigor constituted by this recognition and the final documentary publication, Parker pursued the implicit content of the negative spaces of the actual pole yard: the absent human bodies and the intricate choreography of their social and kinesthetic negotiations.

That choreography is recognizable in the iconic image from the project: a class portrait of all 50 students posing in jaunty bifurcated symmetry, perched up the length of three parallel poles. This curiously geometric mise-en-scène—reminiscent of the cinema of Busby Berkeley and Matthew Barney—carries over into *Relay* (2009). The 24-minute, two-channel video loop, made by the students passing a double-camera-baton as they clambered upward, features the striking innovation of integrating two subjective camera POVs into the articulation of the rhythmical, serialist trust-and-coordination-building exercise.

An earlier Michael Parker project that came to my attention—though I was unaware of his authorship at the time—was a semi-guerilla pop-up art venue he initiated and curated in another urban industrial site—a 40,000-square-foot refrigerated warehouse construction site across the street from his live/work space on the industrial fringes of downtown Los Angeles. This was a breakthrough project for Parker, who was supporting himself as an EMT/ambulance driver at the time.

163

Begun with a handful of contacts from his undergraduate art classes at Pomona College, Cold Storage (2006–7) mushroomed to include "experimental sound, choreography, book releases, bike riding, festivals, street battles, mapping, and *carmadas*," and overlapped with ever-widening and higher-profile circles of Los Angeles' avant-garde communities. Most impressively, Cold Storage was the venue for the performance of James Tenney's *in a large, open space*, in which 17 musicians played a sustained F note for three hours; the composer was in attendance, just six weeks before his death.

Again, the impetus was formal: Parker's eye was caught by the exquisite minimalist grandeur of the giant slab of cast concrete that appeared in the vacant lot next door. As he recalls, "One day I came home from the ambulance and opened my shade. It was early—6:30. The day before they had cast this giant concrete piece of ground at loading dock height, like this floating piece of glass or ice, and I just had this aesthetic response like 'Wow that's just beautiful!' Then they came with the cranes to tilt up the walls. In a matter of hours it became this giant internally enclosed box, and I thought, 'OK, I've *gotta* do something inside that.'"[3]

Cold Storage, 2006–7. Details of installations and events at 40,000-square-foot construction site in downtown Los Angeles.

Doug Harvey

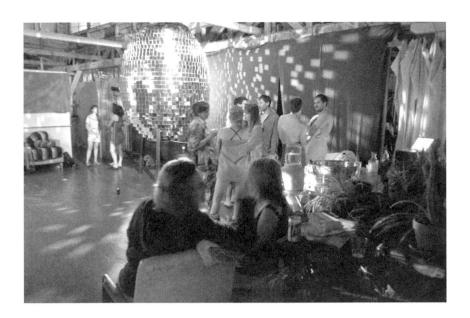

This epiphany epitomizes Parker's deliberate confusion of formalist and relational purities, which arguably reached its delirious apex with *Steam Egg* (2010–present). The project grew out of his extensive (and ongoing) research into utopian communities around the world. As documented in another hefty self-published newsprint zine, *Balloon Route* (2010), Parker traveled to the world's only active Shaker community, located in Sabbathday Lake, Maine; a string of coconut farms in Tamil Nadu, India; Leonard Knight's *Salvation Mountain*, an outsider monument in the California desert; the Indian "universal town" of Auroville; and many other experimental creative social environments, documenting everything and collaborating with community residents.

These research expeditions, combined with a flurry of influences, including Buckminster Fuller, Dan Graham, Hakim Bey's *Temporary Autonomous Zones*, and hot air ballooning, resulted in the glam alchemy of *Steam Egg*, a gorgeous three-legged, bottom-entry disco Fabergé sauna (patent pending) seating up to eight participants in its moist, hollow core. A striking primary sculptural artifact on its own, the *Steam Egg* combined a distilled geometric structure with an absurdly decorative, gaze-deflecting faceted mirror surface while referencing an ongoing motif in Parker's own oeuvre—recurring pod-like forms created from hollowed-out melons (such as an early series of salt-preserved husks) or their negative spaces, including the *Juicework* pendulum lamps.

(above and facing page) *Steam Egg*, 2010–present. Studio views.

In this case, the negative space was activated by the social activities inside and outside the egg,

including rotating casts of collaborators programming audio and olfactory components (AKA DJs and Herb-Js), on top of the essential and rarely investigated tactile medium of temperature manipulation. The shambolic unpredictable steams occurred weekly on and off for a couple of years and became something of a cause célèbre among art world cognoscenti—so much so that Parker had to cease operations or start opening franchises. The egg was put out to pasture.

For the time being. In fact, while *Juicework* was in the works, Parker was simultaneously fabricating and installing the new and improved *Steam Egg 2* (2014–present), now with *Personal Pool* (2014) and an extra layer of Computer Assisted Design aesthetics. The piece was installed at Pomona College for use by the student body—in advance of a pending world tour—while the original *Steam Egg*, which is now back in limited service, was being revamped with a new steam-generating mechanism. But Parker's major project during this timeframe engaged an entirely new set of art historical referents.

The Unfinished (2014–15) overlaps with Parker's earlier incorporation of plausibly minimalist sculptural forms and the intersection of land art's vocabulary with urban industrial infrastructure, but adds a patina of faux-archeological institutional mimicry in the vein of the Museum of Jurassic Technology, as well as the actual Eighteenth Dynasty Egyptian monumental sculptural tradition that Parker's central artifact mimics.

The Unfinished is a group of works predicated on the absurdist concept of digging an actual-sized recreation of the excavation site of Hatshepsut's *Unfinished Obelisk* (circa 1463 BCE), the largest obelisk ever crafted from a single piece of bedrock, commissioned by the longest-ruling female pharaoh. Parker's *The Unfinished* took place at the Bowtie Project, in a disused area on a parcel of land owned by the California State Park system along the banks of the Los Angeles River.

The symbolic transposition isn't as zanily random as it first seems. The Los Angeles River is an iconic site in the long and sordid history of political manipulation surrounding the flow of water in and around the desert megalopolis, channeling the last pathetic westward trickle of Manifest Destiny. With recent memories of the Arab Spring and the Occupy Movement encamped under Los Angeles' obeliskine city hall, Parker seized on the fundamental motifs of monumental verticality and social horizontality, finding a poetic conflation of the two in Hatshepsut's *Unfinished Obelisk.*

The Unfinished, 2014–15.
Google Maps view of 137-foot
urban earthwork excavation.

167

Manufactured by "a group of people trying to make something together that was bigger than anything an individual could do, at the behest of a powerful leader," Hatshepsut's *Unfinished Obelisk* cracked just before completion: "Broken," observes Parker, "by its own internal power." The excavated failure remains in the quarry where it was carved, in Aswan— site of the contentious hydraulic project that ended the annual flooding of the Nile in 1971.

Convoluted as this cluster of signification may be, the layers of relational process involved in realizing the replica were even more baroque—starting with the unlikely attainment of clearances and permissions from a half-dozen government departments, expert consultations involving soil testing and surveys with ground-penetrating radar, arranging for heavy asphalt-cutting and earth moving equipment, and rallying 40-odd volunteers to assist in the dig.

Leaving it at that—a multilayered, politically charged, historically resonant relational negotiation embodied in a quintessential, monumental minimalist earthwork—would be a considerable artistic statement for a more conventionally ambitious artist. But in these times of ostensibly progressive art stars farming out the fabrication of their epic magnum opera to third-world craftsmen, it would break under the weight of its own irony.

Through Parker's celebratory public-access policies, including an evening of collaboratively produced "educational" skits, a summer solstice concert, a repurposing of *The Unfinished* as a stage for a Mexican-American performance piece, and his own gravestone-rubbing documentation that makes up part of the present exhibition, Parker abdicates the pharaonic authority of the master artist while retaining and exercising the option for the abundance of sensual, psychological, and spiritual gifts that engaged interiority and creative action can unleash.

168

Doug Harvey

Notes:

1. Relational aesthetics is a genre of art practice that was christened and launched in the 1990s by critic Nicolas Bourriaud. It encompasses all manner of social activities reframed as art and is typified by Rirkrit Tiravanija's *Untitled (Still)* (1992), in which he displaced the gallery staff from their office to set up a kitchen, where he made and served Thai food to the public.

2. Carol Cheh, "Michael Parker, Juicework, Human Resources, February 6–10, 2015," *Another Righteous Transfer!* accessed February 24, 2015, https:// anotherrighteoustransfer. wordpress.com/2015/02/09/ michael-parker-juicework-human-resources-february-6-10-2015/.

3. This and all other Michael Parker quotes from conversation with the author, January 11, 2015.

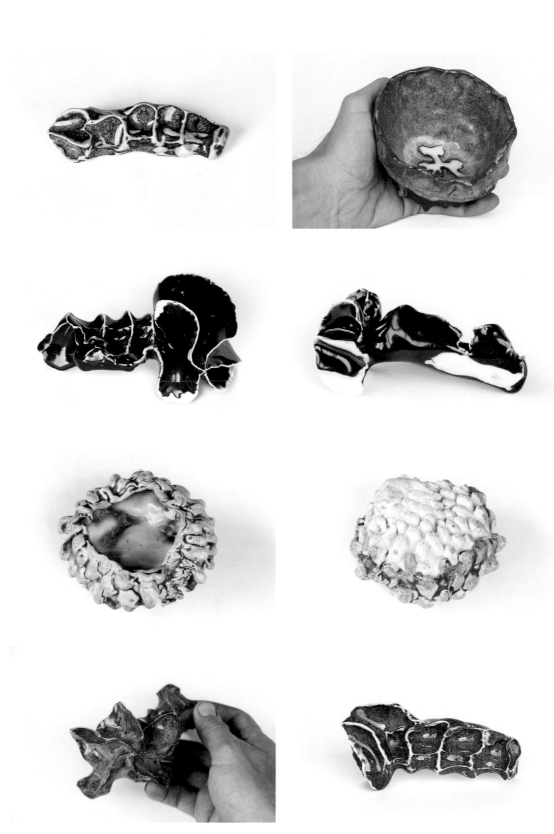

Juicework (details), 2015. Porcelain and
stoneware, dimensions variable.

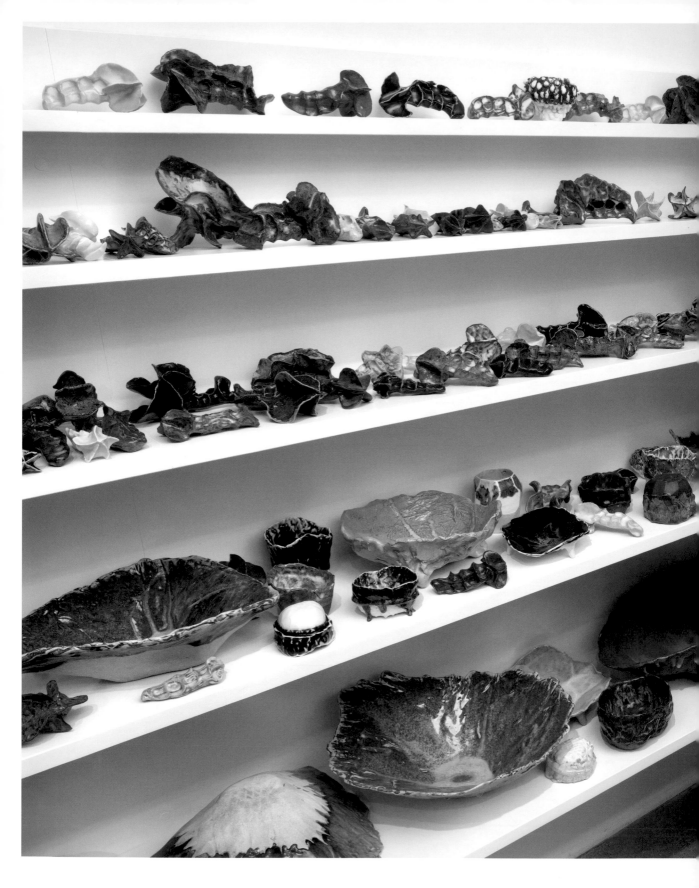

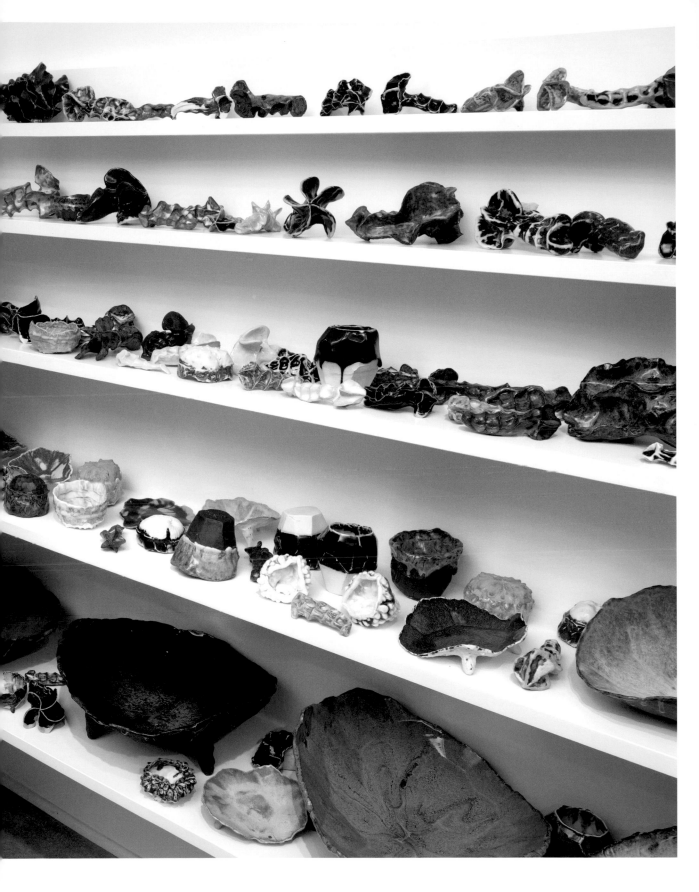

Installation view of *Juicework (1000 tools
and objects),* 2015, in "R.S.V.P. Los Angeles,"
Pomona College Museum of Art, 2015.

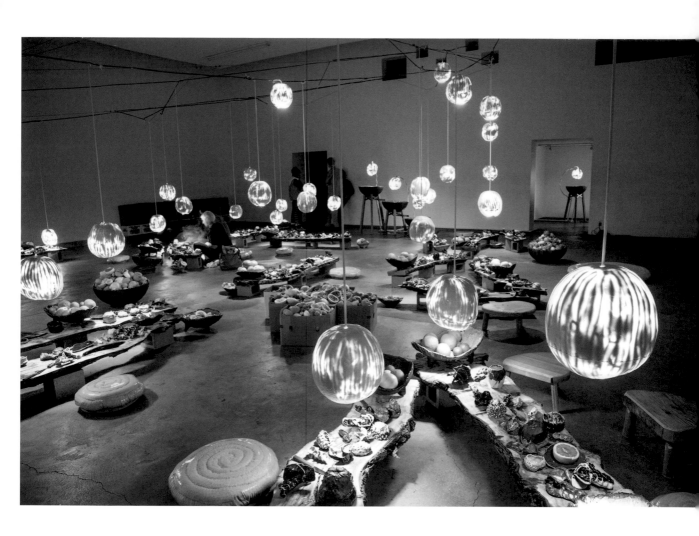

Juicework, 2015. Stoneware, porcelain,
tree slabs, salvaged wood, redwood,
cotton, vinyl, steel, plumbing, foot pedals,
electronics, wire, cable, bulbs, and citrus;
dimensions variable. Installation view at
Human Resources, 2015.

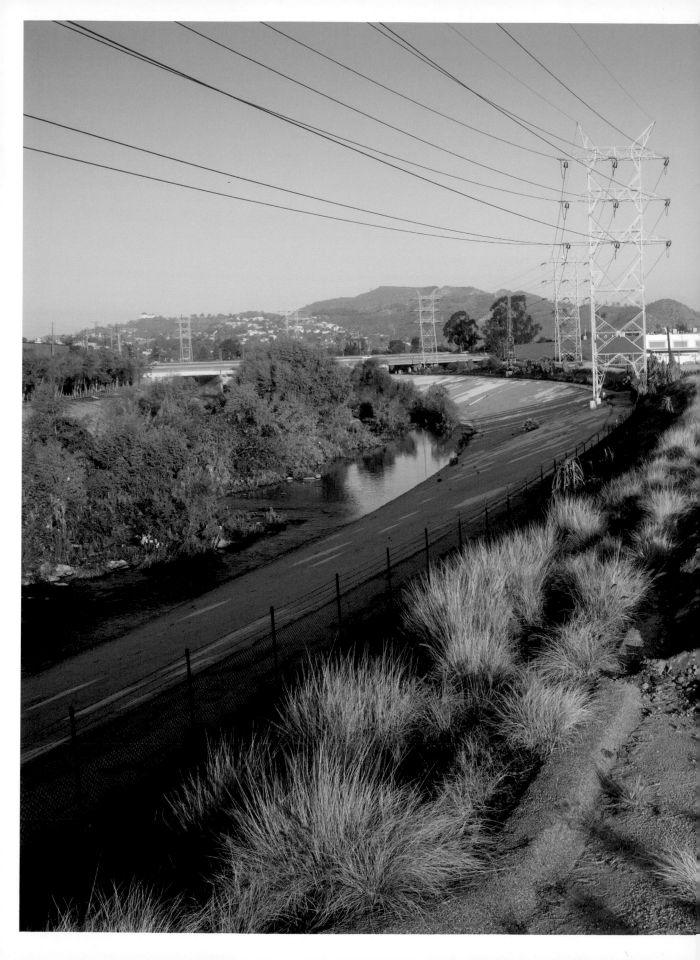

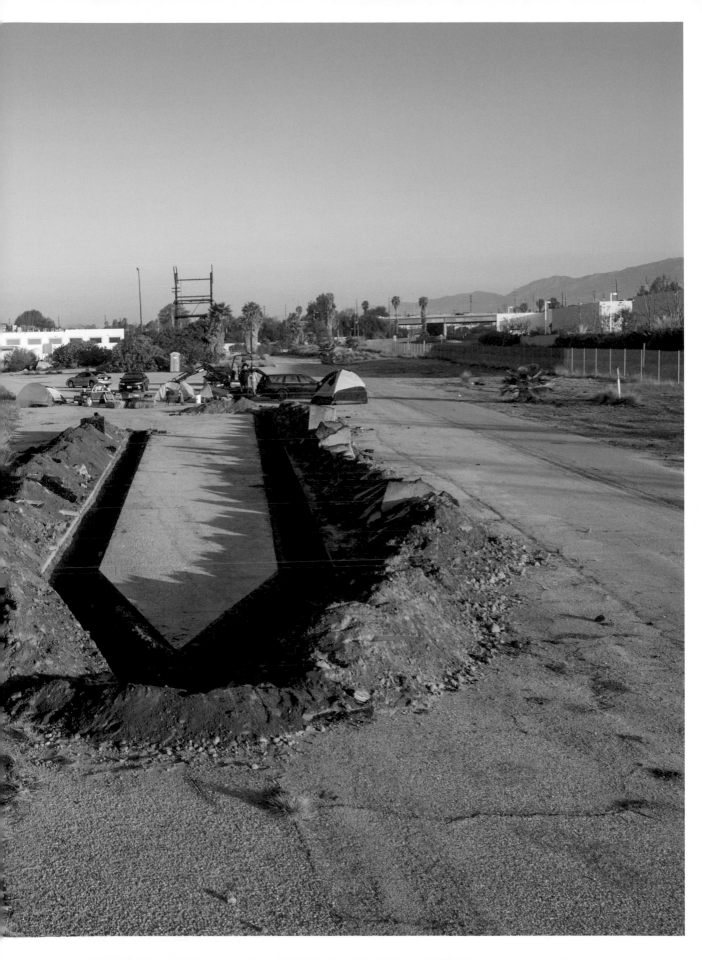

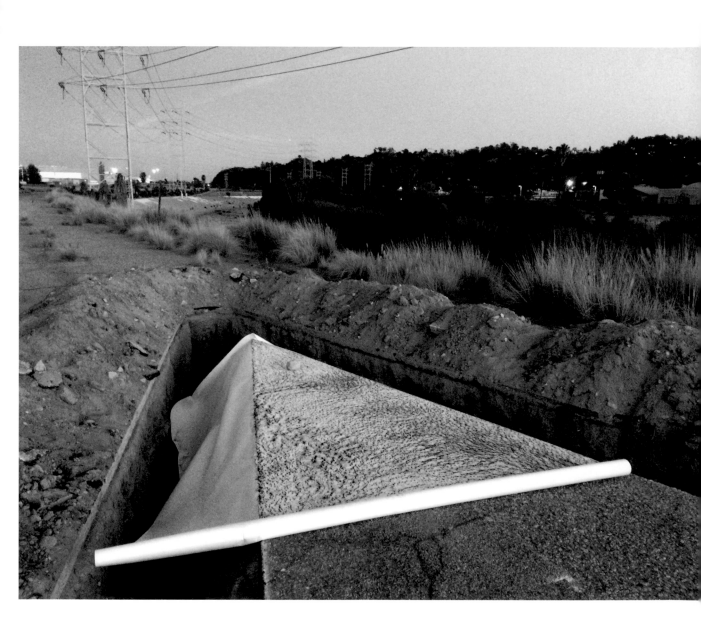

Photograph of production of *The Unfinished*
(Standing and Separated #1–12), 2015.

(previous spread) *The Unfinished*, 2014–15.
Earthwork excavation, 137 feet × 14 feet 9 inches.

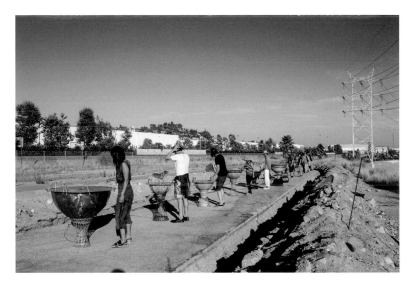

(top) Signage at the Bowtie Project (site of
The Unfinished, 2014).

(bottom) Performance view of Katie Grinnan's
Astrology Orchestra at *The Unfinished*, 2014.

(following spread) Installation view of
Steam Egg 2 and *Personal Pool* (both, 2014)
at Pomona College Studio Art Hall.

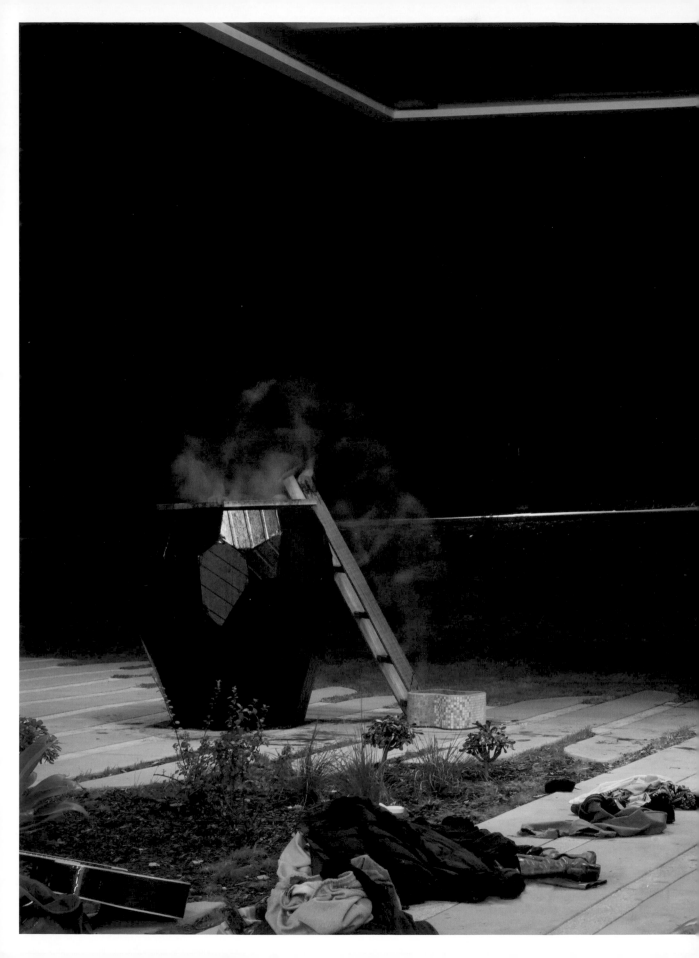

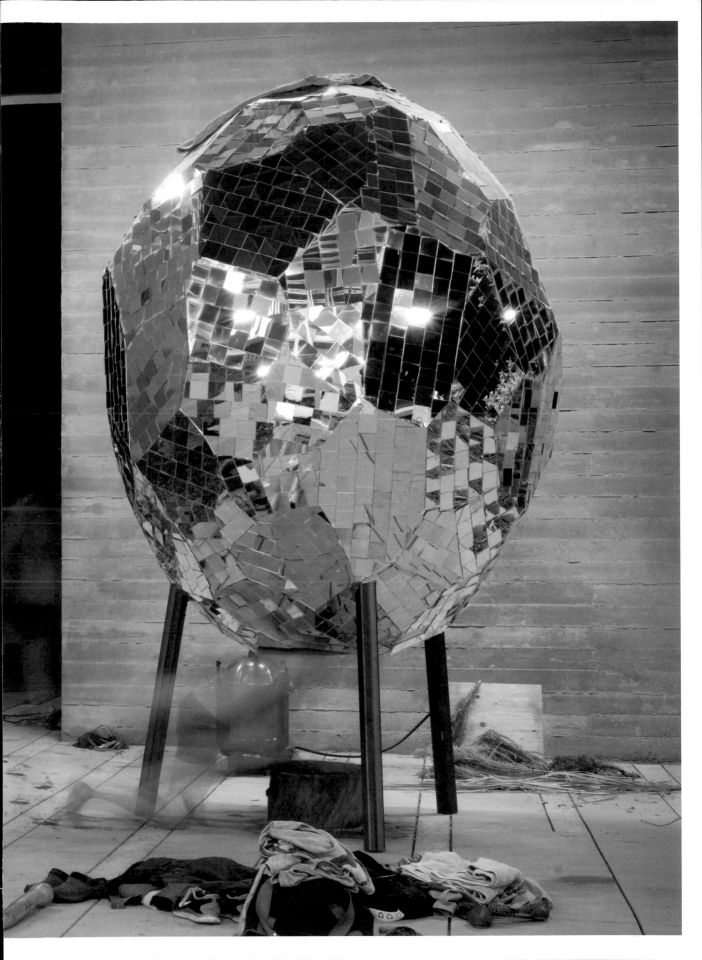

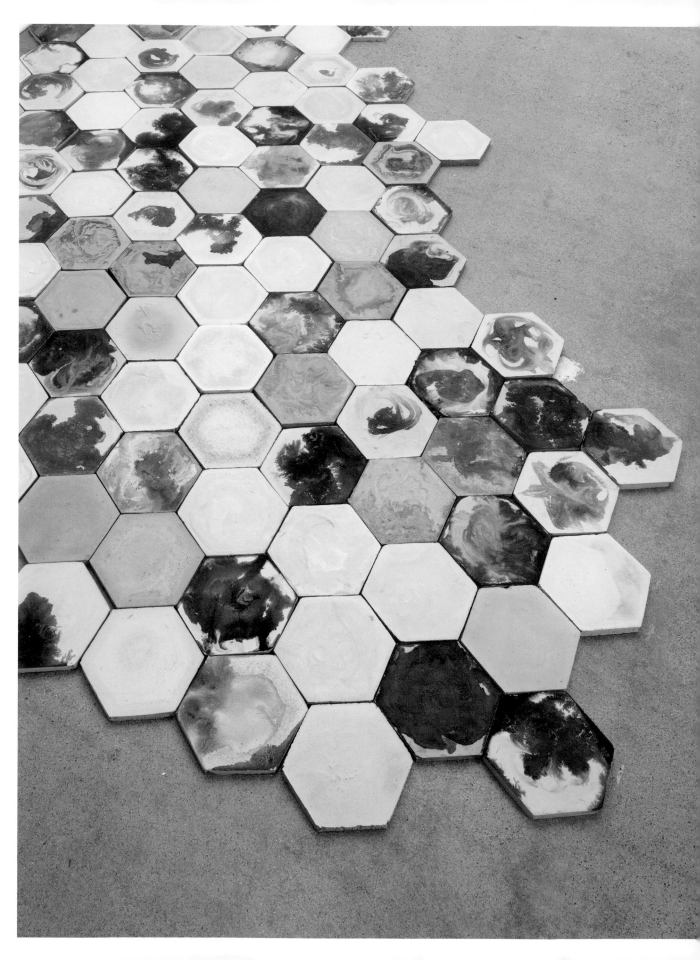

Nikki

Pressley

Deep Exchange/ Good Speech

Nikki Pressley in Conversation
with Rebecca McGrew

REBECCA MCGREW: Nikki, you are currently designing the next issue of *The Liberator Magazine* (forthcoming in fall of 2015), so I thought we could begin our conversation talking about it. Founded in 2002, *The Liberator* is a print magazine with an online journal and blog that publishes stories dealing with art, culture, education, politics, and truth. In the "about" section of the online magazine, the question "Why?" is posed.[1] The answer is long but worth quoting here: "To help preserve humanity, by creating and supporting excellent spaces of deep thought. To make a habit of transcending boundaries. To believe serious storytelling is the precursor to, and companion of, serious action. To remain conscious of our potential to contribute to and help maintain life. And to manifest deep exchange among the urban enclaves of America and between the larger Diaspora." Would you discuss your involvement with *The Liberator Magazine*?

NIKKI PRESSLEY: This may be a long conversation! *The Liberator Magazine* has deeply informed my thinking. I joined in 2007, at the end of my first year at CalArts [California Institute of the Arts]. I knew the editors through a friend who had been a classmate at Howard University before I came to CalArts. This friend put us in contact, and I initially began by posting stories to the blog. Over the next couple of years, my role and involvement grew and I officially joined the "staff" around 2009. I took over art director responsibilities in 2011 and am now a partner. I was drawn to its grassroots activism and inspired by both the study of thought outside the general conversation on racism and the conversations about ancestral connections to African thought, cultures, and religions. Basically, for me, *The Liberator* provides a space for discussion and building around issues that effect us as a culture/community and also, quite simply, as humans. It has been interesting to see our presence expand, especially on the Internet and now in print. At this point, I feel that the work is less tied to doing a job and more to the hope of creating a lifestyle that will one day sustain itself. The challenge we face currently is retaining the original vision and being mindful of how partnerships and models of operation may either exponentially expand or harm that process.

183

This interview took place via email between November 2014 and January 2015 and was edited for publication.

(previous spread) *iterations*, 2014–15. Cement and ink; 100 hexagon tiles, ¾ × 8¼ × 7¼ inches each.

RM: Your work as an artist is complex and multivalent, and also deeply personal. It hybridizes your family history growing up in a Southern Baptist home in South Carolina

with your later interests in collective Black history. I am sure this will come up again in our conversation, but in the context of your involvement with *The Liberator Magazine*, what role does the magazine play in your thinking and art practice?

NP: *The Liberator* has been a great space for me to both learn and contribute to larger discussions around identity and existence. I think I have always felt in a sort of liminal space with regard to my relationship to Blackness and the Black community. I obviously feel a connection there, but I have not always been able to attribute that connection to anything deeper than being born into a particular culture. I suppose I was investigating my investment and the reasons for the investment. The conversations that have happened within and around *The Liberator* have really given me a broader perspective on the intellectual and communal inheritance available to a person of African descent. Growing up, a large part of my "identity" was derived from my connection to the Black church and that narrative of struggle and overcoming. It wasn't until I really got involved with *Liberator* that I began to see the depth of the narrative of not only Blackness, but also African thought. Then I was able to connect a more emotional and nostalgic experience of church to ideas that were more tangible and grounded in sound critical thinking and reason.

The blog is the space where I can put forth ideas for communal discussion, and this has influenced my practice to a large degree. For example, one of my first articles posted on *The Liberator* blog was about Ron Eglash's 1999 book *African Fractals: Modern Computing and Indigenous Design.*[2] I was very interested in African thought around these complex ideas of math and cosmology. I had rarely made connections between African thinking and ingenuity and any of the "Western" ideas I was taught. I suppose it's that moment when you realize that the ideas that we in this country believe in so heartily are very much biased and influenced from a specific perspective. Oftentimes, that excludes other perspectives from the mainstream conversation. Now I'm more interested in making a connection between these mathematical concepts and the relationship of iteration to ideas of history and cultural memory. How moments, ideas, and materials represent the iterations of a culture, slowly, over time, expressing a culture through repetition and building upon a previous method or thought. At one point, I considered composting as an extremely elementary metaphor for the idea of

The Liberator Magazine, 2012.
Front and back covers.

Nikki Pressley in Conversation with Rebecca McGrew

iteration—the image of a powerful regeneration that is both functional and necessary.

RM: Speaking of composting, iteration, and regeneration, let's shift to your current art practice, where, among other things, you are physically exploring ideas of iteration in a set of handmade cement tiles, and you are collecting moss from W. E. B. Du Bois's home site in Great Barrington, Massachusetts, then propagating it in a local greenhouse. Your temporary move from Los Angeles in September 2014 for an artist/teaching residency at the Darrow School in New Lebanon, in upstate New York, has clearly led to new directions in your practice. Your use of unconventional organic materials—such as dirt, dried beans, plants, and moss—combined with painstakingly fabricated objects has now expanded to include the cement tiles. For your residency, you are completing a new body of work that links Du Bois, the contested history of land ownership, landscapes and nature, geologic time, domestic space, formal explorations of ink and graphite, notions of minimalism and seriality, and the power held in inanimate objects. Would you describe this project? I would love to know more about the conceptual starting points for the tiles and the new drawings.

NP: Before I arrived in New Lebanon, I decided that I wanted to attempt to make a body of work that was a response to the place that I was living. I did not enter the residency with any specific ideas about what I would create, but was hoping to continue the line of questioning I had started in the previous works from the Charlie James show (sculptures combining handmade furniture elements with live plants and a series of ink landscape drawings ["Elsewhere in Another Form," Charlie James Gallery, Los Angeles, 2013]). When I got to New York, I was struck by the landscape and the history. After about a month, I found out that Du Bois was born in Great Barrington, about 30 miles south of my residency. I've now made four or five visits to the site. The site itself is mostly a wooded area with a few remnants of a former house, such as the base of the chimney. The house was torn down in haste, leaving many artifacts behind. It is easy to imagine the walls that once stood there, much like the images of domestic objects placed within barren landscapes that I had been drawing previously. Within this is a desire to create unity between the interior and exterior, erasing the dividing structure of the walls to allow for one-ness with the surrounding land. This divide could also parallel the "double

consciousness" that Du Bois often spoke of in his writing. There is perhaps an impulse to unite this consciousness—interior and exterior—to transcend this familiar boundary.

I am fascinated by the Du Bois home site's links with history and land through having been inhabited by this great thinker. Du Bois struggled hard to keep this piece of land within his family, initially purchasing the land, then losing it due to financial reasons. He wrote an essay in his magazine, *The Crisis*, entitled "The House of the Black Burghardts," which is a poetic homage to the home and the New England town where he was born. The ritual impulse in me is to question if this site could potentially hold any energy from his interaction and intention towards it. Many of the religions of the diaspora place a strong emphasis upon the influence and energy of the ancestors that reach to our contemporary age. This influence usually is found in speech and oral tradition, but I believe it is equally potent in our relationship to land and labor and, sometimes, in objects.

Each time I've been to the Du Bois site, I have taken away a few patches of moss with the hope of growing and propagating them in the school's greenhouse. The impulse for this was my interest in the idea of a "propagation" of history. As with my previous works, I paid special attention to how forms shifted from two- to three-dimensional space. In the *Abacus/seat* sculpture (2013), I was curious about the notion that an inanimate object could perhaps "express" itself in the world through an alternate form/material. For the moss at the Du Bois site, it's the same idea except I am now dealing with a living organism.

Also, I worked for a short time keeping bees in Los Angeles and have since been drawn to them mostly for the vital role they play in pollination. This brings me back to ideas around agriculture and land use and the complex system of the natural environment operating alongside human activity. For my new project, I decided upon the hexagon shape early on. The hexagon is a traditional tile shape, and it is the most efficient shape in terms of use of surface area in a tessellated formation. In some communities, the hexagon is significant due to the prolific use of geometry and math in creating domestic and communal spaces. Using the hexagon was also a nod to the obvious—honey bees and their ingenious use of the shape as the most efficient way to store honey. I am constantly pondering the question: How can natural systems be usefully compared with human history to create meaning?

187

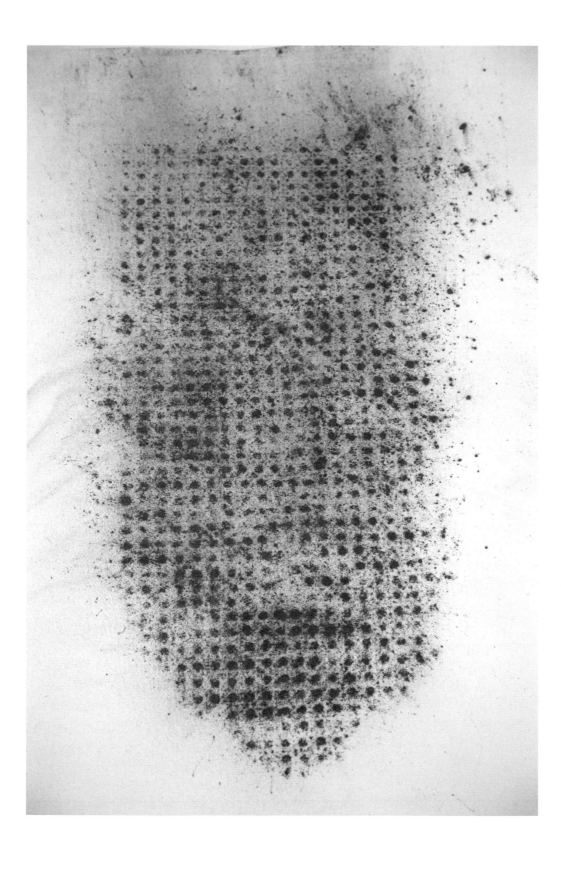

RM: I wonder if your gardening practice—which includes composting, your previous use of live plants or dried beans in your sculptures, and now your propagation of moss—not only connects natural systems to human history but also relates to the exploration of energy and intention toward the land, objects, and the self. I'm thinking of *Abacus/seat*, in which you combined found objects (furniture and fava beans) with a rubbing from the back of the chair that explored the idea of the chair's attempt to express itself through a two-dimensional plane. The chair also reminded you of the furniture from your childhood—a communion chair from your grandparents' church. In *Abacus/seat* you explored the spiritual energy manifesting in the chair through the connection to your own history. In the current work, it seems you expand the exploration of spiritual resonance into your connection with Du Bois's history and his connection with the land through your tiles and drawings.

In this newest work, the graphite's materiality, meaning, and form shift as you use it in the cement tiles *and* in the drawings. Your process not only references the passage of time—echoing geology and other natural modes—but also touches on how materials transform through process and physical conditions. Would you describe your process and your use of materials?

NP: I am interested in how my process documents the set of conditions I am exploring. I previously used cement in my work to create vases for plants, which I included in the sculptures, as in the Charlie James Gallery works. For this new work, my initial idea was to create floor tiles using cement. I was interested in how cement pointed at a domestic interior element using a material traditionally used for outdoor spaces (although many homes now use cement indoors for aesthetic effect). As with the *Abacus/seat* sculpture, I am interested in more analog modes of labor and operation, thus the desire to hand-pour each cement tile using only one mold.

Also, I am exploring the idea of seriality, how the physical repetition begins to mimic iteration, as the mold is transformed each time it is used to make a tile. I will use one mold until it breaks. The shape shifts as I work, the corners become worn, less sharp, and the mold itself becomes less sturdy. Each tile will be more rounded and worn than the preceding tile. As I mentioned before, I'm

Abacus/seat (detail), 2013. Wood, found wood, string, nails, cushion, and fava beans; plinth: 35½ × 48 × 5 inches; chair/abacus: 32 × 20 × 40 inches.

189

interested in looking at the relationship of iteration to ideas of history and cultural memory, and how moments, ideas, and materials represent the iterations of a culture over time. I like how the process and the duration of time are directly linked in making the tiles and the material shapes the quantifiable history of the object—each individual tile. I began using Sumi ink on the tiles to create imagery that was reminiscent of geologic terrain.

Conceptually, the tiles are "grounded" and heavy, and they connect to the earth, to place. They also may appear domestic and reside on the floor. Simultaneous to making the tiles, I am working on new drawings. I had previously been drawing domestic interiors on abstracted landmasses. The landscape in upstate New York is so vast and beautiful, that naturally influenced me. I am using the same materials, but there is a paradox. The drawings are light, the landscapes seem to float, so the ink relates to landscape and location.

I was interested in the materiality of the cement and how it can be achieved in a two-dimensional space. So, my next question was: Could I create the same type of images in another form other than the tiles, one that was not "sculptural," and also use a material that is known for its weighty and foundational properties to exist in a two-dimensional space? I then started using cement washes with the ink in the drawings. The cement itself begins to point to something urban or at least not rural. There was definitely a fascination with kind of "hiding" the true nature of the cement in the drawings and instead creating textured images that still recalled a vast expanse of land. Viewing the drawings and the tiles in the same space, I get a sense of transformation that results in two types of objects that rest comfortably in both two- and three-dimensional space.

Fundamentally, I hope to investigate and explore—in really broad yet personal ways—the histories and lives of objects and what they hold and what they absorb. Time has played a very important, yet subtle, role in my work, especially of late. In the last few months, I've been reading and thinking about the concepts and processes of geologic time—where objects or living things have time behind them. The processes in my work with ink and cement mimic these conditions—materials shifting and transforming as they dry. In thinking about the time behind objects and materials, I am drawn further to the writings and research of Dr. Jacob Carruthers. In his book *Mdw Ntr, Divine Speech: A Historiographical Reflection*

(top) *Run*, 2013. Wood, string, soil, fava beans, green beans, plastic, and paint; 24 × 96 × 43½ inches.

(bottom) *Compost*, 2014. Wood, wire mesh, and Danish oil; two boxes, 32½ × 32½ × 30 inches each.

Nikki Pressley in Conversation with Rebecca McGrew

of African Deep Thought from the Time of the Pharaohs to the Present (1995), he gives a chronology of the role that speech plays in the cultural foundations of ancient Egypt (Kemet) and in West and Central Africa. Carruthers links thought and speech to time and connection throughout the African diaspora. The practice of *mdw nfr* or "good speech" relates to continuing and building upon the transformative ideas and energy that ground life and allow for progression, individually and communally. I am interested in investigating this type of iteration through both content and form. My investment in all of these areas of study is grounded in a deep desire to comprehend the many layers of identity that have been formed and re-formed through time in order to engage fully with the past, present, and future.

Notes:

1. See *The Liberator Magazine*, www.liberatormagazine.com, accessed November 6, 2014. At the time of publication, this descriptive text was no longer available.

2. See *The Liberator Magazine*, http://weblog.liberatormagazine.com/2008/01/african-fractals.html.

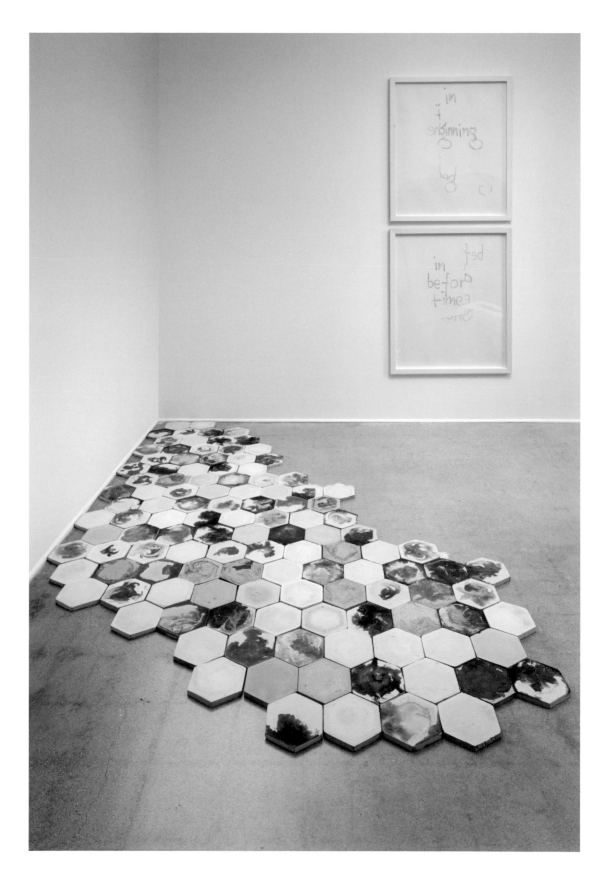

(this page and following spread) Installation
views of "R.S.V.P. Los Angeles" at the Pomona
College Museum of Art, 2015.

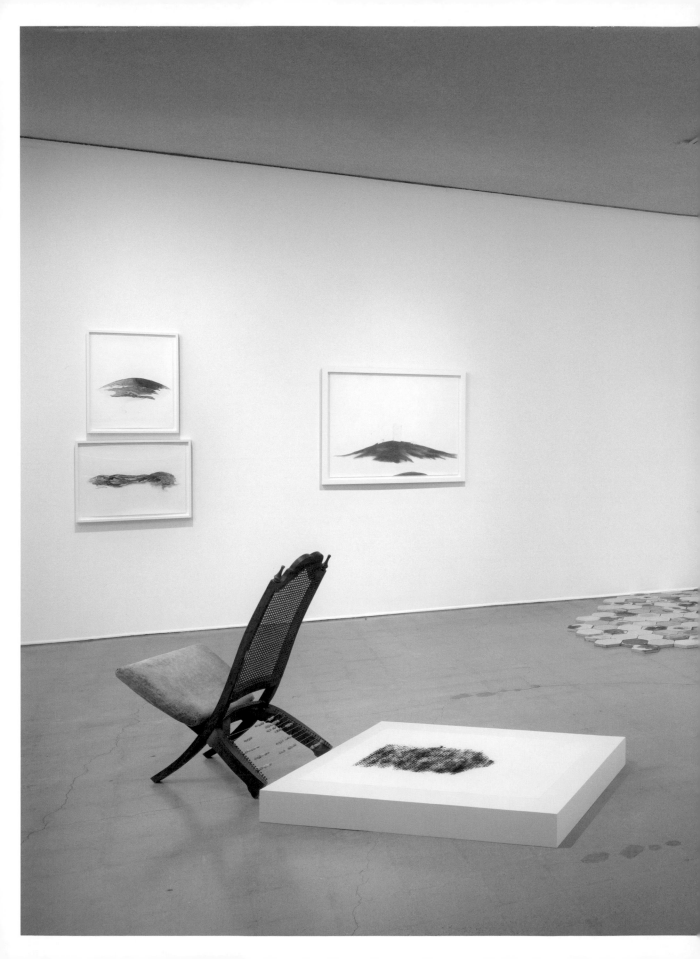

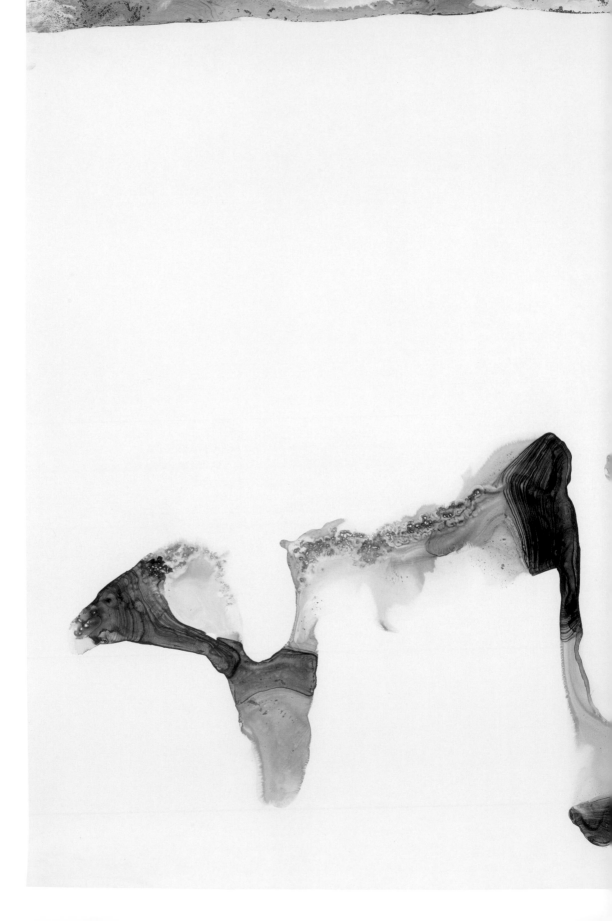

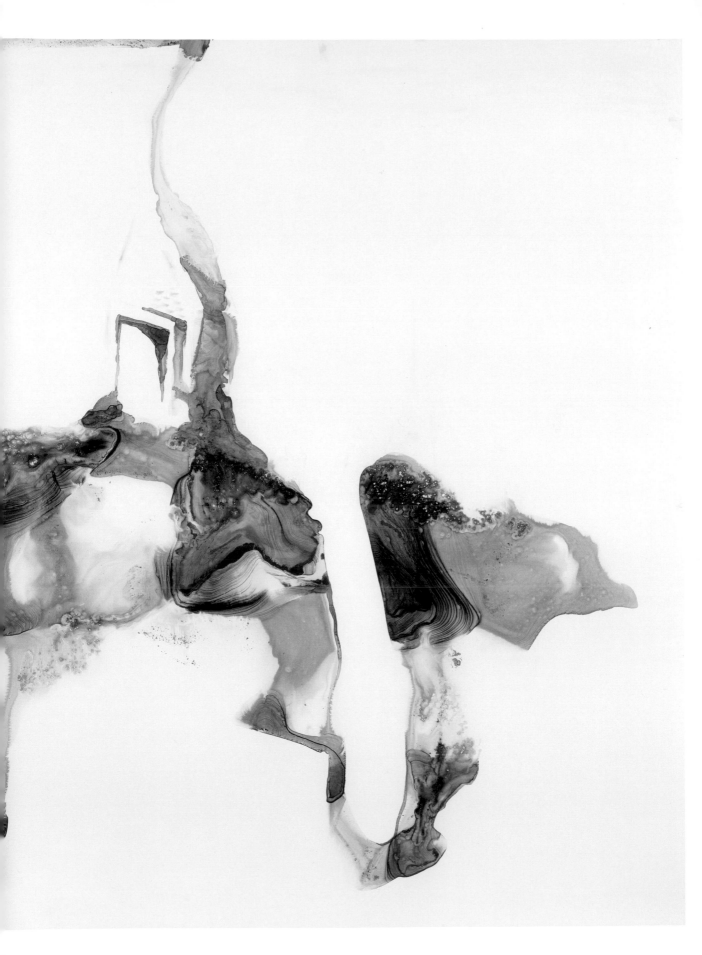

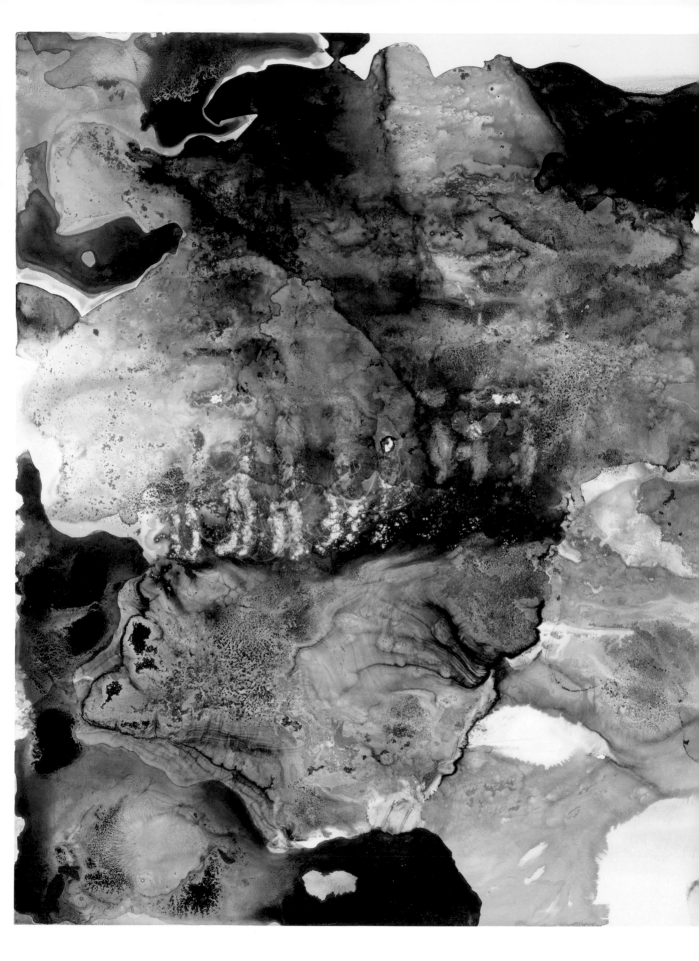

Strata, 2015. Graphite, acrylic, ink, vellum, incense ash, and cement on Yupo paper; 20 × 26 inches, unframed.

(previous spread) *Chimney*, 2015. Ink and cement on Yupo paper; 41 × 60 inches, unframed.

Abacus/seat, 2013. Wood, found wood,
string, nails, cushion, and fava beans;
plinth: 35½ × 48 × 5 inches; chair/abacus:
32 × 20 × 40 inches.

Drawers, 2013. Wood, paint, and
brass and metal knobs; installation:
27 × 25 × 32 inches.

Coffee Table Crawl, 2013. Wood, paneling,
found wood, bamboo, and string; 61½ ×
21 × 18 inches.

Exhibition Checklist

Artist Biographies

Exhibiton Checklist

Justin Cole

41st and Central (White Panther Party), 2014–15
Six silver gelatin prints mounted on plywood
20 × 96 inches total
Prints: 20 × 16 inches each

Detroit, Dust and Scratches, 2010–present
Installation of 30 silver gelatin prints, plywood
shelves, and text on panels
Installation: dimensions variable
Prints: 8 × 10 inches each

First as Tragedy, Then as Farce, 2011
Graphite on paper
60 × 80 inches, unframed

Michael Decker

Black and Decker, 2014
Found cardboard boxes, PVA, and museum
board on hardwood panel
96 × 66 inches

Compress 'n' Dress, 2014
Found cardboard boxes, PVA, and museum
board on hardwood panel
96 × 66 inches

Crockpot Compound, 2013
Archival ink on watercolor paper
22 × 30 inches, unframed

Crockpot Compound 2, 2015
Archival ink on watercolor paper
29⅝ × 22 inches, unframed

Laura and Me, 2014
Fiberglass and fine iron paint
50 × 52 × 48 inches

Location Station, 2014
Found cardboard boxes, PVA, and museum
board on hardwood panel
96 × 66 inches

Mélange La Croix, 2015
Found wood carvings on mirrored plywood tables
Carvings: dimensions variable
Tables one and two: 33 × 40 × 32 inches
Table three: 33 × 40 × 60 inches

Sliders, 2014
Found cardboard boxes, PVA, and museum
board on hardwood panel
96 × 78 inches

Naotaka Hiro

Four-Legged (Toe to Heel), 2014
Cast aluminum
65 × 18 × 20 inches
Courtesy of the artist and Brennan & Griffin,
New York

Night and Fog (Tubes on Black Mountain), 2010
Color video, sound
22 minutes

Untitled Drawings, ongoing
Fifteen drawings in acrylic and graphite
on paper
42 × 32 inches each

Wakana Kimura

I, 2010
Color video, sound
180 minutes

*One trifle-beset night, t'was the moon,
not I, that saw the pond lotus bloom*, 2015
Watercolor, Sumi ink, marker, acrylic color,
venial color on Washi paper (Daitoku roll,
machine made in Fukui Prefecture, Japan,
Hiromi Paper Inc.)
98 × 308 inches total
Four panels: 98 × 77 inches each

Aydinaneth Ortiz

Israel y la Virgen, 2013
Archival pigment print
30 × 22 inches, unframed

La Condición de la Familia, 2013
40-page artist book with cloth-wrapped
hard cover
11 × 17 inches, closed

The Boys' Room, 2013
Archival pigment print
30 × 22 inches, unframed

Time to Reflect, 2013
Archival pigment print
30 × 22 inches, unframed

Michael Parker

Juicework (1000 tools and objects), 2015
Porcelain and stoneware sculptures from the
project *Juicework* (2015)
Dimensions variable

*The Unfinished (Standing and Separated
#1–12)*, 2015
Twelve sequential drawings of the 137-foot
urban earthwork *The Unfinished* (2014)
Each drawing shown once during the exhibition
Graphite on paper
204 × 140 inches each

Nikki Pressley

Abacus/seat, 2013
Wood, found wood, string, nails, cushion,
and fava beans
Plinth: 35½ × 48 × 5 inches
Chair/abacus: 32 × 20 × 40 inches

Chimney, 2015
Ink and cement on Yupo paper
41 × 60 inches, unframed

In the beginning...(king james), 2013
Graphite and embossing on paper
40 × 32 inches, framed

iterations, 2014-15
Cement and ink
100 hexagon tiles: ¾ × 8¼ × 7¼ inches each

Once in a before time (ananse), 2013
Graphite and embossing on paper
40 × 32 inches, framed

Porch, 2013
Graphite on paper
40 × 32 inches, unframed

Strata, 2015
Graphite, acrylic, ink, vellum, incense ash,
and cement on Yupo paper
20 × 26 inches, unframed

Untitled (ground), 2014
Ink, cement, and graphite on Yupo paper
26 × 20 inches, unframed

Untitled (ground 3), 2014
Ink, cement, and graphite on Yupo paper
20 × 26 inches, unframed

All artworks courtesy of the
artist unless otherwise noted.

Artist Biographies

Justin Cole

Born 1981, Detroit, MI

EDUCATION

2005 MFA, Photography, University of California, Los Angeles

2003 BFA, Maryland Institute College of Art

2002 Centre Pour l'Art et le Culture, Aix-en-Provence, France

SOLO EXHIBITIONS

2012 "Suite Sixteen and Tocqueville Photograms," Pepin Moore, Los Angeles

2010 "Historical Impulse," Pepin Moore, Los Angeles

GROUP EXHIBITIONS

2014 "Another Cats Show," 356 S. Mission, Los Angeles
"Material Object," Charlie James Gallery, Los Angeles

2013 "Monument to Rebellion," in collaboration with Alejandra + Aeron, Bergen Assembly, Bergen, Norway
"Suddenness + Certainty," Robert Miller Gallery, New York
"Inaugural Exhibition," Pepin Moore, Los Angeles

2012 "Sunday at 4," California State University, Bakersfield, CA
"Going Public—Telling It As It Is?" ENPAP/Consonni, Bilbao, Spain
"Affective Turns?" organized by Phil Chang, Pepin Moore, Los Angeles
"Los Angeles Goes Live, Pacific Standard Time," Los Angeles Contemporary Exhibitions, Los Angeles

2011 "Pepin Moore at LA Print: Edition 2," Los Angeles County Museum of Art, Los Angeles
"StudioSound," The Studio Museum, Harlem, NY
"Object-Orientation: Bodies and/as Things," Cerritos College Art Gallery, Norwalk, CA
"Pepin Moore at Art Los Angeles Contemporary," The Barker Hangar, Santa Monica, CA
"Frame Rate," Los Angeles Nomadic Division, Los Angeles

2010 "Vinyl Mandala," Actual Size, Los Angeles (curator)
"Second Story," Pepin Moore, Los Angeles
"Los Angeles Art & Music Festival," Los Angeles County Museum of Art, Los Angeles
"Covers," Five Thirty Three, Los Angeles

2009 "The Chef's Theory," curated by Maha Saab, Five Thirty Three, Los Angeles
"MOCA Contemporaries' Night of Urban

"Retreat," presented by AIGA, Solair Residence, Los Angeles
"Engagement Party," Museum of Contemporary Art, Los Angeles

2008 "General Electric," curated by Lia Trinka-Browner, The Project, Los Angeles
"We," curated by Jen Liu, Lizabeth Oliveria Gallery, Los Angeles
"Fall In, Fall Out, Fall Down, Get Ready!" Five Thirty Three, Los Angeles
"Whatcha See Is Whatcha Get...," Five Thirty Three, Los Angeles (curator)

2007 "En La Cumbre," A+D Museum, Los Angeles
"Cali in CPH," Co-Lab, Copenhagen, Denmark
"Passin' Thru the New Amazing," LAXART, Culver City, CA
"You Are My," Bank Gallery, Los Angeles

2006 "Fair Trade," Outpost for Contemporary Art, Los Angeles
"Good Times for Never," Queens Nails Annex, San Francisco, CA
"We All, Us Three," ESL Projects, Los Angeles

2005 "Summer @ Bank," Bank Gallery, Los Angeles
"Supersonic," LA Design Center, Los Angeles
"MFA Thesis Exhibition," New Wight Gallery, University of California, Los Angeles

2004 "Magic Show," curated by Brian Bress, Hayworth Gallery, Los Angeles

LIVE PERFORMANCES WITH OJO

2010 *Instrumental*, hosted by Ned Learner, KXLU 88.9FM, Los Angeles

2008 *Heaven*, Silver Lake Lounge, Los Angeles

2007 DJ set, KXLU 88.9FM, Los Angeles
Hammer Museum, Los Angeles

2006 Track 16 Gallery, Santa Monica, CA
Trudi Gallery, Los Angeles
Instrumental, hosted by Ned Learner, KXLU 88.9FM, Los Angeles

SELECTED BIBLIOGRAPHY

2013 Degot, Ekaterina, and David Riff, eds. *Monday Begins on Saturday*. Berlin: Sternberg Press, p. 281.
Stang, Aandrea. *Engagement Party: Social Practice at MOCA, 2008–2012*. Los Angeles: MOCA, pp. 61–78.

2012 "Noise." *Flaunt* 123 (October), p. 98.
Gubala, Christina. "WaxPhil L.A. #13: Jacknife Records and Tapes, Diga Rhythm Band's Diga." *Dumdum Magazine* (May 8).
Chang, Phil. *Very Short List. New York Observer*, March 13.
"Diesel Presents Thirteen Years of Fortune and Fame." *Flaunt* 119 (Spring), pp. 30–31, 48–49.

2011 MacDevitt, James. *Object Orientation*. Norwalk, CA: Cerritos College. Exhibition catalog.
Bennett, Sarah. "OJO—Ocean View Estate." *L.A. Record* 5.3 (Winter), p. 74.

2010 Villegas, Arely. "The Record as a Form of Art: Vinyl Mandala at Actual Size Gallery." *LAist.com*. (December).
Tuck, Geoff. "Notes on Looking." *ForYourArt.com* (November).
McNeill, Mark. "Frosty," "OJO—La Bolsa Blanca." *dublab.com* (August).
Provo, Ben. "OJO." *ANP Quarterly* 2.4.

2009 Greene, Robert. *Hairy*. New York: PowerHouse Books.
"Flesh Car Crash." *Brand X 1* (July), p. 4.

2008 Wagley, Catherine. "We." *ArtSlant* (July).

2007 Bloom, Rebecca. "Delectable Collectibles." *L.A. Confidential* (Fall).

2006 *Less Art #3*. Compiled by Doug Harvey. Redacted Records.

2005 "Eye on L.A." ABC, Channel 7, Los Angeles. Aired: September 17.

Michael Decker

Born 1982, Spokane, WA

EDUCATION

2005 BFA, California Institute of the Arts, Valencia, CA

SELECTED SOLO AND TWO-PERSON EXHIBITIONS

2014 "Wrinkle Decker Push It @ Chin's Push," collaboration with Aaron Wrinkle, Chin's Push, Los Angeles
"Photo Album Release Party Summer 2014," Patrick Gomez 4 Sheriff, Los Angeles
"New Car Smell," Ambach and Rice, Los Angeles

2011 "Adult Roman Numeral Thirty," Steve Turner Contemporary, Los Angeles

2010 "I wish I could say what I feel," Steve Turner Contemporary, Los Angeles
"Weather Station," Dan Graham, Los Angeles

2009 "Animals, Food, and Animal Food," collaboration with Christian Cummings, USC Roski Gallery, Los Angeles
"Inventory," Circus Gallery, Los Angeles

SELECTED GROUP EXHIBITIONS

2014 "Louie Louie," Human Resources, Los Angeles
"Early Morning," Altadena Community Garden, Altadena, CA

2013 "Folding Time Rhymes," Greene Exhibitions, Los Angeles
"Photo Op," ForYourArt, Los Angeles

"Made in Space," Gavin Brown's Enterprise and Venus Over Manhattan, New York
"The Object Salon," Roberts and Tilton, Los Angeles
"The Archaic Revival," Zic Zerp Galerie, Rotterdam, Netherlands
"Made in Space," Night Gallery, Los Angeles

2012 "Dirty Funk," ACME Gallery, Los Angeles
"Onderdonk," 5028 York Ave., Los Angeles
"Los Angeles Contemporary Tendencies," Hélène Bailly Gallery, Paris, France

2011 "Raw Materials," Greene Park Gallery, Los Angeles
"WAYS/MEANS," Paredon Blanco, Los Angeles
"Shorn from the Black Tusk of the Great Destroyer," RAID Projects, Los Angeles
"The Archaic Revival," Las Cienegas Projects, Los Angeles
"Goldilocks," Commonwealth and Council, Los Angeles

2010 "The Big Four," Steve Turner Contemporary, Los Angeles
"Haunted JMOCA," Justin's Museum of Contemporary Art, Los Angeles
"Please Remember Everything," Actual Size, Los Angeles
"Commonwealth," POST, Los Angeles
"Summer Dudes," Dan Graham, Los Angeles
"Unheralded Media from a Pop-culture Monologue," Slab Projects, temporary space, Houston, TX
"Hidden Bodies," Statler Waldorf Gallery, Los Angeles
"It's Not Simple," S1F Gallery, Los Angeles

2009 "Longest Day of Summer. One Lucky Day," S1F Gallery, Los Angeles
"The Haunted House Show," 5436 Monte Vista St., Los Angeles

2008 "Cocktail Hour with Skip Arnold and Friends," Bonelli Contemporary, Los Angeles
"Old Los Angeles Zoo Exhibit," Slab Projects, Los Angeles
"Cycling Apparati," High Energy Constructs and SolwayJones, Los Angeles
"EGOESDAYGLO," Five Thirty Three, Los Angeles
"KLEVELAND," Bonelli Contemporary, Los Angeles
"The Mystical, Scatological, and the Occult," Monte Vista Projects, Los Angeles

2007 "You are not here, you are still there and you think you are here," High Energy Constructs, Los Angeles
"The Pyramid Show," Monte Vista Projects, Los Angeles
"Something Good to Look At," Center for the Arts Eagle Rock, Los Angeles
"Adam Janes, Michael Decker," Justin's

Museum of Contemporary Art, Los Angeles
"A Warning Shouldn't Be Pleasant," West Los Angeles College Gallery, Culver City, CA

2006 "Chain Letter," High Energy Constructs, Los Angeles

SELECTED PERFORMANCES

2014 *The Objects Are Present*, Brock Smith and Michael Decker, Perform Chinatown: Chaos Reigns, Los Angeles

2012 *Anytime of Year, Anytime of Year*, Joel Kyack and Michael Decker, Venice Beach Biennial, Venice, CA
The Sunday Scag: Waiting for L.Dot, Monte Vista Projects, Los Angeles
The Sunday Scag: The Re-Education of Amerika, organized by Action Bureau at Black Box by Liz Glynn, Los Angeles

2011 *Spectral Psychography, Christian Cummings and Michael Decker,* Las Cienegas Projects, Los Angeles

2010 *Eternal Telethon: Under a Blanket*, Cox's Cottage, Los Angeles
Spectral Psychography, Christian Cummings and Michael Decker, Human Resources, Los Angeles

2006 *Strange Powers*, Creative Time, New York

2005 *Automatic Drawing Brought Forth through the Ouija Board,* Christian Cummings and Michael Decker, Museum of Jurassic Technology, Culver City, CA
Automatic Drawing Brought Forth through the Ouija Board, Christian Cummings and Michael Decker, in 3 x Abstraction: New Methods of Drawing performance event, Santa Monica Museum of Art, Santa Monica, CA

SELECTED BIBLIOGRAPHY

2014 Spears, Jesse, and Michael Decker. *LA Weekly Issue no. 3,669*, self-published zine.
Abelow, Joshua. "Wrinkle Decker, Push It @ Chin's Push." *Art Blog Art Blog*.
Knight, Christopher. "Michael Decker's 'New Car Smell' at Ambach and Rice." *Los Angeles Times*, May 23.
Wagley, Catherine. "5 Artsy Things to Do in L.A." *LA Weekly*, May 7.

2013 Harkawik, Peter, and Laura Owens. *Made in Space*. New York: Gavin Brown's Enterprise. Exhibition catalog.

2012 Wagley, Catherine. "Growing Pains: A New Biennial Brings the L.A. Art World Frighteningly Close to Being 'Established.'" *www.fluentcollab.org*.

2011 Alimurung, Gendy. "Michael Decker's Anti-Cute Art..." *LA Weekly Blogs*, December 12.
Myers, Holly. "Toys Were Hurt in the Production." *Los Angeles Times*, December 2, D12.
Wolf, Kate. "Sitings 8: Thrift Store

210

Materials." *ArtSlant*.
"Michael Decker: I Wish I Could Say What I Feel," *Superstition* 1.
Harvey, Doug. "The Archaic Revival." *ARTINFO*, February 10.
Kimm, Ronni, and Jesse Aron Green. "Dispatches and Directions on Artist-Run Organizations in Los Angeles." *ART2102*, pp. 116–17.

2010 Mizota, Sharon. "Big Four with a Singular Purpose." *Los Angeles Times*, December 3.

2009 Vallance, Jeffrey. "The Medium Is the Message." *Fortean Times* (January).
Harvey, Doug. *ISEPCAH Occasional Paper XVII*. Los Angeles: Roski Gallery, University of Southern California. Exhibition catalog.

2008 Wagley, Catherine. "You Are Not Here, You Are Still There and Think You Are Here." *Daily Serving*.

2007 Brooks, Amra. "Must See Art." *LA Weekly*, December 7, p. 82.

2006 Graves, Hillary. "Possessed: Ouija Board Drawings." *Look-Look*, p. 52.

PUBLICATIONS

2011 Decker, Michael. *Old Growth*. Los Angeles: Steve Turner Contemporary.
Decker, Michael. *I Wish I Could Say What I Feel*. Los Angeles: Steve Turner Contemporary.

Naotaka Hiro

Born 1972, Osaka, Japan

EDUCATION

2000 MFA, California Institute of the Arts, Valencia, CA

1997 BA, University of California, Los Angeles

1996 Universitas Gadja Mada, Yogyakarta, Indonesia

SELECTED SOLO EXHIBITIONS

2013 "Pit and Log," Brennan & Griffin, New York

2012 "Unknown, Video Works 2008–2011," Brennan & Griffin, New York

2008 "Wrong Person," Misako & Rosen, Tokyo, Japan
"Naotaka Hiro," The Box, Los Angeles

2007 "Knows Nothing," Misako & Rosen, Tokyo, Japan

1999 "Naotaka Hiro," Taka Ishii Gallery, Tokyo, Japan

SELECTED GROUP EXHIBITIONS

2014 "East Side to the West Side," FLAG Art Foundation, New York
"Men in LA: Three Generations of Drawings," The Box, Los Angeles

2011 "PT. & PT. with Sid M. Duenas," High Desert Test Sites, Joshua Tree, CA
"Happy Mind My Pleasure—My View," Misako & Rosen, Tokyo, Japan

2010 "Sympathetic Magic: Video Myths and Rituals," Armory Center for the Arts, Pasadena, CA
"To and From," with Sid M. Dueñas, Dobaebacsa, Seoul, South Korea

2009 "Geba Geba," Misako & Rosen, Tokyo, Japan

2008 "Figures," curated by William E. Jones, David Kordansky Gallery, Los Angeles

2007 "Trudi: No Jerks," curated by Catherine Taft and Matthew Chambers, RENTAL, New York

2006 "AJA XX: API/2," curated by Kazuhiro Kosaka, Japanese American Cultural & Community Center, Los Angeles
"Polysphäre," raumcommander, Berlin, Germany
"Panic Our Older Brother," ALM Gallery, Munich, Germany

2003 "Prague Biennale 1," National Gallery Veletrzni Palac Dukelskych, Prague, Czech Republic

2001 "Hiropon Show," curated by Takashi Murakami, Museum of Contemporary Art, Tokyo, Japan
"New Romantic," Diannepruess Gallery, Los Angeles

2000 "Artificial Real," LOW, Los Angeles

1997 "Doug Aitken, Alex Bag, Naotaka Hiro," Taka Ishii Gallery, Tokyo, Japan

SCREENINGS

2010 "Milwaukee International: NO SOUL FOR SALE," Tate Modern, London, England

2009 "I Found Myself an Innovator," curated by Rachel Cook and Yuki Okumura, DiverseWorks, Houston, TX
"The Young and Evil," curated by Stuart Comer, REDCAT, Los Angeles

2008 "The Young and Evil," curated by Stuart Comer, tank.tv
"Murder Pretended," curated by Naotaka Hiro, Casa Vecina, Mexico City, Mexico
"Physical," "Portrait," "ideal #10," Saison Video, Roubaix, France

1998 "Good-Bye," Eniwetok, Beyond Baroque, Los Angeles

SELECTED BIBLIOGRAPHY

2014 Stromberg, Matt. "Men in LA: Three Generations of Drawings at The Box." *Daily Serving* (June).

2011 "Andrea Zittel/High Desert Test Site." *Flash Art International* (November–December).

Taft, Catherine. "Review." *Artforum* (February).

2010 Taft, Catherine. "Top 10 Shows in Los Angeles." *Saatchi Art* (December).

2009 Garcia, Cathy Rose A. "Experimental Video at DoBaeBacSa." *The Korea Times*, February 11.

2008 Davis, Kathryn M. "Los Angeles: Capital of Contemporary Art?" *THE magazine* (July).
Taft, Catherine. "Review of FIGURES." *Modern Painters* (June), p. 94.
Wagley, Catherine. "Bodyscapes." *ArtSlant*.
Taft, Catherine. "Round-up of the Best Shows in Los Angeles." *Saatchi Art*.

2007 Taft, Catherine. "Introducing." *Modern Painters* (November), pp. 58–60.

2003 Politi, Gea. *Come with me,* Prague Biennale 1. Milan: Giancarlo Politi Editore Exhibition catalog.

2000 Pagel, David. "Art Reviews," *Los Angeles Times*, August 25.

1998 Murakami, Takashi. "LA ART." *Studio Voice* (December), p. 114.

AWARDS AND GRANTS

2014 Art Matters, New York

2006 The Asian and Pacific Islander Artist Presenting Initiative (API/2)

2004 The Los Angeles Municipal Art Gallery Associates, The Eungie Joo / REDCAT Award

Wakana Kimura

Born 1978, Izu, Japan

EDUCATION

2011 MFA, Otis College of Art and Design, Los Angeles

2002 BFA, Tokyo University of the Arts, Tokyo, Japan

SELECTED SOLO EXHIBITIONS

2015 "Untitled," LA Artcore, Los Angeles

2012 "iro-iro," Baldwin-Wallace University, Berea, OH

2011 "CHARACTER," Otis College of Art and Design, Los Angeles

2007 "A Matter of Taste," Gallery NEXUS, Kanagawa, Japan

2006 "A Matter of Taste," Gallery NEXUS, Kanagawa, Japan

2005 "Existence as Apiece Relation with the other," Gallery LeDeco, Tokyo, Japan

2004 "A Matter of Taste," Gallery Noraya, Tokyo, Japan

SELECTED GROUP EXHIBITIONS

2014 "Veranda: Contemplating Spaces In Between," Japanese American Cultural & Community Center and Wilshire Boulevard Temple, Los Angeles

2013 AJA Exhibition, George J. Doizaki Gallery, Japanese American Cultural & Community Center, Los Angeles

2011 "US EST," curated by Soo Kim, Pepin Moore, Los Angeles
Otis MFA 2011, Venice 6114, Los Angeles
"Nothing in Common," Otis College of Art and Design, Los Angeles

2010 "Nothing in Common," Otis College of Art and Design, Los Angeles

2002 "Gobidaiten," The Tokyo Metropolitan Art Museum, Tokyo, Japan

Aydinanenth Ortiz

Born 1987, Long Beach, CA

EDUCATION

2014 BA, University of California, Los Angeles
Scholarship for Anderson Ranch Art Center

2010 AA, Photography, Cerritos College, Norwalk, CA

SOLO AND GROUP EXHIBITIONS

2014 "Sunshine and DUIs," Johnny's Saloon, Huntington Beach, CA
"Colorful Babes," W Hotel, Westwood, CA
"Pulling Teeth," UCLA Undergraduate Senior Exhibition, Los Angeles
"That Which Remains," Three-Person Graduate Exhibition with Lizette Olivas and Anabel De Santiago, UCLA Undergraduate Gallery
"UCLA Undergraduate Juried Exhibition," juried by Connie Butler

2013 "Loading Zone," UCLA Undergraduate Senior Exhibition

2012 "UCLA Undergraduate Juried Exhibition," juried by Kimberli Meyer
"Cerritos College Student Art Exhibit," juried by Devon Tsuno

2011 "Through The Lens," solo show, First Fridays Bixby Knolls, Salon Medusa
"Cerritos College Student Art Exhibit," juried by Joe Biel

2010 "Cerritos College Student Art Exhibit," juried by Tyler Stallings

212

Michael Parker

Born 1978, New York, NY

EDUCATION

2009 MFA, University of Southern California, Roski School of Art, Los Angeles

2001 EMT, University of California, Los Angeles, School of Pre-Hospital Care, Los Angeles

2000 BA, Pomona College, Claremont, CA

SELECTED EXHIBITIONS AND PROJECTS

2014 "Steam Egg 2 & Personal Pool: The Rover," Pomona College, Claremont, CA
The Unfinished, at The Bowtie Project, Clockshop and California State Parks, Los Angeles
Hosted: Rafa Esparza's *A Simulacram of Power* and Katie Grinnan's *Astrology Orchestra*, at *The Unfinished*, Los Angeles
Hosted: *The Unfinished (with Skits and Facepaint)*, at Stupid Pills, Hyperion Tavern, Los Angeles
Wellspring Trailhead, The Interpretive Media Laboratory at Los Angeles Historic Site (UCLA–IMLab), Los Angeles State Historic Park
"Another Cats Show," 356 S. Mission, Los Angeles

2013 "Wholesale," Center for Land Use Interpretation, Los Angeles
"The Privilege Show," Control Room, Los Angeles
"Kid's Waiting," with Rocton Woo and Alyse Emdur, Los Angeles Department of Cultural Affairs

2011–13 "Steam Egg," artist's studio, Los Angeles
DJ and HerbJ host at 36 "Steam Egg" events, artist's studio, Los Angeles

2011 "How to Survive," with Alyse Emdur, High Desert Test Sites, Joshua Tree, CA
"Relay, Out the Window," LA Freewaves, Los Angeles

2010 "Intentional and Accidental," USC Roski Gallery, Los Angeles
"Brother Arnold Watches," Sabbathday Lake Shaker Village, New Gloucester, ME

2009 "Lineman: Control the Power—Follow the Energy," USC Roski Gallery, Los Angeles

2008 "Public Release!!*" with the *Journal of Aesthetics & Protest*, Los Angeles
"Feel the Love," with Adam Overton, Machine Project, Los Angeles

2007 "Sound Camp," High Desert Test Sites, Pioneertown, CA

2006–8 "RoutesAndMethods.org," web platform projects

2006–7 Cold Storage, Alameda Industrial Corridor, Los Angeles. Hosted 35 artists' projects, including experimental sound, choreography, book releases, bike riding, festivals, street battles, mapping, and carmadas, in a temporary site in downtown Los Angeles

SELECTED BIBLIOGRAPHY

2015 Meyer, Kimberli, and Sara Daleiden, editors. *Schindler Lab*. Los Angeles: MAK Center for Art and Architecture.

2014 "Rafa Esparza / Elizabeth Sonenberg Interview." *Notes on Looking*.
Purves, Ted, and Shane Aslan Selzer. *What We Want Is Free*. Second edition. Albany: State University of New York.
Parks, Lisa. "'Stuff You Can Kick': Toward a Theory of Media Infrastructures." *Humanities and the Digital*, David Theo Goldberg and Patrik Svensson, eds. Cambridge, MA: MIT Press.
Meltzer, Julia. "The Future of the Unfinished Obelisk." *Artbound, KCET.org*.
Caruth, Allison. "A Brief History of Public Art Along the L.A. River." *Artbound, KCET.org*.
Geoga, Maggie. "The Unfinished: The Meaning of the Obelisk." *Artbound, KCET.org*.
Walsh, Anne. "The Unfinished: The Recumbant Site." *Artbound, KCET.org*.

2013 Wagley, Catherine. "Money in the Art World, from Kickstarter to Michael Ovitz." *LA Weekly*.

2012 "Bottom Entry Sauna, Steam Room, Steam Egg." United States Patent and Trademark Office.
Berardini, Andrew. "Sound, Scent and Steam: Michael Parker's Steam Egg." *ArtSlant, KCET.org*.
Parker, Michael, in conversation with Meghann McCrory. "Why Utopia Now?" *Prism of Reality*.
Cheh, Carol. "Word Is a Virus—New Releases in Artist Run Journals." *Art21 Magazine*.
Tuck, Geoff. "Prism of Reality Launch at X-TRA at For Your Art." *Notes on Looking*.
Kane, Mitchell. *Sploring, i-o-i-p*. Graphic narrative.
Auerbach, Lisa Anne. "Steam Season." *Art21 Magazine*.
"Steam Egg." Project 1, episode 1, season 1. *Artbound, KCET.org*.
Herbst, Robby. "An Oral History of the Steam Egg." *Artbound, KCET.org*.
Laffin, Christelle. "Art Contemporain: L.A. s'éveille." *Le Figaro–Madame*.

2011 Mallouk, Elyse. "Landfill: Part 2, Possible Objects." *Art Practical* 2.11 "Geography Lessons."
Mackler, Lauren. "Steam Egg." *Public Fiction: The Church Issue*.
"Episode 295: Lisa Anne Auerbach and Michael Parker." *Bad at Sports*.

Zittel, Andrea. "How to Survive." *A-Z West Blog.*
Mallouk, Elyse. "How to Survive." *Art Practical.*

PUBLICATIONS

2014 Parker, Michael. "The Unfinished: An Obelisk Along the LA River." *Artbound, KCET.org.*

2010 Parker, Michael. *Balloon Route.* 80-page artist travel book exploring blueprint and iconoclastic utopia.
Parker, Michael. "The Power Class." *Journal of Aesthetics and Protest 7.*

2009 Parker, Michael, Editor-in-Chief. *Lineman.* Artist-book-as-newspaper-as-yearbook.
Parker, Michael. "The Potential of Art in a Micro Society." Graduate Thesis, University of Southern California.

PRIZES AND AWARDS

2014 Center for Cultural Innovation Artists' Resource for Completion Grant, Los Angeles

2010 Printed Matter Award for Artists, New York

2009–10 McComber-Neely Travel Prize, University of Southern California, Los Angeles

2009 Outstanding Teaching Assistant Award, University of Southern California, Los Angeles
Student Recognition Award, University of Southern California, Los Angeles

2000 Flintridge, Senior Thesis Prize, Pomona College, Claremont, CA
Matthew Klopfleish Award, Pomona College, Claremont, CA

Nikki Pressley

Born 1982, Greenville, SC

EDUCATION

2008 MFA, California Institute of the Arts, Valencia, CA

2004 BA, Art/Design, Furman University, Greenville, SC

SOLO EXHIBITIONS

2015 Joline Arts Center, Darrow School, New Lebanon, NY

2013 "Elsewhere in Another Form," Charlie James Gallery, Los Angeles

2011 "forth and back," Thompson Gallery, Furman University, Greenville, SC

2009 "Actions and Contemplations," Las Cienegas Projects, Los Angeles

GROUP EXHIBITIONS

2014–15 "The Avant-Garde Collection," Orange County Museum of Art, Newport Beach, CA

2014 "Spectacular Subdivision," curated by Jay Lizo, High Desert Test Sites, Joshua Tree, CA

2013 "Sunday Collapse," curated by Olga Koumoundouros, 6526 Pollard Street, Los Angeles
"Garden Party," curated by Hadley Holliday and Carolyn Castaño, Fellows of Contemporary Art, Los Angeles

2012 "Fore," curated by Naima Keith, Thomas Lax, and Lauren Haynes, Studio Museum, Harlem, NY
"Shared Threads," California African American Museum, Los Angeles
"Go Tell It on the Mountain," Charlie James Gallery, Los Angeles
"Chiasmus: Zones of Political and Aesthetic Imagination," University of California, Irvine, CA

2011 "Museum as Hub: Steffani Jemison and Jamal Cyrus: Alpha's Bet Is Not Over Yet," The New Museum, New York
Art Platform, Los Angeles
"Black Is the Color of True," Monte Vista Projects, Los Angeles
"Grant v. Lee," Good Children Gallery, New Orleans, LA

2010 California Biennial, curated by Sarah C. Bancroft, Orange County Museum of Art, Newport Beach, CA
"12 Gauge Series," Torrance Art Museum, Torrance, CA

2008 "Conventions and Attitudes," Trade and Row Gallery, Los Angeles
"Domestic Utensils," Coma Art, Los Angeles
"We Want a New Object," CalArts MFA Graduate Group Show, curated by Christine Y. Kim and Malik Gaines, Los Angeles
"Changing Ties: Reconsidering Identity Through Cross-Cultural Interventions," Avenue 50 Gallery, Los Angeles

2007 29025 Eveningside Drive, Val Verde, CA
"The Pyramid Show," Monte Vista Projects, Los Angeles

2006 "Fresh Meat," Furman University, Greenville, SC

2004 "Red Hot Embers, Life and Debt: AIDS and Debt in Africa," DePaul University, Chicago, IL
"Red Hot Embers, Life and Debt: AIDS and Debt in Africa," DePauw University, Greencastle, IN

SELECTED BIBLIOGRAPHY

2012 Glenn, Allison. *Fore.* Exhibition catalog.
Wagley, Catherine. "Burnt Church and Other Sacrilege." *Daily Serving* (January).

10 Artists to Watch, *California Home + Design Magazine* (April 2012).

2011 Anderson, Dick. Prestigious Exhibit Spotlights Pressley's Work. *Furman Magazine* (Winter).

2010 Bancroft, Sarah C. *2010 California Biennial*. Newport Beach, CA: Orange County Museum of Art. Exhibition catalog. Cheng, Scarlet. "2010 California Biennial Spreads the Word," *Los Angeles Times*, November 27.

2009 Davies, Lillian. *Roven #1* (April).

RESIDENCIES, GRANTS, AND AWARDS

2014–15 Artist in Residence, Darrow School, New Lebanon, NY

2014 Nominee, Alice C. Cole Fellowship

2008 CalArts Interdisciplinary Grant
CalArts Alumni Grant
Ahmanson Foundation Scholarship
Donn B. Tatum Scholarship

Project Series Chronology 1999–2015

Compiled by Ian Byers-Gamber and Rebecca McGrew

Soo Jin Kim

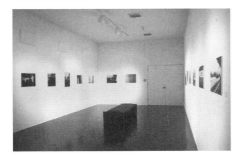

Soo Jin Kim presented new photographs from the series "Speed," "Crowded Skies," and "Air, Land, Sea," and the site-specific installation *Flight*, which echoes travel diagrams found in airline magazines. Reflecting her interests in travel and relocation, and the cultural exchange implicit in both, Kim photographs people on trains, buses, airplanes, and taxis against the background of passing landscapes or reflections of the vehicle's interior. Her work addresses the dislocation of migration, cultural identity, and ideas of place, non-place, and *placelessness* (places that seem the same everywhere).

PUBLICATION
Project Series 1: Soo Jin Kim
Forewords by Marjorie L. Harth
and Alison M. De La Cruz
Essay by Rebecca McGrew
Design by Michael Worthington

PROGRAMMING
Lecture in coordination with Asian American Resource Center and photography courses

Liz Young

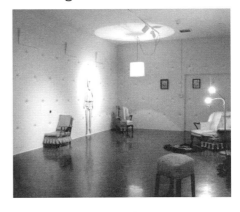

Liz Young's installation *Happy Hide Better Blood* grappled with issues of the body, physicality, and scale. Two rooms—one loosely representing the idea of "flesh," the other "blood"—were linked by a red beaded curtain and by a small hole in the wall next to two altered chairs. These passages simulated the rupture of a wound—where the substances of flesh and blood come into contact. Young accompanied her exhibition with performances that she calls "live procedures," rudimentary activities that refer to the objects and spaces of her installations.

PUBLICATION
happy hide better blood
Text and Poetry by Liz Young
Design by Esperanza Garcia

PROGRAMMING
Installation of exhibition assisted by Art in Context course

PROJECT SERIES 03
Stas Orlovski

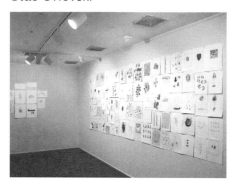

AUGUST 31— OCTOBER 17, 1999

Stas Orlovski's exhibition consisted of new drawings inspired by nineteenth-century accounts of mesmerism, animal magnetism, and hypnosis. Pinned to the wall in groupings, the small drawings functioned like visual memories, transitory thoughts, and a highly personal history of the human body based on memory. Orlovski's archive of images includes absurd nose jobs, fictitious afflictions, superstitions, birthmarks, blemishes, and botanical studies.

PUBLICATION
Project Series 3: Stas Orlovski
Interview by Mary-Kay Lombino
Design by Amanda S. Washburn

PROGRAMMING
Lecture and workshop for drawing courses

PROJECT SERIES 04
Nancy Kyes

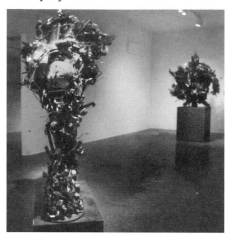

NOVEMBER 2— DECEMBER 19, 1999

Nancy Kyes presented two sculptures from the series "blackbody radiation/DISH." Kyes creates her sculptures by hand, binding and packing objects onto large armatures, manipulating and weaving together the discrete objects to create a singular entity. *Black Box #1* and *Black Box #2* are massive accumulations of hundreds of found objects. The sculptures blend the attraction of everyday materials with metaphysics, personal experience, and current scientific theories, including wave/particle theory, chaos theory, and systems theory.

PUBLICATION
Blackbody Radiation/DISH
Interview by Rebecca McGrew
Design by Steve Comba

PROGRAMMING
Lecture and workshop for physics and sculpture courses

PROJECT SERIES 05

Lynne Berman and Kathy Chenoweth

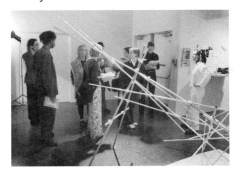

JANUARY 18—FEBRUARY 20, 2000

Lynne Berman and Kathy Chenoweth's installation *The Distratic Institute for Modu-Port Studies Presents: The Pomona College Beta Test* and accompanying performative *Work-Sites* addressed work and mobility through absurdity. Their project focused on the rhythms, rituals, and routines endemic to middle-class American society. The artists worked at the museum two days a week. Eight *Work-Sites* were scheduled at locations around Pomona College; students, faculty, and staff performed as Guest Workers in *Work-Stations* or *Modu-Ports* designed for worker interaction and education.

PUBLICATION
The Distratic Institute for Modu-Port Studies Presents: The Pomona College Beta Test
Essays and texts by Gordon Haines, Lynne Berman, and Kathy Chenoweth
Design by Lynne Berman and Kathy Chenoweth

PROGRAMMING
Performances presented at various campus locations including math, art, and English departments

PROJECT SERIES 06

Dinh Q. Lê

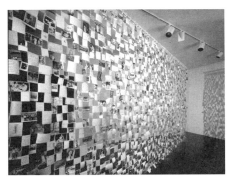

MARCH 4— APRIL 9, 2000

The photographic installation *Mot Coi Di Ve* and the two-channel video installation *Snake Juice* comprised Dinh Q. Lê's exhibition. Lê bought thousands of old family photo albums in Ho Chi Minh City in the hopes of finding the photo albums that his own family abandoned when they escaped from Vietnam to Thailand in 1978. The artist attached thousands of these found black-and-white photographs together, creating a story-quilt that hung from the ceiling to the floor. Lê inscribed the backs of all the photographs with texts from three different sources: *The Tale of Kieu*, written by Nguyen Du, who is considered Vietnam's greatest poet; excerpts from interviews with Vietnamese-Americans about their experiences, from the book *Hearts of Sorrow: Vietnamese-American Lives*; and excerpts from letters from soldiers and their wives during the Vietnam War. Focusing on contemporary life in Ho Chi Minh City, *Snake Juice* juxtaposes a traffic scene on the busy streets with the making of the traditional curative Snake Alcohol.

PUBLICATION
True Journey Is Return
Essay by Rebecca McGrew
Design by Steve Comba

PROGRAMMING
Lecture in coordination with Asian American Resource Center

Elizabeth Saveri

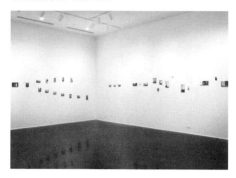

AUGUST 29— OCTOBER 15, 2000

Elizabeth Saveri brought together four series of paintings, including *The Claremont Series*. This new site-specific painting installation, consisting of 35 paintings that range in size from 1½ inch square to 8 by 10 inches, chronologically represented the artist's association with Pomona College. Melding the languages of film, photography, and painting, Saveri combines depictions of places she inhabits and objects she observes, or thinks about, while moving through those spaces. Influenced by the film industry of her native Los Angeles, Saveri uses a variety of filmic strategies in her paintings, such as close-ups, pan shots, and blurs.

PUBLICATION
Project Series 7: Elizabeth Saveri
Essay by Colin Gardner
Design by Steve Comba

PROGRAMMING
Lecture for painting courses

Jody Zellen

NOVEMBER 4— DECEMBER 17, 2000

Jody Zellen's outdoor installation of 11 large-scale digital banners explored the city and its history in colorful, gridded images. Mounted on the museum's facade and on Thatcher Music building, her grainy, fragmented images of architecture and the urban environment generated a dialogue between the real and the imagined city. Zellen appropriates and alters texts, selected from critical writings about architecture and urban theory, and images drawn from the media and popular culture.

PUBLICATION
Jody Zellen: Gridded Paths
Essay by Colette Dartnall
Design by Jody Zellen

PROGRAMMING
Lecture for photography courses

Ashley Thorner

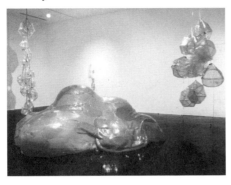

JANUARY 20 — FEBRUARY 25, 2001

Ashley Thorner presented new sculptures, including the large-scale *Beware of the Blob* and four "chandelier" sculptures: *Pink Love Lotus*, *Blue Love Lotus*, *Synthetic Green*, and *Neon Pink*. Thorner created their glistening surfaces, synthetic colors, and globular shapes using vinyl, glitter, candy, latex, cow gut, and liquid plastic. Her technique is intensely laborious; for example, she used the head of a pin to place thousands of tiny dots on her chandeliers. Her sculptures evoke Eva Hesse's process-oriented, anti-form sculptures; Claus Oldenburg's playful transformation of manufactured objects; and science-fiction cartoons and 1950s monster movies like *The Blob*.

PUBLICATION
Ashley Thorner: Dots, Blobs, and Chandeliers
Essays by Rebecca McGrew and
Doug Harvey
Design by Steve Comba

PROGRAMMING
Lecture and workshops for sculpture
courses

Anne Bray and Molly Cleator

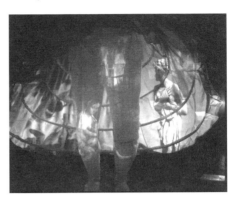

MARCH 10 — APRIL 8, 2001

Anne Bray and Molly Cleator's video installation *Pressure Drop* placed the viewer underneath a woman's room-sized skirt. The audience was forced to look through her skirt to see the video footage that was projected onto the woman's body and the wall behind her. In the video, a man cuts down flowers with a weed wacker. The woman's lower torso and legs are fashioned from inflated material that expands and deflates, suggesting her struggle to resist the overwhelming force of the images projected onto her. Bray and Cleator's video projection addresses gender, power, community, and mass- mediated society.

PUBLICATION
Anne Bray and Molly Cleator: Pressure Drop
Essay by Holly Willis
Design by Steve Comba

PROGRAMMING
Student presentations for panel in
coordination with photography and
media studies courses

221

Edgar Arceneaux

SEPTEMBER 4— OCTOBER 21, 2001

In his installation *The Trivium*, Edgar Arceneaux combined drawings in graphite on vellum with objects from his studio, such as pencils, tape, scissors, and mailing tubes, to explore identity, history, and popular culture. Arceneaux uses language to inscribe a territory and construct a narrative situation or voice that is highly inflected and subjective. The installation at Pomona linked Dante's *Inferno* and Socratic philosophy with the music of Thelonious Monk, Pharoahe Monch, and Pharoah Sanders, juxtaposing the intellectual histories of Western society with hip-hop and jazz music.

PUBLICATION

Edgar Arceneaux: The Trivium, a Socratic Model of Understanding
Essay by Franklin Sirmans
Interview by Vincent Johnson
Design by Edgar Arceneaux and Steve Comba

PROGRAMMING

Lecture for drawing and history of African American art courses

222

Charles LaBelle

NOVEMBER 3—DECEMBER 16, 2001

Charles LaBelle's exhibition included the immersive video installation *Horror of Light*, which consists of footage shot during repeated journeys through the mile-long Eisenhower Tunnel in Colorado. LaBelle also presented two photographs from the "Illuminated Mounds" series, which were made using long nighttime exposures at empty construction sites. By moving lights over piles of dirt, he essentially painted the mounds with light. In both projects, LaBelle explores the literal and figurative search for illumination that is implicit in the notion of the road trip, the search for the light at the end of the tunnel, and the transformative potential of a journey through the "underworld."

PUBLICATION

Charles LaBelle: Horror of Light
Essay by Charles LaBelle
Design by Charles LaBelle and Steve Comba

PROGRAMMING

Lecture and video presentation for drawing, sculpture, and installation courses

PROJECT SERIES 13
Hilja Keading

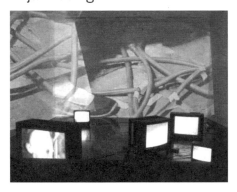

Hilja Keading's nine-channel video instal-
lation, *Backdrop*, reflects her longstanding
interest in issues of desire, illusion, per-
formance, childhood joys and fears, and
complex adult psychological dramas. The
work contains elements of the performative,
ranging from the artist herself performing
for the camera to her filmed documents
of events such as circus acts and rodeo
performances. Keading investigates the
impact of experience and memory on
judgment and examines the constructs
of illusion and perfection—those stories,
products, and other fabricated realities
that drive one to search for an illusionary
goal, that distract one from the truth, or
that falsely promise control over one's life.

PUBLICATION
Backdrop
Essay by Carol Ann Klonarides
Design by Steve Comba and Hilja Keading

PROGRAMMING
Lecture for new media and media
studies courses

PROJECT SERIES 14
Charles Timm-Ballard

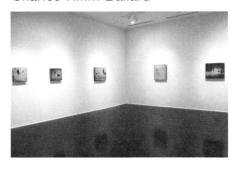

MARCH 10—APRIL 7, 2002

Ten new works by Charles Timm-Ballard
explore the interplay between the earth-
bound, sculptural quality of ceramics and
the more ethereal realm of landscape paint-
ing. Timm-Ballard transformed earth—
minerals, mud, rocks—into landscape
images built up through layers of porcelain,
stoneware slip, rust, and chunks of slag.
After an initial firing, he inscribed the
surface, drawing images and geometric
divisions, and pressing in plant roots to
create tree-like forms. Using the kiln as
a painting tool, he layered glazes and
metal oxides in sequential firings until he
achieved the desired level and depth
of color.

PUBLICATION
Charles Timm-Ballard: Fused
Essay by Rebecca McGrew
Design by Steve Comba

PROGRAMMING
Lecture for painting and drawing courses

223

PROJECT SERIES 15
Jason Rogenes

SEPTEMBER 3–OCTOBER 20, 2002

Jason Rogenes's installation, *project 9.03g*, incorporated post-consumer waste, such as Styrofoam, cardboard, and tape, in a dramatic exploration of scale and a blurring of the boundaries between sculpture and architecture. Contrasting industrialization and space technology with low-tech packing materials, Rogenes employs a handmade aesthetic that begins with his collecting of cast-off materials, continues in the intuitive process of carving and gluing, and culminates in the careful balance of glowing white Styrofoam sculptures nestled in cardboard caves.

PUBLICATION
Project Series 15: Jason Rogenes
Essay by Julie Joyce
Interview by Philip Martin
Design by elle + elle, Los Angeles

PROGRAMMING
Lecture and workshop for sculpture courses

PROJECT SERIES 16
Mark Bradford

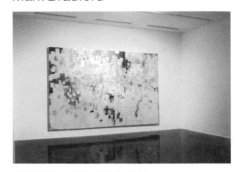

NOVEMBER 2—DECEMBER 15, 2002

Mark Bradford's *Don't Be Fooled by the Rocks I Got* is a mixed media work on panel in three parts. The painting incorporates materials associated with the beauty industry: endpapers for hair permanents provide both texture and formal structure, while cellophane hair color gives the canvases incandescent hues. Collaged material on the surface of the painting references hip-hop culture and street life, such as text from flyers found in the artist's neighborhood, torn strips of posters, and ink stamps. By bringing together his experiences as an artist, a beauty operator, and a cultural historian, Bradford links the art-historical traditions of Minimal abstraction with a pop-culture look at Black aesthetics.

PUBLICATION
Project Series 16: Mark Bradford
Essay by Eungie Joo
Design by Steve Comba

PROGRAMMING
Lecture for history of African American art and painting courses

PROJECT SERIES 17
Steve Roden

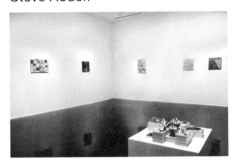

Steve Roden's "the another silent green world" encompassed new drawings, paintings, sculptures, and a sound piece. The works examine translation as a process of fracturing words and images into pieces and transferring them from the printed page to a new context. Roden's "silent world" paintings were created using a system of letter-to-measured-line equivalence: a = 1-inch line, b = 2-inch line, etc. Each painting contains a visual translation of the title of oceanographer Jacques Cousteau's first book, *The Silent World*. Roden made the *another another green world* sculptures with his eyes closed, listening to different pieces of music from Brian Eno's *Another Green World*.

PUBLICATION
steve roden: the another silent green world
Introduction by Steve Roden
Design by Steve Roden

PROGRAMMING
Lecture and workshop for sculpture and ceramics courses

PROJECT SERIES 18
Christina Fernandez

Christina Fernandez's seven photographs from the "Lavanderia" series capture the movement of people in storefronts in East Los Angeles. Working at night, she used a 4 × 5 view camera with very long exposures, which enabled her to capture simultaneously the domestic activity within the building and the graffiti on its windows. The graffiti's calligraphic flow mirrors the lyrical physical movements of the people inside the buildings. Fernandez explores the personal and historical, utilizing a formal, frontal aesthetic that expands on the documentary traditions of photography.

PUBLICATION
Project Series 18: Christina Fernandez
Text by Christina Fernandez
Design by Steve Comba

PROGRAMMING
Lecture for photography courses

225

Abdelali Dahrouch

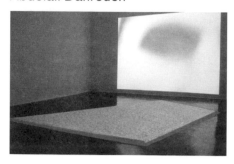

AUGUST 30—OCTOBER 12, 2003

Abdelali Dahrouch's video installation *Desert Sin, Revisited* examined the complex sociopolitical relations between the United States and the Middle East. Dahrouch revisited the powerful media images in his 1995 video installation *Desert Sin*, which he created in response to the 1991 Gulf War. Dahrouch projected on the wall the original footage of United States government officials, Iraqi parents, and dead soldiers. He also included new components: a floor piece made out of loose plaster upon which is impressed a fragment of text from the neoconservative think tank Project for the New American Century, a projection on the plaster surface of images of sand blowing, and the subtle sound of desert winds commingled with distorted excerpts from speeches by George W. Bush.

PUBLICATION
Abdelali Dahrouch: Desert Sin Revisited
Essay by Laura Kuo
Design by Jaeger Smith

PROGRAMMING
Lectures for photography, new media, and Asian American studies courses

Pauline Stella Sanchez

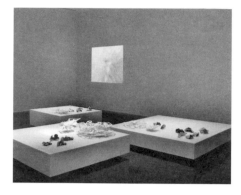

OCTOBER 25—DECEMBER 21, 2003

Pauline Stella Sanchez's *…self-portrait… with notes and opera light* video, three sculptural arrangements entitled *Sun helmutbonnethalo prototypes that are to be solitarily made of water with ubu stairs…*, and one of her "Surrogate Sun" paintings explored systems of art and production and mythologies of the sun. The video consists of footage from an art history lecture by Sanchez interspersed with flowers, sun imagery, and a fabricated photograph of the artist on the sun. The sculptures—small wooden quasi-Cubist "staircase" structures and hand-modeled, cartoon-color glazed porcelain objects that play with notions of use for a "helmet," a "bonnet," and a "halo"—were arrayed atop floating wooden pedestals.

PUBLICATION
Pauline Stella Sanchez: sun spectacle works
Essay by Carol Jackson
Design by Trevor Hernandez

PROGRAMMING
Lecture for drawing, painting, and sculpture courses

226

PROJECT SERIES 21

Sandeep Mukherjee

JANUARY 20 — FEBRUARY 22, 2004

Sandeep Mukherjee's monumental drawing installation conflated Asian landscape painting conventions with soft washes of airbrushed surfaces and the lyricism of narrative content. In fields of glowing color, Mukherjee's figures and forms float through an inscrutable space. He created these works with a precise and painstaking process—sheets of Duralene (a translucent vellum-like paper) were airbrushed with brilliant hues, then the opposing surface was delicately drawn with fine pencils. He embossed both sides with scribing/etching tools, which disrupted the surface plane and created a linear relief sculpture.

PUBLICATION

Sandeep Mukherjee: New Work
Essay by Christopher Miles
Design by Jaeger Smith

PROGRAMMING

Lecture and workshop for drawing courses

PROJECT SERIES 22

Shirley Tse
Power Towers

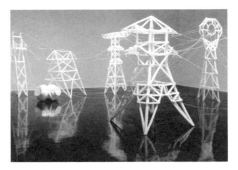

MARCH 6 — APRIL 4, 2004

Shirley Tse's sculptural installation *Power Towers* examined the sociological and cultural association of plastic as an everyday consumer packing material and its philosophical associations with fluidity, multiplicity, paradox, and contingency. Consisting of six sculptures made of high-density polyethylene linked with plastic wires and plugged with Silly Putty, *Power Towers* represented a selection of types of transmission towers from around the world and a brief tour of the construction style of towers through history. Tse's installation brought together the history of plastics, electricity, technology, and creative thought.

PUBLICATION

Shirley Tse Power Towers
Essay by Christopher Miles
Design by Jaeger Smith

PROGRAMMING

Lectures and workshop for sculpture and installation courses

227

PROJECT SERIES 23

Allan deSouza: The Lost Pictures

AUGUST 31—OCTOBER 10, 2004

Allan deSouza presented work from the series "The Lost Pictures," which utilizes slides his father took during the artist's childhood in Nairobi, Kenya. DeSouza printed the images and taped them onto surfaces around his home, where they became coated with bodily fluids, dust, food, hair, and toothpaste. He scanned the worn and marred images, digitally manipulated them, and then printed large-scale photographs. His method super-imposes the scrim of daily life on the image, emphasizing the surface and obscuring the family photographs hovering behind. In the sculpture *House*, deSouza built a scale model of his childhood home, burned the exterior, and gradually covered the remains in layers of wax and detritus. Over time, he carved into these accretions, excavating the house and exposing surfaces and accumulated materials.

PUBLICATION

Allan deSouza: The Lost Pictures
Essays by Eve Oishi and Allan deSouza
Design by Jaeger Smith

PROGRAMMING

Lecture for drawing and photography courses

PROJECT SERIES 24

Amy Myers

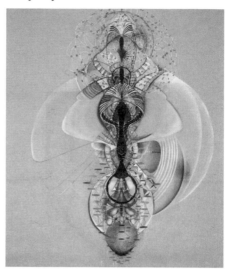

OCTOBER 24—DECEMBER 19, 2004

Amy Myers creates intricate yet monu-mental graphite and gouache drawings in a visionary blending of art, mathematics, and physics. *The Opera Inside of the Atom* is based on a musical composition by Myers. The artworks include references to physics' four fundamental forces of nature—the strong, the weak, electromag-netism, and gravity—and move back in time, before the moment of the Big Bang, to string theory's original ten-dimensional super-symmetrical universe. Myers's drawings are highly complex and loosely symmetrical networks of forms and sys-tems of activity that shift in perspective and scale and reference models of altered states of consciousness.

PUBLICATION

Project Series 24: Amy Myers
Essay by Robert A. Sobieszek
Design by Jaeger Smith

PROGRAMMING

Lecture for drawing, painting, and ceramics courses

228

PROJECT SERIES 25

Karen Carson:
Fires

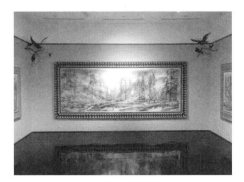

JANUARY 22— FEBRUARY 27, 2005

Depicting the emotional and elemental effects of forest fires, Karen Carson's series of paintings and light boxes stemmed from a year in which wildfires ravaged the West. The installation of paintings—executed on transparent silk in fabric dyes and acrylic and metalic washes—and layered, transparent Plexiglass light boxes, alluded to nineteenth-century Victorian theatricalism and the Romantic landscape tradition. In this work, Carson tackles the representation of "nature" as a manifestation of the sublime, as seen by a fast-paced, techno-logical, consumerist culture.

PUBLICATION
Karen Carson: Fires
Essay by Kristina Newhouse
Design by Jaeger Smith

PROGRAMMING
Lectures for painting and drawing courses

PROJECT SERIES 26

Judie Bamber:
Further Horizons

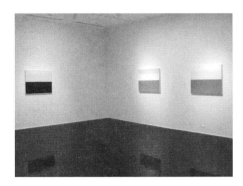

MARCH 5— APRIL 10, 2005

In "Further Horizons," Judie Bamber presented new paintings in the plein-air tradition. In a shift away from earlier works that used photographs as source material, the artist made watercolor studies of the Pacific Ocean from her former home in Malibu, then translated those images into oil paintings. The seascape paintings, rendered in subtle washes of color, oscil-late between minimalist abstractions and illusionistic images, recording the enduring yet constantly shifting relation-ship of the colors of the sea and sky.

PUBLICATION
Judie Bamber: Further Horizons
Essay by Nayland Blake
Design by Jaeger Smith

PROGRAMMING
Lecture and workshop for painting and drawing courses

Kaz Oshiro

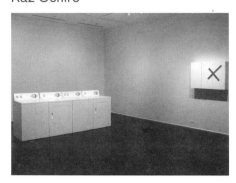

AUGUST 23— OCTOBER 9, 2005

Kaz Oshiro transforms paint and canvas into domestic and utilitarian objects that blur the boundaries between painting and sculpture, illusion and function. His sculptures appear to be exact replicas of appliances, cabinetry, or electronics, but are painstakingly made with a painter's traditional tools of oil and canvas, supplemented with Bondo, a material commonly used by car refinishers. Oshiro's installation featured life-sized replications of washers, dryers, and wall cabinets. He meticulously constructed their three-dimensional reality from two-dimensional surfaces, yet revealed the underlying structure of the illusion by allowing a view of the canvas and stretcher bars beneath.

PUBLICATION
Project Series 27: Kaz Oshiro
Essay by Michael Duncan
Design by Jaeger Smith

PROGRAMMING
Lecture and workshop for sculpture, photography, and painting courses

Jared Pankin

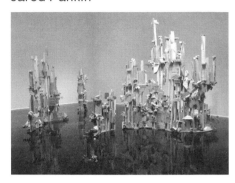

OCTOBER 22— DECEMBER 18, 2005

Mining a terrain of political and ecological urgency, Jared Pankin's *Long in the Tooth (Snaggleteeth)* installation linked his past adherence to formal sculptural qualities and pressing ecological issues to investigations of the forms of construction. The work united the modularization of the building trades—the repetition of architectural forms to produce cost-efficient and streamlined structures—and sustainable materials, such as found or reclaimed wood and lumber. The wooden armature and layered accretions of wood in *Long in the Tooth (Snaggleteeth)* evoke barren and rugged mountain ranges; the pinnacles, spires, and arches of canyons; and the jutting curves of coral reefs.

PUBLICATION
Jared Pankin
Essay by Doug Harvey
Design by Jaeger Smith

PROGRAMMING
Lecture and workshop for sculpture courses

PROJECT SERIES 29

Machine Project
Guide to Cultural History
& the Natural Sciences

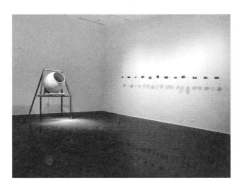

JANUARY 21— APRIL 9, 2006

Machine Project, an educational arts organization founded by Mark Allen, presented a series of events planned by artists. The exhibition featured a floral volcano by Holly Vesecky, Brian Crabtree and Kelli Cain's egg-tapping robots, Ryan Taber and Cheyenne Weaver's *Raft of the Medusa* transforming into a printing press, and Phil Ross's post-industrial time machine. Focusing on artistic process, experimentation, and student participation, the exhibition flowed continually from one installation into the next, with a series of public events for each artist's project. This exhibition marked Machine Project's first museum residency.

PUBLICATION

Machine Project Guide to Cultural History & the Natural Sciences
Essays by Mark Allen and Jason Brown
Design by Kimberly Varella

PROGRAMMING

Lecture by Brian Crabtree and Kelli Cain; workshop and lecture by Ryan Taber and Cheyenne Weaver; cement mixer demonstration and lecture by Phil Ross; construction of exploding flower pyramid by Holly Vesecky

PROJECT SERIES 30

Ken Gonzales-Day:
Hang Trees

SEPTEMBER 10— OCTOBER 22, 2006

Ken Gonzales-Day's exhibition "Hang Trees" was comprised of photographs from three related bodies of work that look at the representation of Latinos in the history of the American West. His project began as a photographic study of portraits of Latinos in California from 1850 to 1900. Gonzales-Day discovered that the earliest photographs he found were of criminals condemned to die, and later photographs were of lynchings. This research culminated in both the works on view in the exhibition and in the book *Lynching in the West: 1850–1935*. The exhibition included digitally altered historical postcards of lynchings in which the victim has been erased; "Hang Trees," photographs of lynching trees presented in the classic tradition of landscape photography; and photographic portraits of Latino men that resist the erasure of the Latino subject.

PUBLICATION

Ken Gonzales-Day: Hang Trees
Essays by Rita Gonzalez and
Ken Gonzales-Day
Design by Jaeger Smith

PROGRAMMING

Lecture and book signing in coordination with Latino Studies Center

231

PROJECT SERIES 31

Katie Grinnan
The Rise and Fall

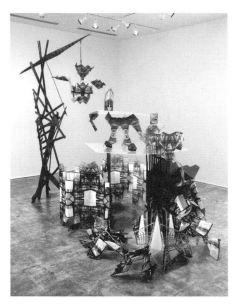

NOVEMBER 5— DECEMBER 17, 2006

"The Rise and Fall" included five works by Katie Grinnan related to her project *Rubble Division*. Emphasizing movement, transformation, renewal, and ruin, the project exists in multiple forms, proliferating its own mythology through sculpture, video and language. Two videos—*Rise and Fall* and *Rubble Division Interstate*—document different components of the project; and two interconnected sculptures—*Tower Story* and *Crane*—involve the collision of physical, photographic, psychological, and political space. An artist book compresses all the components of *Rubble Division*, acting as a record of the project.

PUBLICATION
Rubble Division
Essays by Michael Ned Holte and
Robby Herbst
Design by Katie Grinnan

PROGRAMMING
Lecture and workshop for sculpture, photography, and digital new media courses

PROJECT SERIES 32

Liat Yossifor
The Tender Among Us

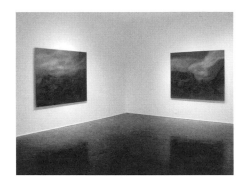

JANUARY 23— APRIL 7, 2007

Liat Yossifor's exhibition "The Tender Among Us" included a suite of four black, deep blue, and dark umber monochromatic paintings and several sketches based on war imagery and the processes of painting. Her paintings consist of abstracted scenes of layered, prone bodies or several figures in conflict—the torsos, legs, and backs alluding to the hills and valleys of the landscape. Inspired by Jacques Callot's 1633 etchings *The Miseries and Misfortunes of War*, Francisco Goya's 1810–20 etchings *Disasters of War*, El Greco's 1608–14 painting *Laocoon*, and Theodore Gericault's 1819 painting *The Raft of the Medusa*, Yossifor used a wet-on-wet oil painting technique to render the emotionally charged and complicated subjects of war and its victims.

PUBLICATION
Liat Yossifor: The Tender Among Us
Essay by Kristina Newhouse
Design by Jaeger Smith

PROGRAMMING
Lecture and workshop for painting courses

PROJECT SERIES 33

Jessica Bronson

SEPTEMBER 4— OCTOBER 21, 2007

Jessica Bronson presented two LED-based text works, *perpetual perceptual (speculative spectrum)* and *for Helen Keller*. Both works reflect her ongoing interest in linking the science of perception and art practice. The moving text installations employ the phenomenon of retinal painting, and each work emits words and sentence fragments from sources related to color theory and perception. In *perpetual perceptual (speculative spectrum)*, Bronson references Sir Isaac Newton's and Johann Wolfgang von Goethe's investigations of color perception. The text "an incidental result for/of an elemental principle" flashes in red, orange, yellow, green, blue, and violet. In *for Helen Keller*, an all white LED flashes "remain colorless," referring to white pigment as the absence of color, white light as the combination of all the colors of the visible spectrum, and blindness.

PUBLICATION
Project Series 33: Jessica Bronson
Interviews by Anoka Faruqee, Shirley Tse, and Benjamin Weissman
Design by Jaeger Smith

PROGRAMMING
Lecture for new media and photography courses

PROJECT SERIES 34

Iva Gueorguieva

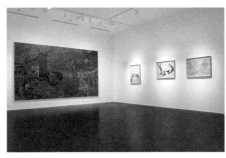

OCTOBER 27— DECEMBER 16, 2007

Iva Gueorguieva's exhibition included two new paintings, *Olympia* and *Dead Matador*, and several drawings. Her abstract canvases are grounded in Modern art history, philosophy, and contemporary painting. The artist is inspired by the powerful expressions of emotion and humanity by artists such as Edouard Manet, James Ensor, and Francisco Goya. In her fracturing of multiple spaces, layering of simultaneous narratives, and liberation from a pre-Modern, or Renaissance, space, Gueorguieva's paintings also allude to Cubism, Fauvism, Futurism, and German Expressionism. She titled her *Olympia* after Manet's iconic work of 1863, in honor of his attack on nineteenth-century bourgeoisie mores and sensibilities.

PUBLICATION
Project Series 34: Iva Gueorguieva
Essay by Rebecca McGrew and Rochelle LeGrandsawyer
Design by Jaeger Smith

PROGRAMMING
Lecture and workshop for painting and drawing courses

233

PROJECT SERIES 35

Evan Holloway

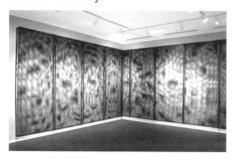

MARCH 1— MAY 17, 2008

Evan Holloway transformed the gallery into a sculptural and perceptual installation. Drawing on sources such as Minimalist sculpture, Light and Space art, Op art, and Conceptual art, Holloway's untitled installation created dramatic optical— almost psychedelic—effects from the most ordinary of materials, including steel panels, newspaper sheets, and painted cardboard. The accompanying artist-designed newsprint publication, *Analog Counterrevolution*, was an integral component of the exhibition, and its pages of printed dots covered the gallery walls. This "newspaper" served as art object, artist book, and, potentially, takeaway wallpaper, gift wrap, and craft material for the viewer.

PUBLICATION

Analog Counterrevolution
Interview by Bruce Hainley
Design by Art Design Office

PROGRAMMING

Lectures and workshops for installation courses culminating in students assisting in fabrication and assembly of wallpaper component of installation

234

PROJECT SERIES 36

Predock_Frane Architects

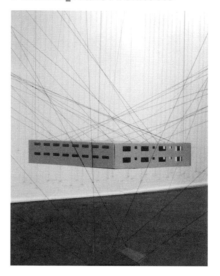

SEPTEMBER 2— OCTOBER 19, 2008

Predock_Frane Architects was established by Hadrian Predock and John Frane in 2000 as a collaborative research and development architecture and design studio. Their exhibition, "Inland Empire," reflected the artists' interpretation of components of the built environment common in the decentered landscapes of the Inland Empire: regional depot buildings, big-box retail stores, mini-malls, housing, and the corresponding network of transportation corridors. "Inland Empire" incorporated everyday materials— thread, string, foam core, wood—into an installation that indexed the existing mass of materials, subjects, and structures within the designated research locality.

PUBLICATION

Predock_Frane Architects: Inland Empire
Essay by Brooke Hodge
Design by Anne Swett-Predock

PROGRAMMING

Lectures for installation and new media courses culminating in students assisting in installation

PROJECT SERIES 37
Ben Dean

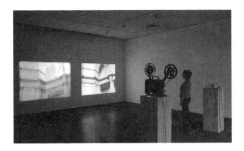

NOVEMBER 1— DECEMBER 21, 2008

Ben Dean's multimedia installation *Account* and six related C-prints investigated the history and theory of Modernism, early film history, structural film, video art, and the growing prevalence of computer-generated imagery. Dean chose three sites in the San Francisco area: Islais Creek, San Francisco City Hall, and Pacific Shores Center. Using a dual projection format, he filmed the sites then digitally re-created each film using strict rules and parameters as guides. At the two outdoor locations, Dean completed filming by launching the camera into the sky, using a protective framework for the camera and a catapult that he designed and fabricated. As the camera ruptures the visual plane, the viewer experiences an awareness of dimensionality and physical presence.

PUBLICATION
Ben Dean: Account
Essays by Glenn Phillips and Ben Dean
Design by Lausten & Cossutta Design

PROGRAMMING
Lecture and workshop for photography, sculpture, and new media courses

PROJECT SERIES 38
Constance Mallinson
Nature Morte

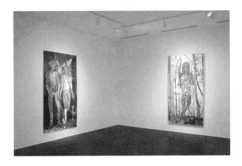

AUGUST 25— OCTOBER 18, 2009

Constance Mallinson's richly detailed paintings in "Nature Morte" examine how we construct meaning from nature and situate ourselves in nature, especially in an increasingly urbanized world. Her still life imagery comes from arrangements and compositions of decaying natural materials she collects on daily walks. Combining the beautiful and the grotesque, the life-size works, painted in oil on paper or plywood, depict figurative imagery, such as a pile of twisted dead branches resembling severed limbs, a naked couple composed of twigs and logs, and an exacting recreation of Manet's *Olympia* in natural materials, including palm fronds, bark, branches, dried moss, and flowers.

PUBLICATION
Constance Mallinson: Nature Morte
Essays by Rebecca McGrew and Michael Duncan
Design by Lausten & Cossutta Design

PROGRAMMING
Lecture and workshop for painting courses

235

PROJECT SERIES 39

Rachel Mayeri
Primate Cinema

OCTOBER 31— DECEMBER 20, 2009

Working at the intersection of art and science, Rachel Mayeri observes human nature through the lenses of media studies, primatology, video art, and film history. Mayeri presented work from "Primate Cinema," a video series that deals with primates and their on-screen dramas. The exhibition included the two-channel installations *Baboons as Friends*, which contrasts field footage of baboons with human actors reenacting the primate footage, and *How to Act Like an Animal,* which juxtaposes footage from Jane Goodall's 1995 National Geographic special program *The New Chimpanzees* with performers reenacting a clip from this documentary.

PUBLICATION
Primate Cinema Rachel Mayeri
Essays by Rebecca McGrew and
Doug Harvey
Interview by Deborah Forster
Design by Department of Graphic Sciences

PROGRAMMING
Lectures for installation and new media courses

PROJECT SERIES 40

Amanda Ross-Ho

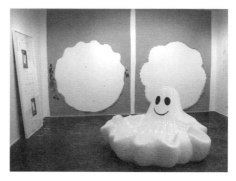

JANUARY 23— APRIL 11, 2009

Amanda Ross-Ho's "The Cheshire Cat Principle" consisted of a site-specific installation of large-scale cut-canvas paintings, altered sheetrock slabs and gallery walls, photographs of collaged arrangements on her studio walls, and fabricated objects mirrored in the photographs. The exhibition title alludes to Lewis Carroll's *Alice's Adventures in Wonderland* (1865), which features the familiar grinning Cheshire Cat; Carroll's sequel, *Through the Looking-Glass and What Alice Found There* (1871); and a paradoxical theory within quantum physics that describes variables within visibility. The exhibition wove together residue from earlier works, fictional versions of studio vignettes, and traces of works completed but not yet seen. These gestures of absence were punctuated by an enlarged reproduction of a ghost-shaped candy dish, which emblematizes Ross-Ho's fascination with inversions, translations, and visibility.

PUBLICATION
Amanda Ross-Ho: The Cheshire Cat Principle
Essay by Angie Keefer
Design by Dexter Sinister

PROGRAMMING
Lecture and workshop for photography and new media courses

PROJECT SERIES 41
Ginny Bishton

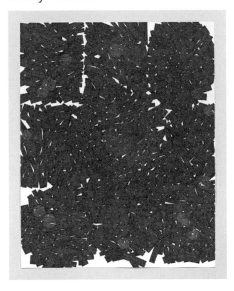

AUGUST 31— OCTOBER 17, 2010

Ginny Bishton's exhibition featured work from two series: large, vibrant collages composed of colorful circles and minimalist, grid-based pen-and-ink drawings comprised of tens of thousands of marks. Her practice links cooking, gardening, hiking, and reading with conceptualism, minimalism, photography, and drawing. Based on her daily life and routines, Bishton works on a continuum, considering every element of her artistic process, from garden to kitchen to studio. For example, she grew vegetables and fruits for her homemade soups, which she then photographed. She cut the photographic prints into precise circles and collaged them together. Her intricate, hand-gridded drawings, consisting of overlapping layers of cross-hatched bands of four different colors of ink—violet, red, green, and purple—on large sheets of gesso-primed paper, convey both delicacy and mass.

PUBLICATION
Project Series 41: Ginny Bishton
Essay by Sonia Campagnola
Design by Victoria Lam

PROGRAMMING
Lecture for photography courses

PROJECT SERIES 42
M.A. Peers

OCTOBER 20— DECEMBER 19, 2010

For her exhibition, M.A. Peers presented portraits of dogs and a singular abstract painting. In the abstraction, she utilized an unrestrained style of mark making and saturated fields of color. In the dog paintings, Peers examined pictorial structure and form through portraits of competitive whippets. In the aesthetic world of dog shows and dog breeding, the "look" is often the final arbiter of success. Peers captures in paint the formal relationships between the parts of each dog's body, exemplifying the physical variations within the vision of what makes an ideal breed.

PUBLICATION
Project Series 42: M.A. Peers
Essay by Doug Harvey
Design by Kimberly Varella, Department of Graphic Sciences, Los Angeles

PROGRAMMING
Panel discussion with M.A. Peers and Steve Roden, moderated by Doug Harvey

237

In the Shadow of Numbers: Charles Gaines Selected Works from 1975–2012

SEPTEMBER 4— OCTOBER 21, 2012

The survey exhibition "In the Shadow of Numbers: Charles Gaines Selected Works from 1975–2012" was co-curated by Rebecca McGrew and Ciara Ennis and presented in collaboration with Pitzer Art Galleries at Pitzer College. The exhibition consisted of photographs, sculptures, video, and drawings from five series: "Explosions," "History of Stars," "NIGHT/CRIMES," "Shadows," and "Walnut Tree Orchard." In these works, Gaines investigates the relationships between aesthetic experience, political beliefs, and the formation of meaning. For example, the twelve-foot-wide light box sculpture *Skybox I* displayed four political texts. Spanning three hundred years and several continents, the texts reveal global perspectives on topics ranging from oppression and colonization to democracy and freedom. At regular intervals, the gallery lights dimmed, making visible LED lights shining through thousands of laser-cut holes on the sculpture's surface, creating an image of the night sky.

PUBLICATION
In the Shadow of Numbers: Charles Gaines Selected Works from 1975–2012
Foreword by Rebecca McGrew and Ciara Ennis
Essay by Michael Ned Holte
Design by Kimberly Varella, Department of Graphic Sciences, Los Angeles

PROGRAMMING
Lecture in coordination with Pitzer Art Galleries; performance by Charles Gaines Ensemble (Charles Gaines, Terry Adkins, Louis Lopez, Wadada Leo Smith, and Nedra Wheeler)

The Bureau of Experimental Speech and Holy Theses

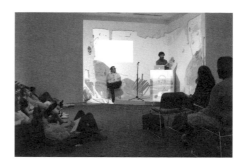

NOVEMBER 1— DECEMBER 16, 2012

The Bureau of Experimental Speech and Holy Theses (BESHT), a collaborative consortium created by artists Adam Overton and Tanya Rubbak, featured work by over 20 Los Angeles artists. An experiment in public address, BESHT explored the commingling of speech, authority, and performance. A series of weekly events temporarily converted the Pomona College Museum of Art's Project Series gallery into a public speaking hall. BESHT served as a reading room and Free Speech Auditorium with occasional Diction-for-Dollars Open Mic events for students, faculty, and visitors. All BESHT proceedings were broadcast online, and a weekly newspaper publication designed by Rubbak accompanied the exhibition.

PUBLICATION
The Bureau of Experimental Speech and Holy Theses Weekly, Issues 1–5
Contributions by John Burtle, Carol Cheh, Elana Mann, Anna Mayer, Adam Overton, Hannah Pivo, Tanya Rubbak, and Mathew Timmons
Design by Tanya Rubbak

PROGRAMMING
Series of artist-coordinated events and open mic space for visitors; lectures and workshops for Art Writing, Feminist Online Spaces, Foundation of Digital Design, Introduction to Art Theory, Introduction to Media Studies, Art Major Seminar, and Voice for Actor courses

PROJECT SERIES 45
Kirsten Everberg:
In a Grove

JANUARY 22— APRIL 14, 2013

The suite of paintings in Kirsten Everberg's exhibition "In a Grove" employed her technique of pouring glossy enamel paint onto horizontal canvases, creating lush surfaces that blur representation and abstraction. The paintings are based on filmmaker Akira Kurosawa's 1950 classic drama *Rashomon*, which centers around a rape and murder told from four different and contradictory points of view. Everberg's paintings are titled after the four characters: Bandit, Ghost, Wife, and Woodcutter. Forest scenes from the film inspired the structure of each work, and specific elements in the paintings came from *Rashomon* film stills, found botanical photographs of Japanese plants, early twentieth-century photographs by C. H. Wilson of the Komyoji Temple Forest and the Nara Forest in Japan (where the film was shot), and photographs shot by the artist at local botanical gardens.

PUBLICATION
Kirsten Everberg: In a Grove
Essays by Rebecca McGrew and
Gloria H. Sutton
Design by Kimberly Varella, Content
Object Design Studio

PROGRAMMING
Lecture for painting courses

PROJECT SERIES 46
Hirokazu Kosaka:
On the Verandah
Selected Works 1969–1974

SEPTEMBER 3— OCTOBER 20, 2013

The survey "On The Verandah Selected Works 1969–1974" examined the early artwork of Hirokazu Kosaka. The exhibition, co-curated by Rebecca McGrew and Glenn Phillips, included documentation of Kosaka's early performance works and rarely seen films. Influenced by his knowledge of Buddhism, Zen archery, Noh and Kabuki theater, Japan's Gutai Group, and his exposure to contemporary art in Southern California, Kosaka experiments with body art and performance. Merging his early experiences in Japan with an emphasis on physical endurance, process, repetition, and concrete forms, Kosaka attempts to creatively reconcile spiritual practices, such as meditation and pilgrimage, with avant-garde artistic innovations.

PUBLICATION
Project Series 46: Hirokazu Kosaka:
On the Verandah Selected Works
1969–1974
Introduction by Rebecca McGrew
Essay by Glenn Phillips
Text by Shayda Amanat and Hirokazu Kosaka
Design by Kimberly Varella, Content
Object Design Studio

PROGRAMMING
Zen archery presentation and calligraphy workshop for Worlds of Buddhism course; curatorial intern talk by Shayda Amanat

PROJECT SERIES **47**

Krysten Cunningham: Ret, Scutch, Heckle

OCTOBER 31— DECEMBER 22, 2013

Krysten Cunningham's "Ret, Scutch, Heckle," co-curated by Rebecca McGrew and Hannah Pivo, included abstract sculptures and drawings that explore craft, metaphysics, perception, and social justice. Using hand-dyed yarn, fabric, steel, plaster, rope, wood, and plastics, Cunningham combines color, line, scale, and space with craft-oriented feminist art, socially-engaged conceptual art, and Native American textile patterns. In her "God's Eye" series, she takes inspiration from the spiritual traditions of the Huichol Indians of Central Mexico and creates large, complex three-dimensional forms that also function as abstract models of hypercubes, which are theoretical models of four-dimensional space. Other sculptures explored the intersections of materials and spirituality, while the juxtaposition of sleek, metal structures with hand-dyed and hand-woven textiles emphasized labor and craft.

PUBLICATION
Krysten Cunningham
Essays by Rebecca McGrew and Hannah Pivo
Design by Kimberly Varella, Content Object Design Studio

PROGRAMMING
Five workshops for students in Art History, Environmental Analysis, Media Studies, Studio Art, and Theater departments, culminating in a performance in consultation with Professor Dwight Whitaker, Department of Physics; curatorial intern talk by Hannah Pivo

PROJECT SERIES **48**

Andrea Bowers: #sweetjane

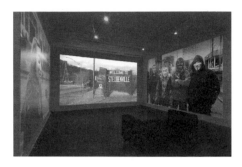

JANUARY 21— APRIL 13, 2014

"Andrea Bowers: #sweetjane" was co-curated by Rebecca McGrew and Ciara Ennis and co-presented with the Pitzer College Art Galleries. The exhibition examined the notorious Steubenville, Ohio, high school rape case and the subsequent trial. Bowers's project, "#sweetjane," draws attention to the under-recognized issue of rape culture on college campuses, the history of violence against women, the role of social media, the notion of anonymity, and the complex issues around women's healthcare rights. On view at the Pomona College Museum of Art was *#sweetjane*, a video that critically retells the Steubenville rape case through media clips, YouTube postings, Bowers's own footage, photo-murals of Anonymous members protesting during the trial, and a drawing of Texas State Senator Wendy Davis during her filibuster of anti-abortion legislation. Pitzer College Art Galleries exhibited a 65-foot drawing installation based on a partial transcript of text messages retrieved from the phones of individuals involved in the rape case.

PUBLICATION
Andrea Bowers
Introduction by Rebecca McGrew
Essays by Maria Elana Buszek and Peter R. Kalb
Interview by Ciara Ennis
Design by Kimberly Varella, Content Object Design Studio

PROGRAMMING
Lecture in coordination with Women's Union; lecture by Maria Elena Buszek in coordination with Pitzer Art Galleries; zine workshops and zine publication coordinated by Justine Bae, Estephany Campos, and Winona Bechtle

PROJECT SERIES 49
Sam Falls

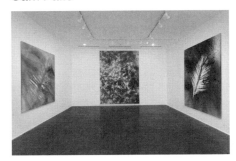

SEPTEMBER 2— DECEMBER 19, 2014

Sam Falls creates his "Ferns and Palms" paintings by placing large sheets of raw canvas outside prior to a storm, then arranging organic material—palm fronds in California and ferns in Vermont—on the canvas, and, finally, spreading dry pigment over the plants and canvases. The resulting image is determined by the duration of the storm, the quality and amount of rain, the randomly applied pigmentation, and the vegetal forms. In the sculpture *Untitled (Life in California),* installed in the courtyard outside of the museum, Falls sandblasted his 1984 truck in random patterns to reveal layers of red and tan paint and the steel base beneath. He clear-coated some parts to protect from rust while others were left raw. After altering the pickup, he planted it with succulents. Over time, the sculpture will shift and transform—the plants will grow, and the truck's surface will change color and texture as it rusts and weathers.

PUBLICATION
Sam Falls: Ferns and Palms
Introduction by Rebecca McGrew
Essay by David Pagel
Design by Nicholas Gottlund

PROGRAMMING
Lecture and studio visits for Art Major Seminar

PROJECT SERIES 50
Brenna Youngblood

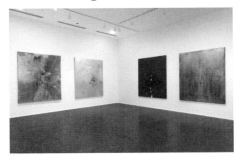

JANUARY 20— MAY 17, 2015

The eight lyrically distressed paintings in Brenna Youngblood's exhibition explored gestural abstraction, color field painting, and collage, and posed questions about memory, identity, and class. By combining materials such as canvas, found papers, panel, faux wood, acrylic paint, and other detritus from her studio with fragmented photographs of solitary everyday objects, Youngblood created layered, expressionist, heavily-worked surfaces. Youngblood frequently utilizes a singular image or object—chain link fencing, a solitary chair or light bulb, a star or pine tree air freshener— to symbolize the ordinariness of a lonely or overlooked humanity.

PUBLICATION
Project Series 50: Brenna Youngblood
Essays by Rebecca McGrew and
Naima J. Keith
Design by Kimberly Varella, Content
Object Design

241

Acknowledgments

Artistic vision, creativity, and collaboration have been the cornerstones of the Project Series at Pomona College since its inception in 1999. As a core program of the Pomona College Museum of Art, the Project Series links the rigorous and stimulating work of emerging artists with multiple generations of students and with faculty from a broad range of disciplines. Now, with "R.S.V.P. Los Angeles: The Project Series at Pomona," creative partnership is at the heart of our process in every stage.

The exhibition, on view at the Pomona College Museum of Art in fall 2015, and this accompanying publication represent years of curatorial labors of love. The Project Series program is embedded deeply into the ethos of the museum, and we have been able to grow our permanent collection with targeted acquisitions of some of the works shown in the Project Series. Now, more than fifteen years later, we are extending the program's vision of contemporary art that enlightens and inspires—culturally, politically, and intellectually. We envisioned the "R.S.V.P. Los Angeles" exhibition as a way for us to engage even more closely and creatively with artists in Los Angeles and students, faculty, and staff at Pomona College, through the exhibition curation and the related academic and public programs. This exhibition process has expanded our understanding of art and artists in the greater Los Angeles area and our ability to connect them to the college.

After coming up with the idea of an invitational exhibition where selected former Project Series artists would nominate artists to be considered for "R.S.V.P. Los Angeles," we knew the next step was the formation of an inclusive, engaged committee of our colleagues at Pomona College. Our faculty committee members—Lisa Anne Auerbach, Jonathan Hall, and Valorie Thomas—offered expertise and insight at all stages of this complex project. They willingly and patiently explored this new curatorial process with us, and we are extraordinarily grateful to them. Studio art and art history major Nicolás Orozco-Valdivia ('17), joined our committee soon after, and proved a valuable addition. Our endeavors were supported every step of the way by the curatorial assistance of Ian Byers-Gamber ('14). We thank our team members for their generosity, intellect, and open-mindedness.

Over 50 remarkable artists have been part of the Project Series over the years, and we wish to extend immense gratitude to each of these artists who have inspired the Pomona College community. Recognizing the significance of this legacy, and wanting to broaden our curatorial perspective, our committee unanimously selected former Project Series artists Christina Fernandez, Charles Gaines, Ken Gonzales-Day, Katie Grinnan, Soo Kim, Hirokazu Kosaka, and Amanda Ross-Ho. Each of these seven artists was invited to propose two artists based in Los Angeles. We are extremely grateful to our nominating artists for their enthusiasm and willingness to thoughtfully consider this challenge.

"R.S.V.P. Los Angeles" would not have been possible without the exhibiting artists: Justin Cole, Michael Decker, Naotaka Hiro, Wakana Kimura, Aydinaneth Ortiz, Michael Parker, and Nikki Pressley. Our team was honored to have the opportunity to discuss formative ideas with each of them. We are grateful for their creativity, generosity, and vision, and we thank them for extending loans of existing work and/or creating new work for the exhibition.

Rebecca McGrew and Terri Geis

Our team later expanded to include graphic designer Kimberly Varella of Content Object, who provided creative input throughout the process. Her vision for the *R.S.V.P. Los Angeles* book harnessed our broad notions of an elegant and original design to complement both the exhibition and the Project Series history. Editor Elizabeth Pulsinelli astutely edited the texts in this publication and expertly managed the process at all stages. Exhibition designer and preparator Gary Murphy consulted with each artist, and his artful problem solving, highly perceptive design sense, and fabrication skills created the stage for each artist's installation. The Project Series bookshelf was designed and fabricated by Byers-Gamber, Davis Menard ('17), and Gary Murphy, with considerable support from Lucas Littlejohn ('17), Professor Michael O'Malley, and the Pomona College Studio Art Department. We are grateful to all of these crucial collaborators.

Critic Doug Harvey and Getty Research Institute curator Glenn Phillips—both former Project Series catalog essayists—have contributed insightful new essays. Critic Sarah Wang, Pomona College Museum of Art director Kathleen Stewart Howe, and our committee team members Lisa Anne Auerbach, Valorie Thomas, and Nicolás Orozco-Valdivia also produced perceptive texts for the publication. We appreciate the keen and thoughtful analysis reflected in all of their writings. With utmost care, Robert Wedemeyer expertly photographed the majority of images in the book, including the installation views of "R.S.V.P. Los Angeles."

This exhibition would not have been possible without the generosity and assistance of a number of other individuals and institutions. At Pomona College, we are indebted to friends of the College (many of whom are also listed on page 244) who have supported exhibition, academic, or internship programs, including Janet Inskeep Benton ('79), Louise and John Bryson, Josephine Bump ('76), Graham "Bud" ('55) and Mary Ellen ('56) Kilsby, Lucille Paris, Carlton and Laura Seaver, the Eva Cole and Clyde Alan Matson Memorial Fund, the Edwin A. and Margaret K. Phillips Fund to Support the Museum, and the Rembrandt Club of Pomona College. We are most grateful to longtime supporters the Pasadena Art Alliance, who recognized the merit of the Project Series in the early days and who have consistently championed the program. We simply could not have done the exhibitions and publications without them.

Others who have provided crucial support include our research assistants Shayda Amarat (Scripps College '14), Parker Head ('17), Davis Menard, Jenny Muniz ('15), and Hannah Pivo ('14), who have devoted hours of work to this project over a period of several years. As always, every member of the museum's staff has played a vital role: Kathleen Stewart Howe, whose encouragement and support of this project from the very beginning has been crucial and deeply appreciated; Justine Bae, whose assistance in all aspects and planning of complementary Art After Hours events was unwavering and always helpful; Barbara Coldiron, who helped manage every stage of budget and accounting; Steve Comba, who coordinated all registration for the exhibition and assisted with framing; and Benjamin Kersten ('15), who, as curatorial assistant, added immeasurably. We extend many heartfelt thanks to them all for support during all aspects of the exhibition's organization.

Rebecca McGrew '85
Senior Curator

Terri Geis
Curator of Academic Programs

SUPPORTERS OF THE POMONA COLLEGE MUSEUM OF ART PROJECT SERIES, 1999–2015

ARC grant from the Center for Cultural Innovation

Edwin A. and Margaret K. Phillips Fund for Museum Publications

Danny First

Japanese American Cultural & Community Center

Sarah Miller Meigs

Brenda Nardi '85

Dr. M. Lucille Paris

Pasadena Art Alliance

Dr. Ernest Ross and Judy Maltese Ross

Evy and Fred Scholder

Carlton and Laura Seaver

Andrew Sloves '86

Steve Martin Charitable Foundation

Eileen Williamson and Michael Williamson '86

SUPPORTERS OF THE POMONA COLLEGE MUSEUM OF ART INTERNSHIP PROGRAMS

Janet Inskeep Benton '79

Josephine Bump '76

Graham "Bud" '55 and Mary Ellen '56 Kilsby

The Getty Foundation Multicultural Undergraduate Summer Internships Program

PROJECT SERIES ARTIST GALLERY SUPPORTERS, 1999–2015

1301PE Gallery, Los Angeles

ACME., Los Angeles

Andrew Kreps Gallery, New York

Angles Gallery, Los Angeles

Capitain Petzel Gallery, Berlin, Germany

Carl Berg Gallery, Los Angeles

Dunn Brown Contemporary, Dallas, TX

Jenn Joy Gallery, San Francisco, CA

kaufmann repetto, Milan, Italy

Lombard-Fried Fine Arts, New York

Margo Leavin Gallery, Los Angeles

Patricia Faure Gallery, Santa Monica, CA

Richard Telles Fine Art, Los Angeles

Rosamund Felsen Gallery, Santa Monica, CA

Shoshana Wayne Gallery, Santa Monica, CA

Susanne Vielmetter Los Angeles Projects, Los Angeles

Talwar Gallery, New York

Contributor Biographies

LISA ANNE AUERBACH's sweaters, publications, and photographs have been shown in museums, galleries, cooperative bicycle repair shops, *Kunsthalles*, and on vacant desert lots internationally, including solo exhibitions at Malmö Konsthall, Malmö, Sweden (2012); American Philosophical Society Museum and Philagrafika2010: Out of Print, Philadelphia (2010); Nottingham Contemporary, Nottingham, United Kingdom (2009); University of Michigan Art Museum, Ann Arbor (2009); Aspen Art Museum, Colorado (2008); Printed Matter, New York (2009); and CPK Kunsthal, Copenhagen (2006). Her work was also included in "Whitney Biennial 2014," Whitney Museum of American Art, New York; Parasophia International Festival, Kyoto, Japan (2015); and "Nine Lives: Visionary Artists from L.A.," Hammer Museum, Los Angeles (2009). She has self-published numerous magazines, including *American Megazine*, *Saddlesore*, and *American Homebody*. She received a BFA from Rochester Institute of Technology, New York, and an MFA from Art Center College of Design, Pasadena, California. She is the recipient of a 2007 California Community Foundation Fellowship for Visual Artists, a 2009 Louis Comfort Tiffany Foundation Award, and a 2012 City of Los Angeles Department of Cultural Affairs Individual Artist COLA Grant. Auerbach is Associate Professor at Pomona College.

IAN BYERS-GAMBER is a Los Angeles-based videographer and artist. He is a graduate of Pomona College ('14) and has recently done work for Machine Project, the Pomona College Museum of Art, and a number of visual and performing artists in Los Angeles. His current focus is on performance and gallery documentation and the practice of creating visual archives for temporary works.

TERRI GEIS is Curator of Academic Programs at the Pomona College Museum of Art. Geis is a specialist on the intersections between Surrealism and the Americas, with past projects and publications including "In Wonderland: The Surrealist Adventures of Women Artists in Mexico and the United States" (Los Angeles County Museum of Art, 2012); an essay on the Brazilian artist Maria Martins in *Surrealism in Latin America: Vivísimo Muerto* (Getty Research Institute, 2012); and contributions to *Catalogo comentado del acervo del Museo Nacional de Arte. Pintura, Siglo XX* (Museo Nacional de Arte, Mexico, 2014). Forthcoming articles investigate Surrealism's connections with Afro-Caribbean art and culture, including "Myth, History and Repetition: André Breton and Vodou in Haiti" (*South Central Review*, Johns Hopkins University Press) and "'The Old Horizon Withdraws': Surrealist Connections in Martinique and Haiti: Suzanne Césaire/André Breton, Maya Deren/André Pierre" (University of Manchester Press).

Since graduating with an MFA in painting from the University of California, Los Angeles, in 1994, DOUG HARVEY has juggled multiple careers as a critic, curator, educator, and multimedia artist. He has written extensively about the Los Angeles and international art scenes and other aspects of popular culture for *LA WEEKLY*, *Art issues*, *Art in America*, *The New York Times*, *The Nation*, *Modern Painters*, and many other publications. He has written museum and gallery catalog essays for Jeffrey Vallance, Tim Hawkinson, Marnie Weber, Lari Pittman, Mike Kelley, Thomas Kinkade, and many others. Major curatorial initiatives have included two *Annual LA Weekly Biennials*, *Aspects of Mel's Hole: Artists Respond to a Paranormal Land Event Occurring in Radiospace* (2008), and *Chain Letter* (2011)—a global self-curating multi-centered group show that can theoretically include every artist on earth, and the second of his curatorial projects to shut down the Bergamot Station exit off the I-10 freeway. His activities may be monitored online at www.dougharvey.blogspot.com and www.dougharvey.la.

KATHLEEN STEWART HOWE joined Pomona College in 2004 as the Sarah Rempel and Herbert S. Rempel '23 Director of the Pomona College Art Museum and Professor of Art History. The focus of Howe's work is the interplay of photography and culture. She has curated over 100 exhibitions including "In Search of Biblical Lands: 19th century Photography in the Holy Land," at the Getty Villa (2011). At Pomona College, she has curated exhibitions featuring artists John Divola, Edgar Heap of Birds, David Michalek, James Turrell, Frederick Hammersley, Kara Walker, and

245

Enrique Chagoya. She has contributed to or edited books on the role of photography in archaeology, the connections between photography and the graphic arts, contemporary photography, and contemporary Native American printmaking, as well as essays for monographs in photography.

REBECCA MCGREW is Senior Curator at the Pomona College Museum of Art. Recent exhibitions include "Project Series 50: Brenna Youngblood" (2015), "Andrea Bowers: #sweetjane" (2014), and "Project Series 49: Sam Falls, Ferns and Palms" (2014). She has organized many other exhibitions, including most recently, "Mowry Baden: Dromedary Mezzanine" (2014), the award-winning and critically acclaimed "It Happened at Pomona: Art at the Edge of Los Angeles 1969–1973" (co-organized with Glenn Phillips, 2011–12), "Steve Roden: when words become forms" (2010), "Hunches, Geometrics, Organics: Paintings by Frederick Hammersley" (2007), "Ed Ruscha/Raymond Pettibon: The Holy Bible and THE END" (2006), and "The 21st Century Odyssey Part II: The Performances of Barbara T. Smith" (2005). McGrew is the recipient of a Getty Curatorial Research Fellowship (2007) and Getty Foundation grants under the Pacific Standard Time initiatives in 2009–11 and 2014.

NICOLÁS OROZCO-VALDIVIA is an art history/studio arts double major at Pomona College ('17). Early exposure to art and artists at Los Angeles cultural institutions like Plaza de la Raza, Self-Help Graphics, and Avenue 50 Studio sparked his interest in the relationships between cultural production, institutions, and communities. Orozco-Valdivia has pursued this interest as a participant and support staff member in the Smithsonian Latino Center's Young Ambassador Program, as a curatorial intern at the Pomona College Museum of Art, and as an Andrew W. Mellon Undergraduate Curatorial Fellow at the Los Angeles County Museum of Art.

GLENN PHILLIPS is Curator of Modern and Contemporary Collections at the Getty Research Institute in Los Angeles. His exhibition "California Video" won the International Association of Art Critics award for best exhibition of digital media, video, or film in 2008, and the project "It Happened at Pomona: Art at the Edge of Los Angeles 1969–1973" (co-organized with Rebecca McGrew) won the Association of Art Museum Curators award for Best University Exhibition of 2011. Other

past projects include "Pioneers of Brazilian Video Art 1973–1983"; "Surveying the Border: Three Decades of Video Art about the United States and Mexico"; and "Radical Communication: Japanese Video Art 1968–88." His next exhibition, "The Kingdom of Obsessions," about the Swiss curator Harald Szeemann, will open at the Getty Center in 2017.

Professor **VALORIE THOMAS** won a 2013 Wig Excellence in Teaching Award as an Associate Professor of English and Africana Studies at Pomona College, where she has worked since 1998. She holds a PhD in English from the University of California, Berkeley, and an MFA in Screenwriting from the University of California, Los Angeles. Her courses focus on social justice and include AfroFuturisms, Literature and Film of the African Diaspora, Healing Narratives, Literature of Incarceration, and Contemporary Native American/First Nations Literature. Her work has appeared in *Toni Morrison: Memory and Meaning*, edited by Adrienne Seward and Justine Tally; *African American Review*; *Frontiers: A Journal of Women Studies*; *Black Cool: One Thousand Streams of Blackness*, edited by Rebecca Walker; and *Jalada Africa 2: Afrofuturism*. She is completing a manuscript titled *Diasporic Vertigo: Memory, Space and Charting the Future in African Diaspora Arts*.

SARAH WANG is a writer based in New York who has written for *The Last Newspaper* at the New Museum of Contemporary Art, semiotext(e)'s *Animal Shelter*, *The Los Angeles Review of Books*, *Conjunctions*, Keren Cytter's *Poetic Series*, published by Sternberg Press, Night Gallery's *Night Papers*, and *Black Clock*, among other publications.

PHOTOGRAPHY CREDITS

All images courtesy of the artist unless otherwise noted.

Project Series installation photographs courtesy of Pomona College Museum of Art unless otherwise noted.

Edgar Arceneaux and Julian Myers: 53

Lisa Anne Auerbach: 164

Justine Bae: 17, 24–25

Charles Benton: 37, 104, 114–15, 117

Brennan & Griffin, New York: 104, 109, 117

Ian Byers-Gamber: 10, 27–28, 76–77

Alexis Chanes: 172, 174–75, 177

Google Maps: 167

Jyunichi Hirose: 130–31

J. Paul Getty Trust, Image © J. Paul Getty Trust: 52

Don Lewis: 45 (top)

Jason Mandela: 109

Rebecca McGrew: 12, 18, 22

Davis Menard: 45 (bottom)

Fredrik Nilsen: 227, 239

Heather Rasmussen: 98–101

Osceola Refetoff: 188, 191, 200–203

Dylan Schwartz: 38

Robert Wedemeyer: 14, 20–21, 43, 46, 54, 80, 85–86, 93–97, 118–19, 124, 133–39, 149–53, 156, 170–71, 180, 193–99, 234 (left), 236 (right), 237 (right), 238 (left), 239 (right), 240–241

ARTIST ACKNOWLEDGMENTS

JUSTIN COLE
Khana Lacewell
Beatrice Cole
Julie and Charles Cole
John Nelson
Juan Capistran
Charles Gaines
Joshua Callaghan
Angelica Sanchez
Phil Chang
Phil Ranelin

MICHAEL DECKER
Adam Avalos
Brett Goldstone
Laura Owens
Lisa Anne Auerbach
Sarah Wang

NAOTAKA HIRO
Brennan & Griffin, New York
Glenn Phillips
Misako & Rosen, Tokyo
Paul and Karen McCarthy
Rika Hiro
The Box, Los Angeles

WAKANA KIMURA
Hiromi Paper, Inc.
David MacLeod
Kevin Reeve
Mori Vision
Ian Byers-Gamber

MICHAEL PARKER
Stephanie Campbell
Troy Rounseville
Wesley Hicks
Katherine Cox
Jim Haag
Alexis Chanes
Jeannette Viveros
Nic Gaby
Brianna Allen
Mark Ditchkus
Ian Byers-Gamber
Eli Lichter-Marck
Luke Fischbeck
Robin Smith
Alyse Emdur

NIKKI PRESSLEY
Liz and Dennis Fougere and Darrow School
The Nathan Paulding '89 Artist in Residency Program made possible by Bart and Connie Paulding
Charles Gaines

AYDINANETH ORTIZ
Isrrael & Ana Ortiz
Annie Ortiz
Juan Manuel Valenzuela

POMONA COLLEGE
MUSEUM OF ART

This catalog was published on the occasion of the exhibition "R.S.V.P. Los Angeles: The Project Series at Pomona," presented at the Pomona College Museum of Art, September 1–December 19, 2015.

Pomona College Museum of Art
333 North College Way
Claremont, CA 91711
www.pomona.edu/museum
Tel: 909-621-8283

ISBN: 978-0-9856251-7-7

Available through D.A.P./
Distributed Art Publishers, Inc.
155 Sixth Avenue
New York, NY 10013
www.artbook.com

Coedited by Rebecca McGrew and Terri Geis

Designed by Kimberly Varella,
Content Object, Los Angeles

Copy edited by Elizabeth Pulsinelli

Separations by Echelon, Santa Monica, CA

Printed and bound by The Avery Group
at Shapco Printing